DRAW
DRAWN
DRAWING

QUOTIDIAN LINES by artist

MICHAEL JAMES PLAUTZ

octane press

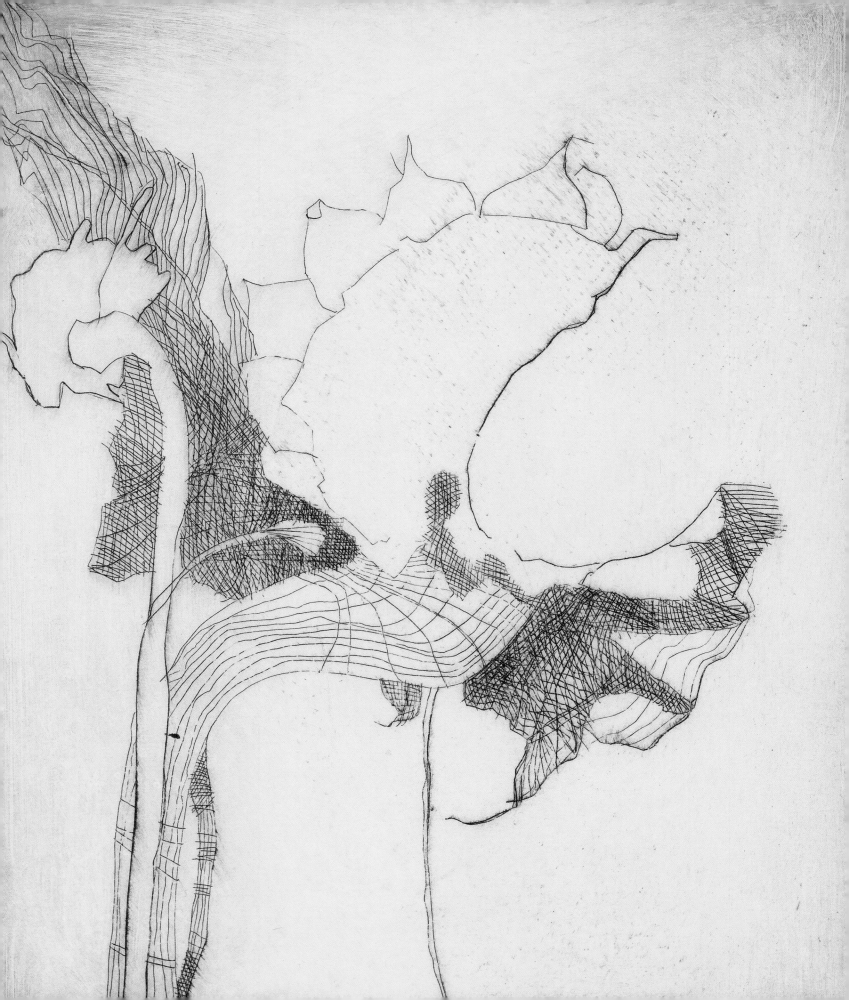

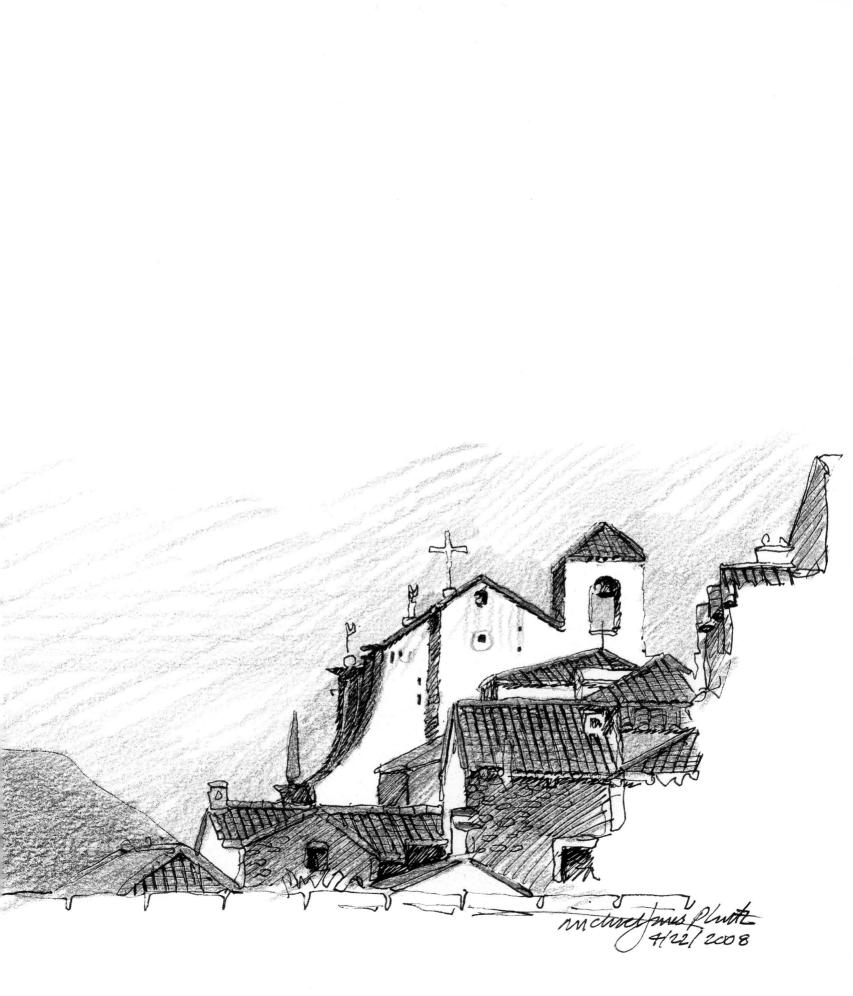

michael Jones plueitt
4/22/ 2008

First Edition, November 2011

Copyright © 2011

ISBN-10: 0-9829131-4-1

ISBN-13: 978-0-9829131-4-7

On the cover: Bodegas Ysios Winery, Rioja Country. Spain. 2003. Pen.

On the frontispiece: Dry Sunflower. Paris, France. 1965. Etching.

On the verso: Louvre, Old and New. Paris, France. 2008. Pen.

On the back page: Wild Hair #2. Santa Fe, New Mexico, USA. 1985. Silkscreen.

Cover design by Nick Lamoureaux

Book design by Cindy and Karl Laun

octane press

www.octanepress.com

Printed in China

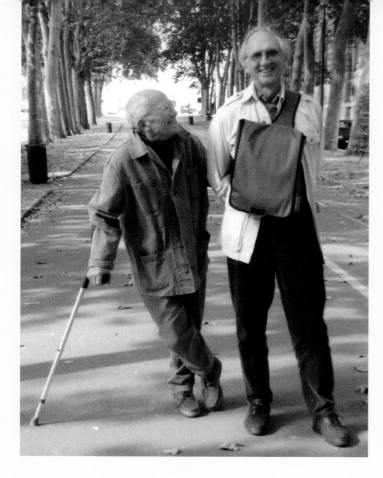

IN MEMORIAM:
PROFESSOR ALEXANDRE NOTARAS

I dedicate this book to Alec Notaras,
my professor and mentor.
I owe much to him.

Alec had an interesting background that colored his personality. He was born in Izmir (Smyrna, Turkey) to Greek parents in 1921. At the age of three he was rescued by an American naval captain from the Turkish/Greek pogroms, then grew up in Paris where he survived the Nazi occupation, and was a star pupil at the *École des Beaux Arts*, immensely talented in design, drafting and sketching/painting.

In the 1950s he came to the United States and taught architectural design at the University of Oklahoma and then in the mid-1960s at the University of Illinois at Urbana-Champaign, where I met him. He was a tremendous critic of design and had little patience for students who didn't work hard. In the fall of 1966, I was sequestered in his office day and long nights for five weeks while I worked on the Paris Prize national student competition. Each morning he would walk into the office, take off his beret, get up on a stool, look at what I had drawn the night before and say (in his best Greek-French-Okie accent), "It's good, but not good enough to win…" so off again I went with rolls of tracing paper to draw endless alternatives I ultimately won the competition thanks to his tireless prodding. The prize—a year of travel and visiting architecture throughout Europe—propelled and fueled my lifelong passion for drawing and traveling.

Alec went on to head up the University of Illinois' foreign studies program in Versailles, France, a position he held until his retirement. In the early 1980s, he recruited me to come to France at least once a year for two weeks to teach urban analysis, design, and sketching to the American architecture students. This started a 28-year odyssey of travel, observation and sketching in a variety of countries. We became friends, traveling and sketching together with students—straddling walls in French hill towns in front of castles; drawing the streets, cityscapes and nunneries of Patmos, Greece; and visiting Hagia Sophia in his native Turkey and Ephesus in Asia Minor.

He died early in 2011 at the age of 89. This photo of the two of us—our last meeting on the Avenue de Sceaux near the school in Versailles—is forever etched in my memory; both of us students, both of us teachers, not caring which was which.

Michael J. Plautz
Minneapolis
July 2011

Contents

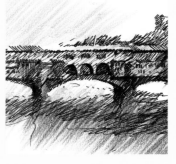

Foreword By EMMANUEL GUIBERT

My English is too poor to say what you mean to me, Mike.

I wish to write directly in your language, though, because it's been one of the bridges that led us to friendship. Another oh so precious bridge is the person who introduced me to you and Gloria: the one and only Juliette Fournot. Another bridge is our mutual fondness for good laughs. Another bridge may be the huge one over the Atlantic Ocean that often leads you to Europe, where you would live today if your Slovenian grandparents hadn't decided, once upon a time, to take that bridge the other way.

But let's imagine, Mike, all those bridges never existed. You and I just meet by chance, today, in an urban or natural landscape; wherever. You have your sketchbook, I have mine. At first, we don't notice each other, because we are both deeply concentrated on the object of our focus. That may be a tree, a building, a pedestrian, a dog, or a cloud. You draw this, I draw that. Bit by bit, the effects of concentration broaden our senses, enlarge our view, and one of us notices the only point that is perfectly still in the panorama: the other sketchman. Hey!? A brother . . . it's not so common to meet a colleague when one isn't within the four walls of an art school or a museum. And the one who has seen the other first feels this sudden and imperative desire to see what the other is drawing. The sketch in progress needs to be finished, though, because the dog may wake from his nap, stand up, and go away (and so may the cloud). Before one has decided whether he's going to keep on drawing or glance above the other's shoulder, he feels a presence behind him. It's the other! In fact, the **OTHER** has been quicker in approaching. And to make things clearer, let's say that you are the other, while I'm the **OTHER**. The first words we exchange soon teach us that we don't speak the same language. You speak English, I don't. I speak French, you don't. That makes us slightly uncomfortable and disappointed at first, but it doesn't last long, because you offer me your sketchbook and I offer you mine. And we start to flip through them. And I get to know you. And I like what I discover, because it goes along very well with your smiling face: this sketchbook is like a salt-of-the-earth box. Everything that makes life valuable is here, seen through the eyes and the pencil of a genuine life lover. What

Emmanuel Guibert with his daughter Cecilia.

we call in French a *bon vivant*—someone who's never tired of looking around. Someone who asks discretely, *in petto*, an endless question to the world and seeks answers in forms and beings of all sizes, shapes, and colors, without any prejudice. Someone who visits people and places with the inner peace of one who knows he's here to love, build, celebrate, and certainly not the contrary. Someone who likes crafts and tools. Someone who shares his discoveries without climbing on a barrel and gesticulating, but practices in the midst of others; a pupil so involved in his subject that he naturally becomes a teacher.

Some pages of the sketchbook are watercolors where light and shade have been treated with balance and precision. I convey my admiration by raising a thumb and two eyebrows, but you're too stuck on my own sketchbook to even notice. Man! We're surely sharing a nice moment, side by side, discussing silently through our sketchbooks. It comes to my mind that the world would be a better place if we'd use sketchbooks as passports. You want to know who I am and where I've been, Mr. Customs Officer? Here is my sketchbook, everything's in it. Take your time. And, by the way, show me yours. I, too, want to know who you are.

This world doesn't exist yet, Mike, but as I'm standing by your side, enjoying the good your drawings do to me, it becomes Plautzible.

Emmanuel Guibert, Paris, the 10th of June 2011
Co-author of The Photographer, *with Didier Lefèvre and Frédéric Lemercier (First Second Books, 2007)*

SANTA FE HOUSE.
2001. Pen and color pencil.

Introduction WHY A BOOK OF DRAWINGS

To affect the quality of the day, that is the highest of the arts.

—Henry David Thoreau

I draw to seek the Teilhard de Chardin-esque godhead in all phenomena. I draw to seek illumination. I draw to define all those lovely edges:

> between light and dark,
> dark and darkness,
> earth and sky,
> the built and the unbuilt,
> twilight and dusk,
> leaves and wind.

I seek all those hues and values as yet undiscovered. I draw in reverence of raw paper, unfound caves, and the ascending fragrance of a moist garden.

I draw because it is the most joyful thing I do.

I draw because of *faber* (to craft), because I have hands and eyes and brain and can use them to carve out a modest rapport, a fragile understanding of the visible and the spirit behind the visible—to extract (*to draw*) a bridge between these two worlds. By drawing you say yes to an existence, a thought, a concept. You learn. We are *form-seeking*, our genes programmed for survival. We are constantly exchanging information between ourselves and the world around us, between lungs and air, people and place, light and dark, the binary mysteries of *chiaroscuro*, all those possibilities between the dots. We are all Papagenos and Papagenas looking for each other.

Drawing is my view of the world—of all its beauty, of all its information.

Like Quixote perhaps, trying to trap small bits of light, or a child spooning water out of the ocean with microns of ink and water, graphite and earth, searching for alchemy.

Glory in sun and shadow, inflections, inversions, a search for beauty, for temporary rectification of a daily worldview, a daily prayer, a quotidian mark, an epiphany of the commonplace, an offering to a tree, a feast for the eye, a gift for friends.

This compilation of work brackets more than thirty years of study, roaming, teaching, and architectural practice in a variety of mediums. The vast majority of the works were done in front of the subject, *en plein air*, or in a studio setup or the dining room table because my wife Gloria just brought home an orchid and it must be drawn. Many were done alone, many were done while teaching students abroad or at home. Many are used as studies for watercolors, a related passion of mine.

For every poet it is always morning in the world. History a forgotten, insomniac night; History and elemental awe are always our early beginning, because the fate of poetry is to fall in love with the world, in spite of History.

—Derek Walcott

Like Midas and Scrooge,
I bank a sketch just found,
A penciled gift but for the ravages
Of time,
Forever mine,
A world of light and space and home,
An equation of *chiaroscuro*,
A feast with friends.

SELF PORTRAIT.
2011. Pencil.

The true work of art is but a shadow

of the divine perfection.

—Michelangelo Merisi da Caravaggio

1 SACRED PLACES

Sacredness: A need to seek the spiritual and elevate our lives to a higher plane. To take the daily needs of shelter, the hearth, food storage, and a place to live and gather together far beyond—to carve a perceptual simplicity out of ordinariness.

Sacred. Belonging to or dedicated to God or a god; consecrated; worthy of reverence . . . mankind has created archetypes in the forms of temples, churches, mosques and synagogues in celebration and dedication to a belief system to give meaning and focus to our lives.

It is my belief that sacredness is everywhere; the refined archtetypes we see now evolved over time from fundamental daily observations into elevated concepts . . . stone fertility votives, 25,000-year-old cave paintings, and the Eagle Shrine at Macchu Picchu are all certainly sacred.

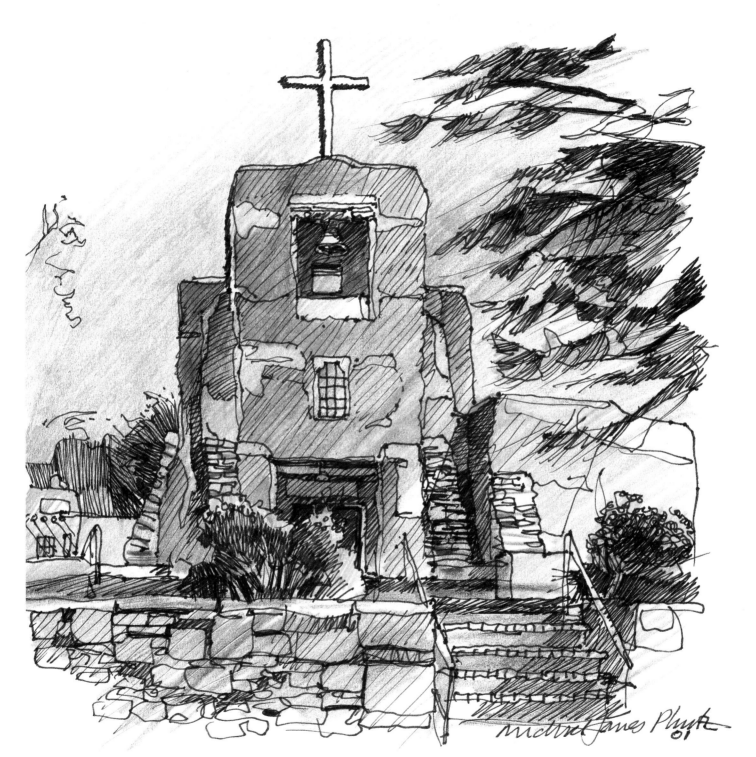

ST. MICHAEL'S CHURCH.

SANTA FE, NEW MEXICO.

2001. Pen and color pencil.

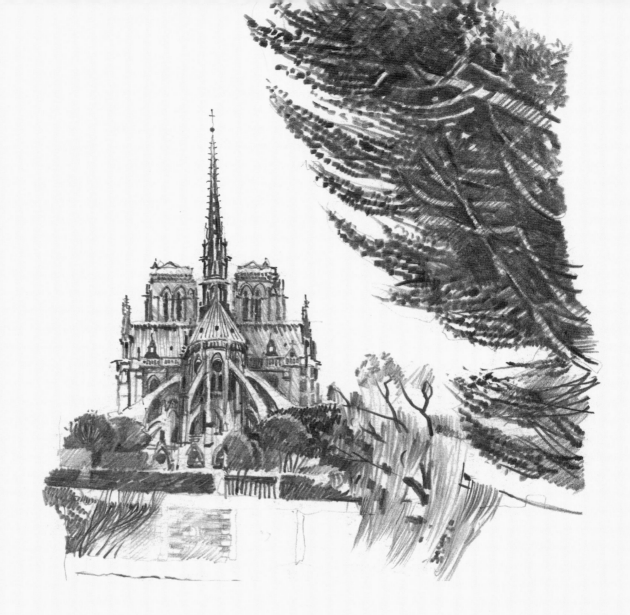

These needs became forms, forms begot spaces: a circle of stones to mark and track celestial bodies, simple huts in Greece for chieftains to meet and officiate evolved into megaron peristyled halls, Slovenian hay barns on stilts protecting precious grains and hay. Grains evolved into sacred hosts to celebrate on high in Notre Dame Cathedral, Japanese rice-storage structures on stone pillars morphed into the highest Shinto shrine in Ise, rebuilt every twenty years for fifteen centuries. Megarons evolved into civic basilicas for the caesars; in Rome evolving into high places for God and the gods, built to offer in the vertical thanksgiving for daily life and tomorrow's minute. These sacred chiaroscuric symphonies of art and science are vessels of light and wonder, as is each drop of water, each breath of a tree, each morning's shaft of light; a whole Magister Ludi's portfolio, enough for all kings and queens and priests and imams—all of us—if we only look and see.

NOTRE DAME CATHEDRAL.
PARIS, FRANCE.
2000. Pencil.

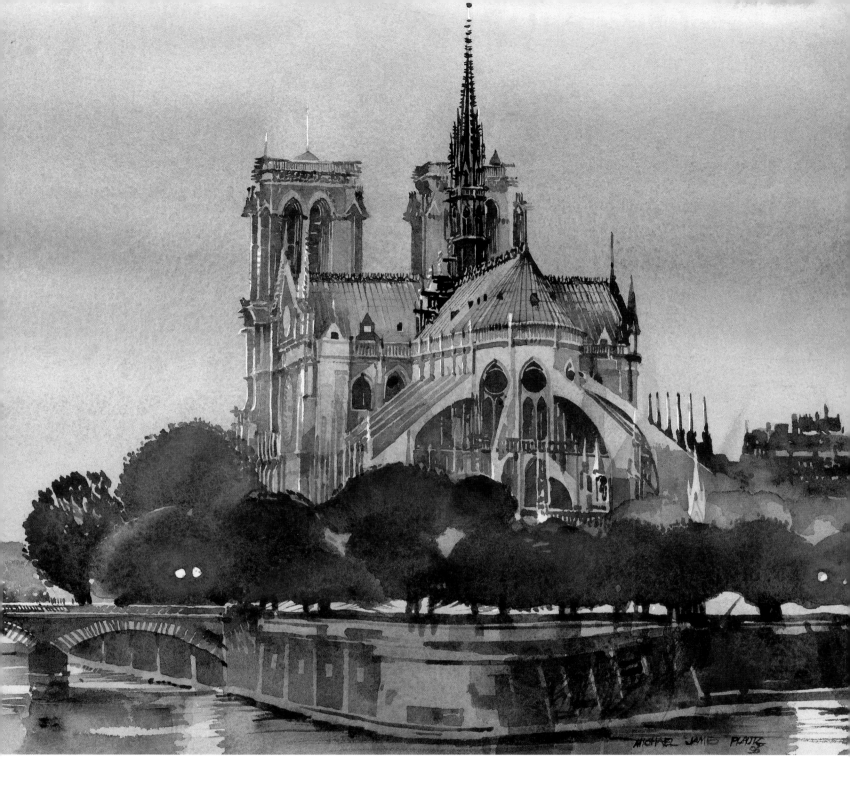

NOTRE DAME CATHEDRAL.
PARIS, FRANCE.
1996. Watercolor.

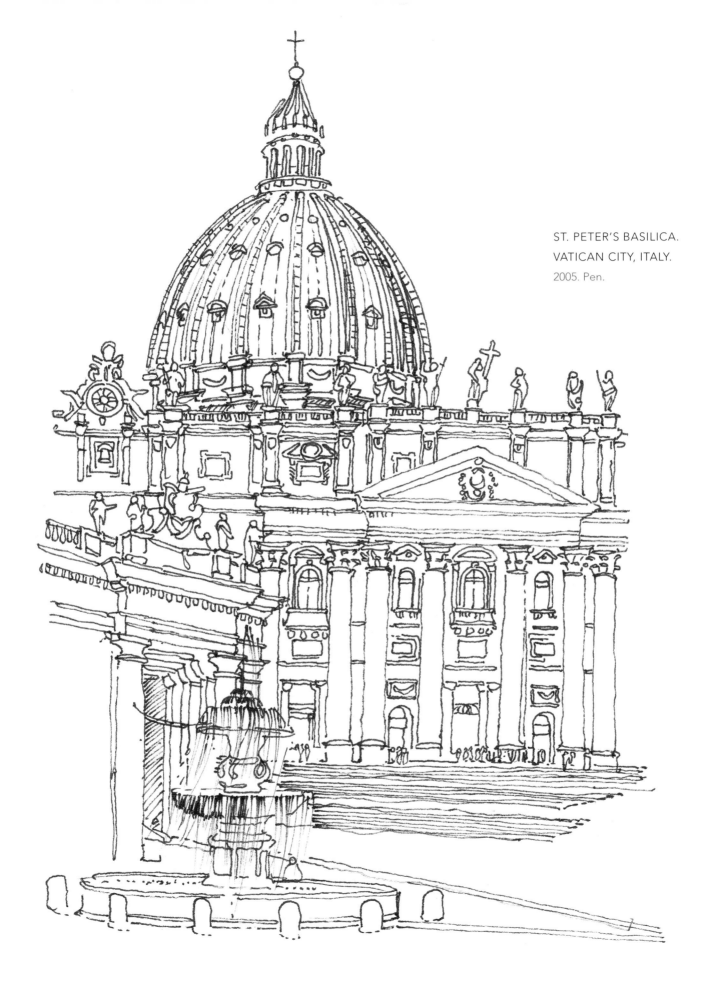

ST. PETER'S BASILICA.
VATICAN CITY, ITALY.
2005. Pen.

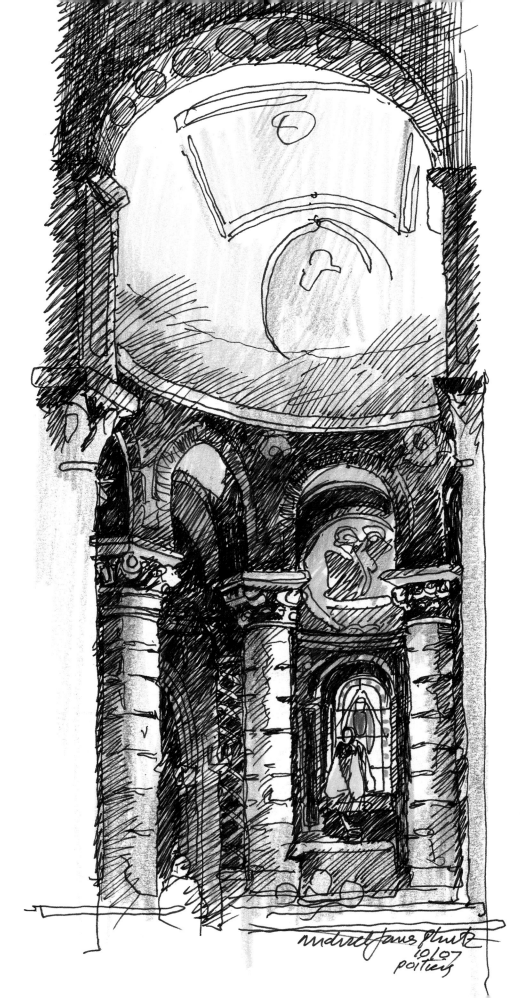

CHURCH INTERIOR.
POITIERS, FRANCE.

2007. Pen and color pencil.

COLUMN CAPITAL. AUTUN CATHEDRAL.
AUTUN, FRANCE.
1983. Charcoal.

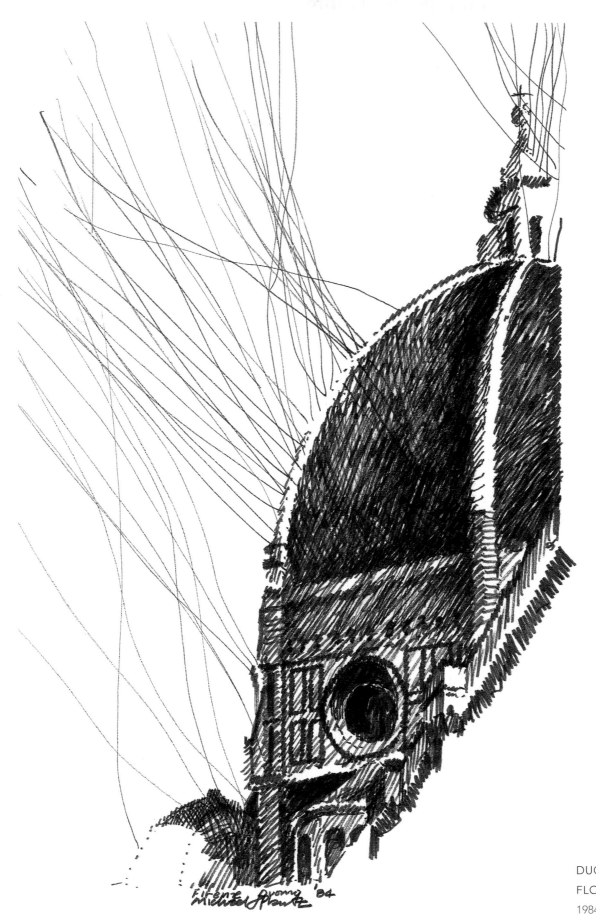

DUOMO.
FLORENCE, ITALY.
1984. Pen.

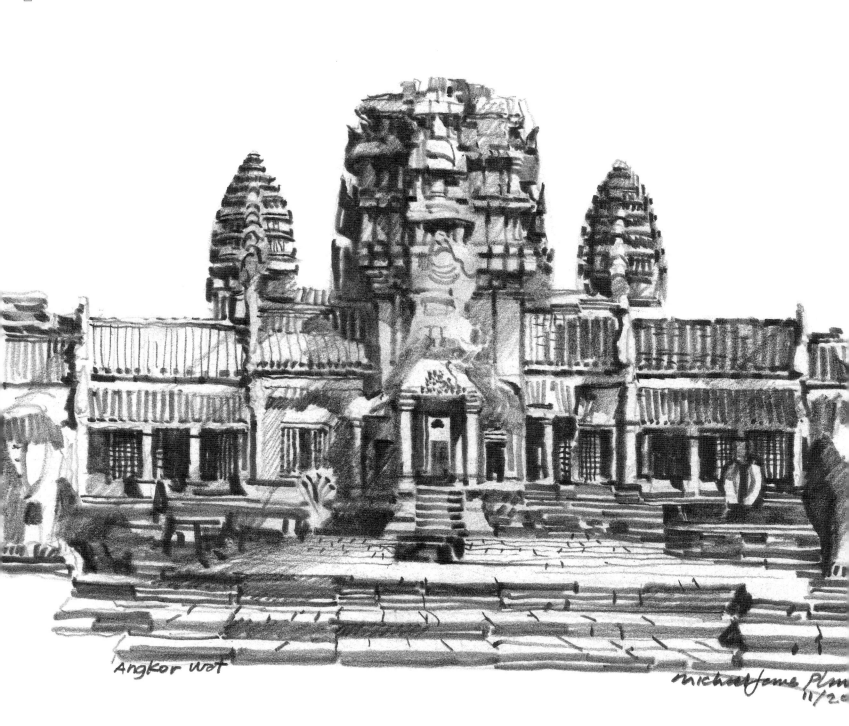

Angkor Wat

ANGKOR WAT TEMPLE.
ANGKOR, CAMBODIA.
2000. Pencil.

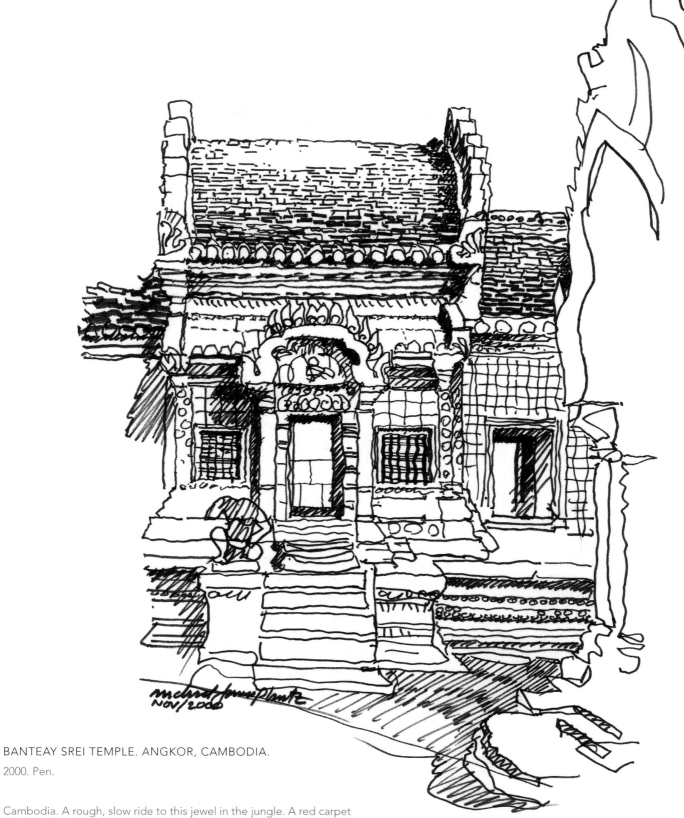

BANTEAY SREI TEMPLE. ANGKOR, CAMBODIA.
2000. Pen.

Cambodia. A rough, slow ride to this jewel in the jungle. A red carpet
was rolled out before me—the president of China and his entourage
were viewing in ceremony only yards away. No one paid attention to
me sketching—they had no idea of the treasure I was stealing away
with paper and pen.

CAVE DRAWING: FISH INSIDE A WHALE. ALTAMIRA, SPAIN. 2002. Pen.

Altamira, Spain. A 25,000-year-old cave drawing. A fish in the belly of a larger fish, my kerosene light better than that of the Paleolithic artist's light, but her inner light burning brighter than mine;
 muscled hand,
 sweeping rough surfaces,
 stone against stone,
 the sound of earth drawing,
 in echoed silence.

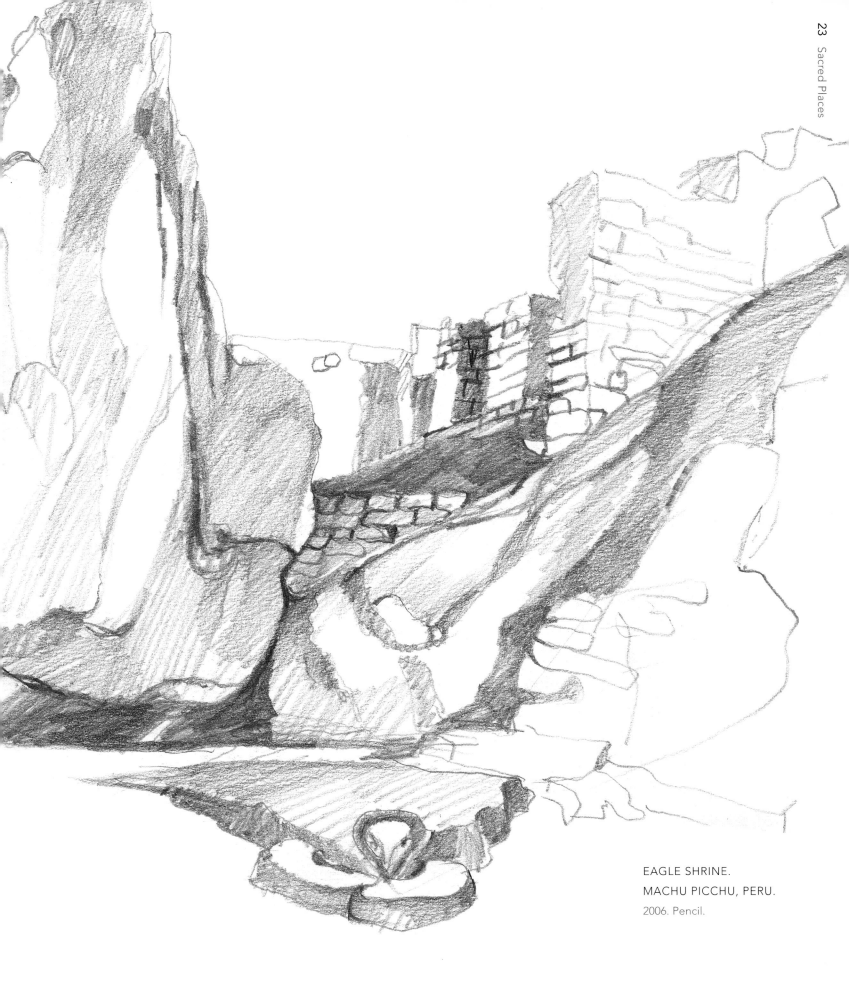

EAGLE SHRINE.
MACHU PICCHU, PERU.
2006. Pencil.

INTERIOR,
PILGRIMAGE CHURCH.
NOTRE DAME DU HAUT NEAR COLMAR, FRANCE.
2001. Pencil.

We arrived in the dark. Shafts of light were cutting the mists of night through the irregular stained-glass openings in the façade of Notre Dame du Haut, Le Corbusier's masterpiece pilgrimage church in eastern France. The minister was playing Bach's *Toccata and Fugue in D Minor* on the organ. Night or day, this sacred sculpture explodes mystery and light to a universal consciousness.

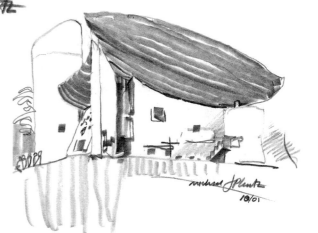

NOTRE DAME DU HAUT
NEAR COLMAR, FRANCE.
2001. Pencil.

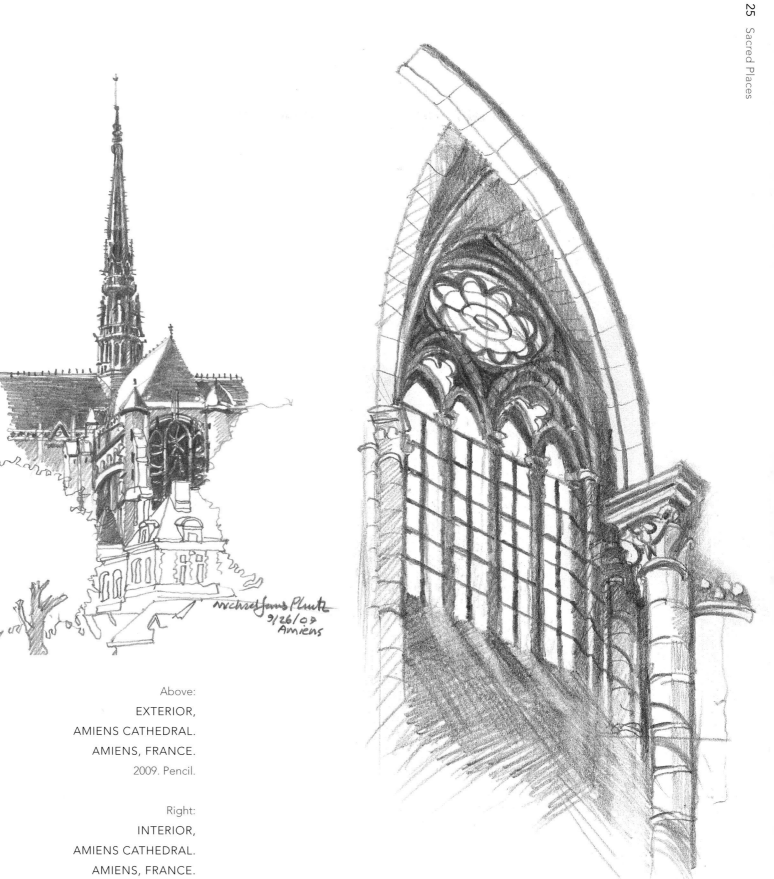

Above:
EXTERIOR,
AMIENS CATHEDRAL.
AMIENS, FRANCE.
2009. Pencil.

Right:
INTERIOR,
AMIENS CATHEDRAL.
AMIENS, FRANCE.
2009. Pencil.

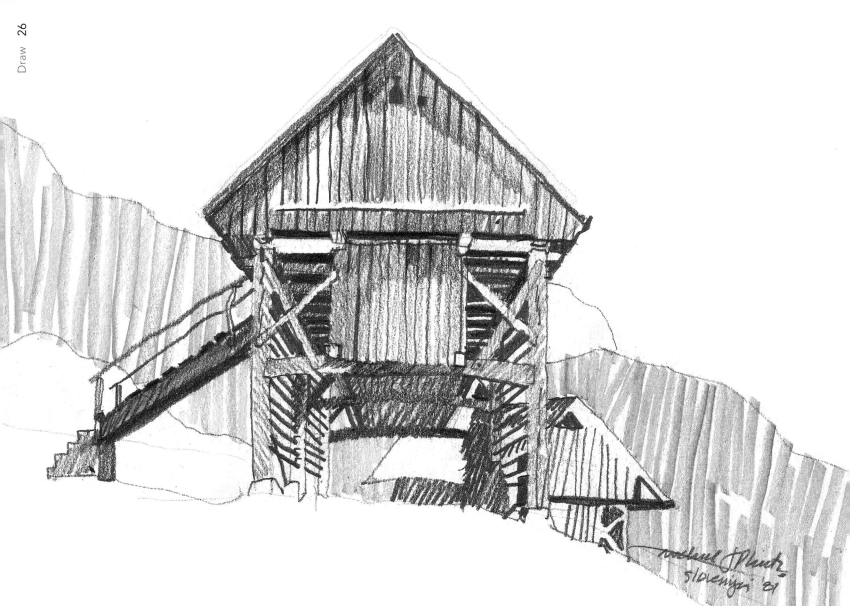

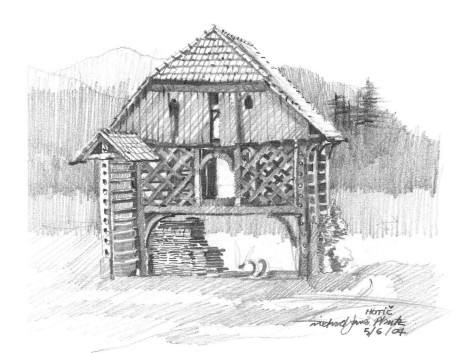

Above:
TRADITIONAL BARN.
NEAR YAMNIK, SLOVENIA.
1981. Pencil.

Right:
TRADITIONAL BARN/HAY RACK.
NEAR HOTIČ, SLOVENIA.
2004. Pencil.

ST. PRIMOŽ, WITH HAY RACK.
JAMNIK, SLOVENIA.
2003. Pencil.

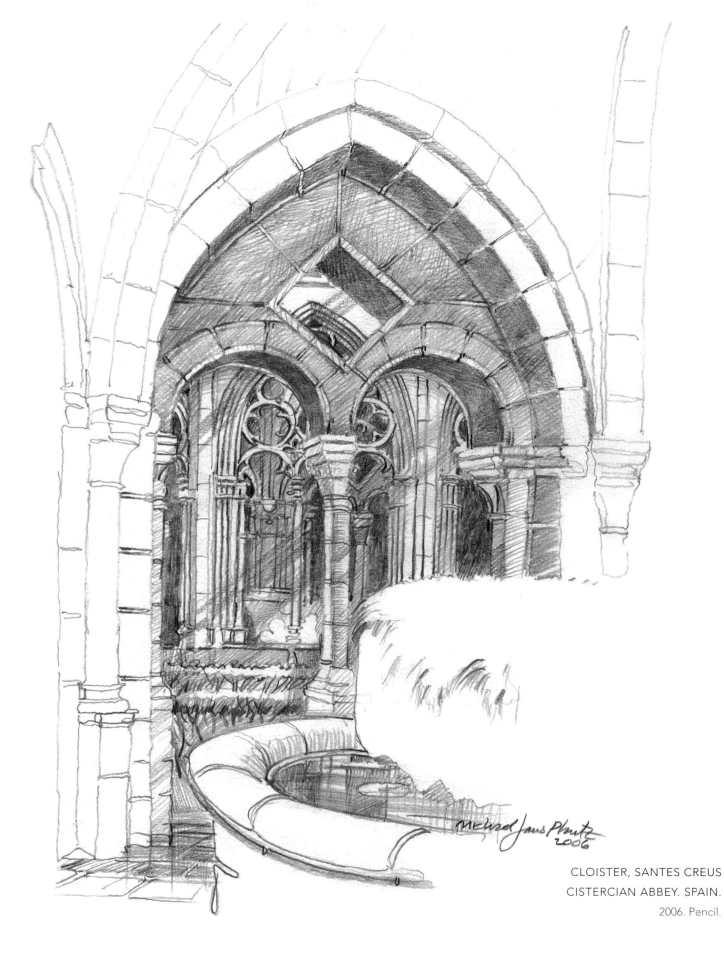

CLOISTER, SANTES CREUS
CISTERCIAN ABBEY. SPAIN.

2006. Pencil.

CLOISTER ARCADE.
LE THORONET ABBEY.
FRANCE.
2006. Pencil.

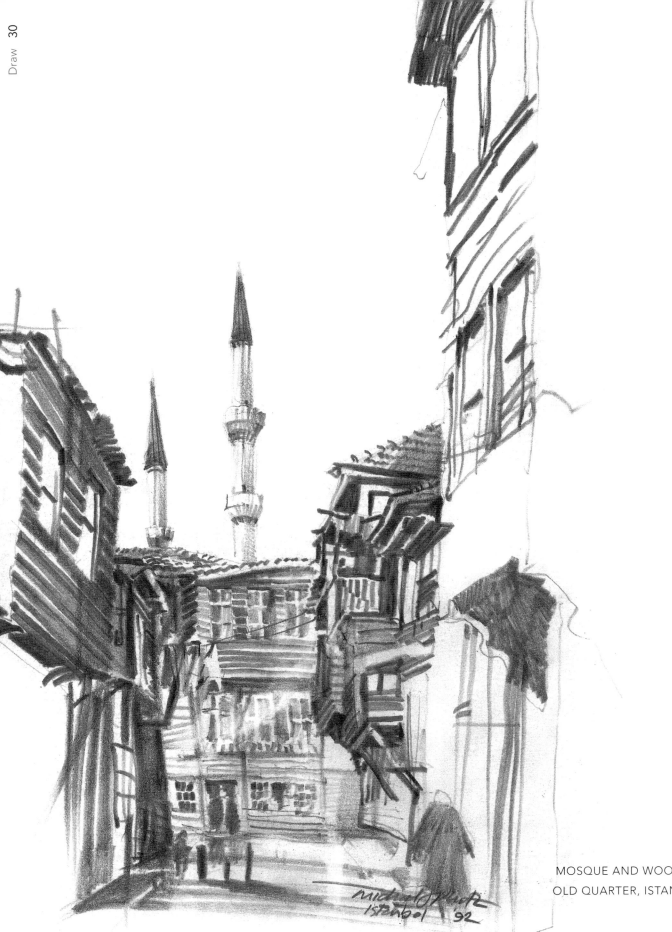

MOSQUE AND WOODEN HOUSES.
OLD QUARTER, ISTANBUL, TURKEY.
1992. Pencil.

FARMHOUSE AND BARN.
WILLARD, WISCONSIN.
2005. Pen.

Travel is fatal to prejudice, bigotry, and narrow-mindedness,

and many of our people need it sorely on these accounts.

Broad, wholesome, charitable views of men and things cannot

be acquired by vegetating in one little corner of the earth

all one's lifetime.

—Mark Twain

3 FOOTSTEPS

La Rue des Bernardins. Footsteps. May. 1968. Paris. The police batons rattled across the pull-down metal shutter on the storefront of our modest Left Bank hotel. The radio crackled with reports of where the rioting was surging nearby: fires, some cars burning, the beautiful granite pavers, the *pavés*, torn up and thrown, our little red Volkswagen Bug safely ensconced in the cul-de-sac in front, the water from the open fire hydrant ensuring no fires spread. *Doctor Zhivago* lying open next to our bed upstairs.

It was our sixth week in Paris. Gloria and I arrived in April as part of a one-year tour of Europe that started in September of 1967. A winning drawing got us there—first place in a design competition called the Paris Prize was the ticket to a yearlong traveling scholarship that was to include a student project at the *École des Beaux-Arts*. Alas, the historic events of May 1968 closed down the school and instead the political events of the times were a much more visceral and valuable lesson in the urban history and politics of a city like Paris.

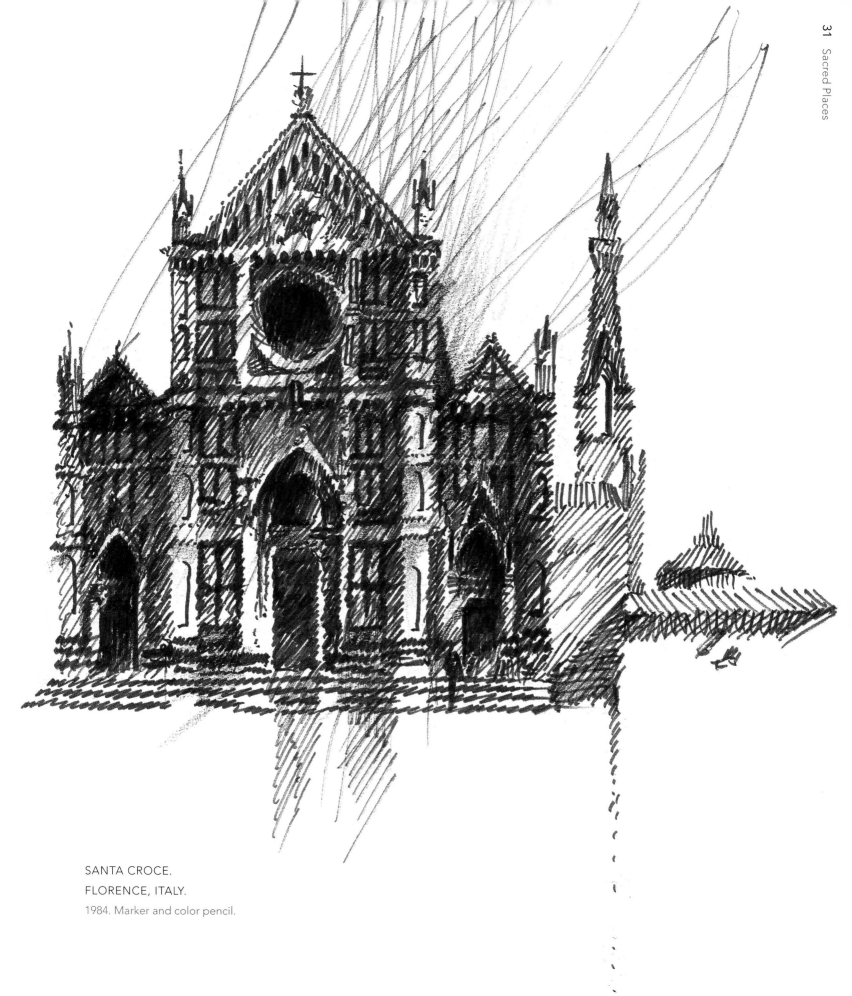

SANTA CROCE.
FLORENCE, ITALY.
1984. Marker and color pencil.

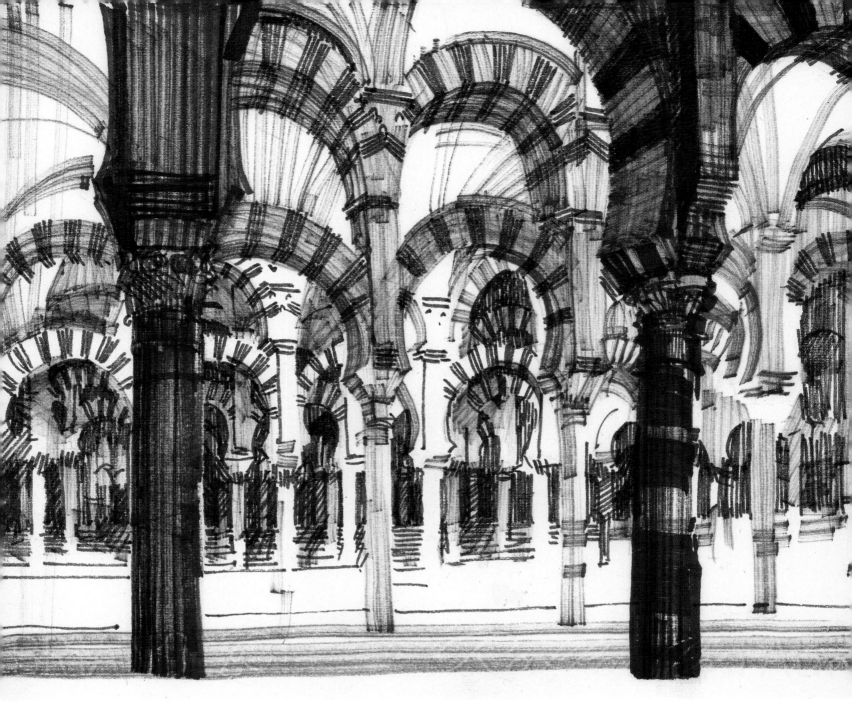

MOSQUE.
CORDOVA, SPAIN.
1967. Marker.

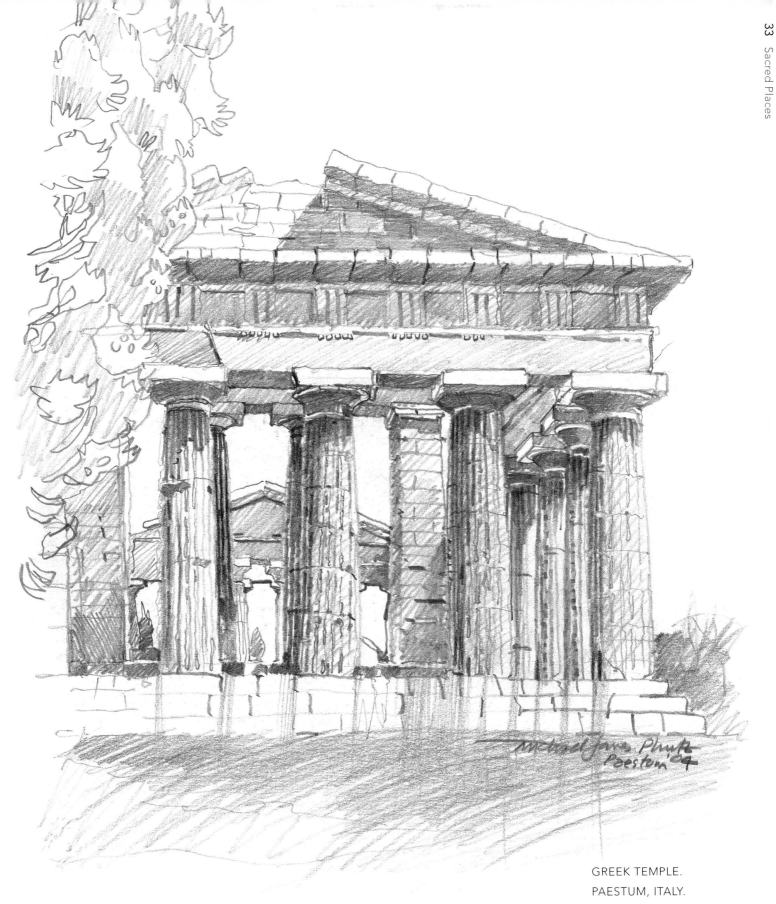

GREEK TEMPLE.
PAESTUM, ITALY.
2004. Pencil.

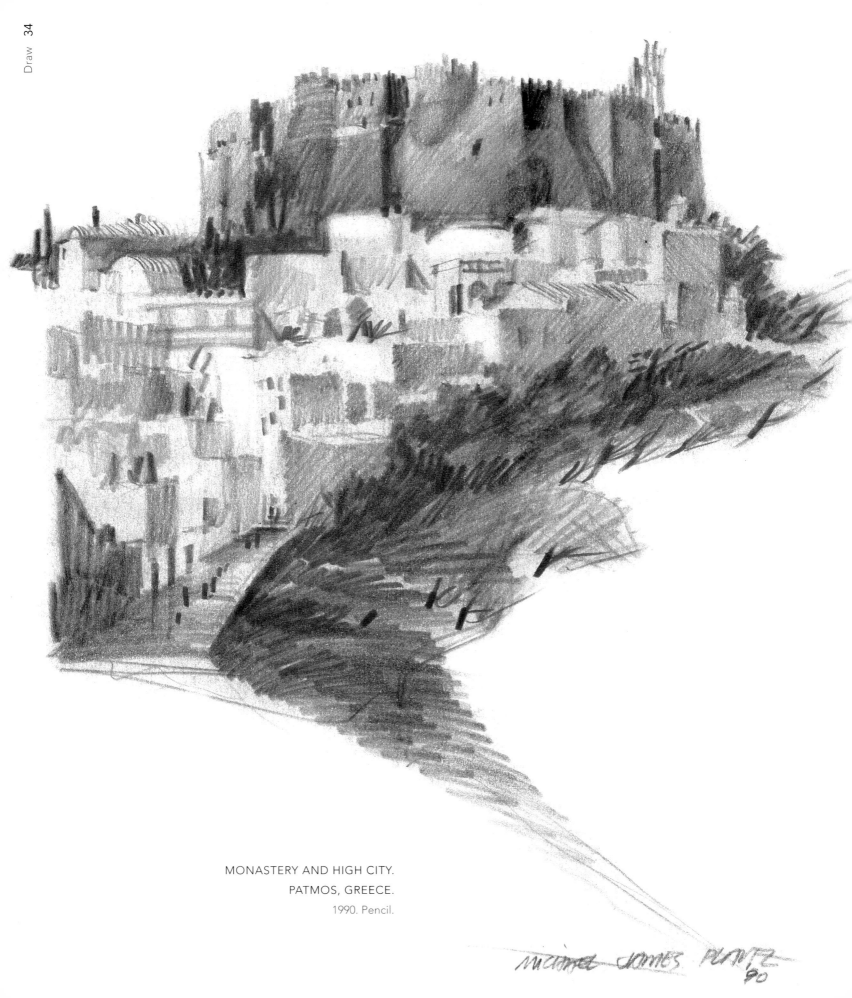

MONASTERY AND HIGH CITY.
PATMOS, GREECE.
1990. Pencil.

Farther down the hill was the cave where St. John the Divine was said to write in his Revelations: "I am the Alpha and the Omega." St. John chasing Light—I never grew tired of chasing light in the monastery, the nunnery, the labyrinthine streets, and lovely courtyard houses. This place first taught me that drawing the same view at different times of the same day creates a totally different composition in light and shade.

MONASTERY WITH
ST. JOHN OF PATMOS
BOOK OF REVELATION SHRINE.
PATMOS, GREECE.
1989. Pen and color pencil.

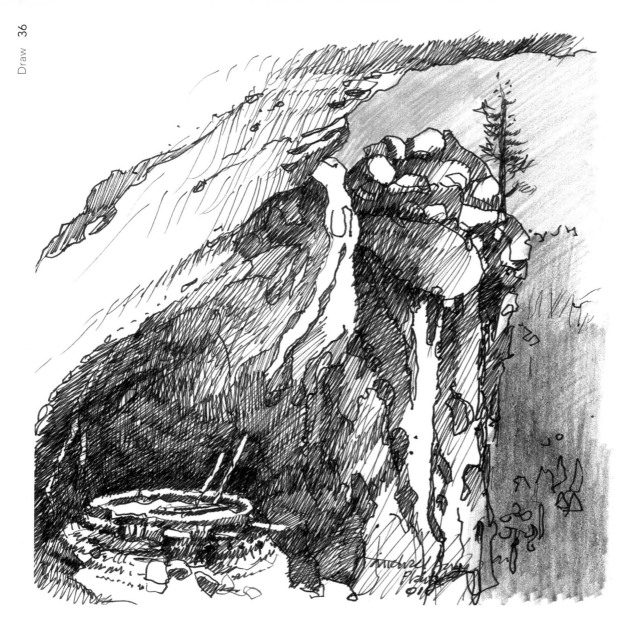

HIGH KIVA.
BANDELIER, NEW MEXICO.
2001. Pen and color pencil.

Song of the Sky

O our Mother the Earth, O our Father the Sky

Your children are we and with tired backs

We bring you the gifts you love

Then weave for us a garment of brightness

May the warp be the white light of morning

May the weft be the red light of evening

May the fringes be the falling rain

May the border be the standing rainbow

Thus weave for us a garment of brightness

That we may walk fittingly where grass is green

O our Mother the Earth, O our Father the Sky

WHITE HOUSE RUINS.
CANYON DE CHELLY,
ARIZONA.
1992. Color pencil.

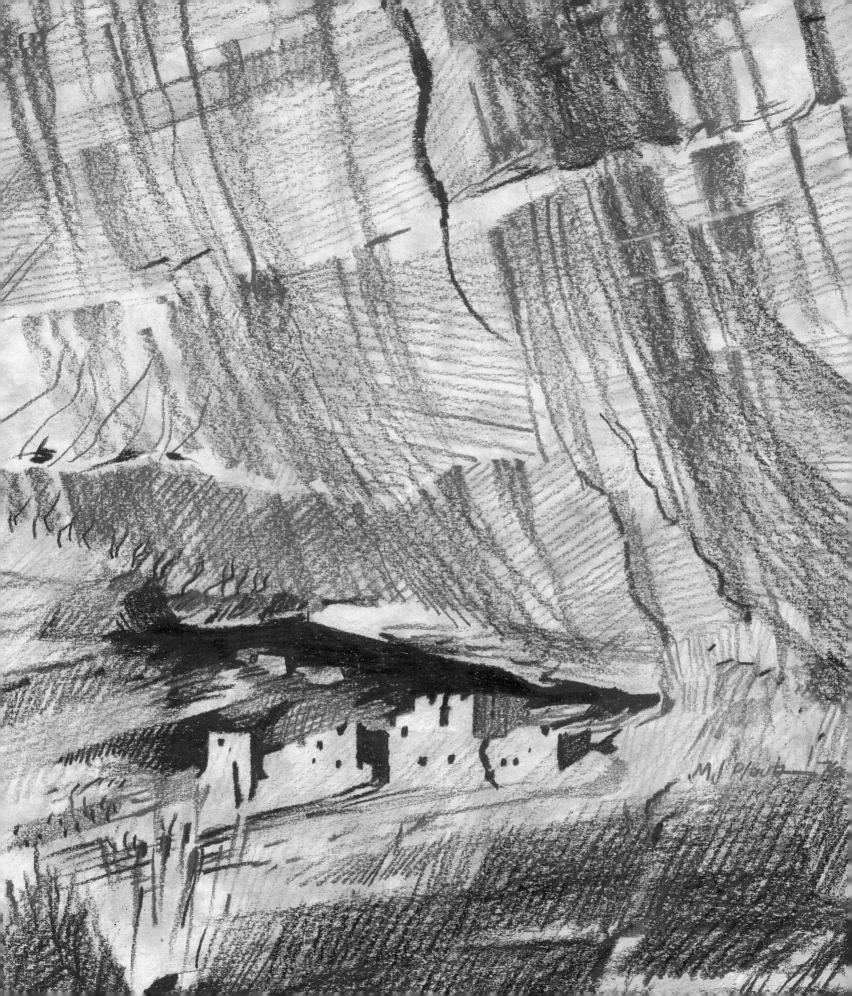

Every day is a journey,
and the journey itself is home.

— Matsuo Basho

2 ROOTS

Mother's hands—large, strong, capable, worn—almost ten decades from a childhood Christmas gift of an orange: snow inside on the upstairs bedside window sill, icy stars streaked across hard pack snow between house and barn, the musty, warm breath of cows cared for better than some poor mother's child. The two-dollar lantern lit the path to post-chores house, evening barn smells better tolerated then than icy January morning's barn clean need, the straw no longer fresh. These hands bore the drudgery of picking stones and hay, countless pails of water fed to pigs and ponies, and the tug of home life's yoke 'twixt cow and Art, field and Picasso. These hands, conflicted between her Cancer birthright and July's crop scramble, school-time joy anchored by noon-time hungry chickens, Minerva calling and a thousand silvery star shards beckoning, the Milky Way a hundred steps between house and barn.

Those hands, resisting dusty times and father thin, the calf not worth the price of market transport. Those horses big, those hooves, those bones; hers, those scars forever large yet binding calcium to a larger frame, a lifelong warp and woof resisting dusty grasshoppers, desiccant flesh of father's frame, her mother's infirmities, men found dead, and buried husbands.

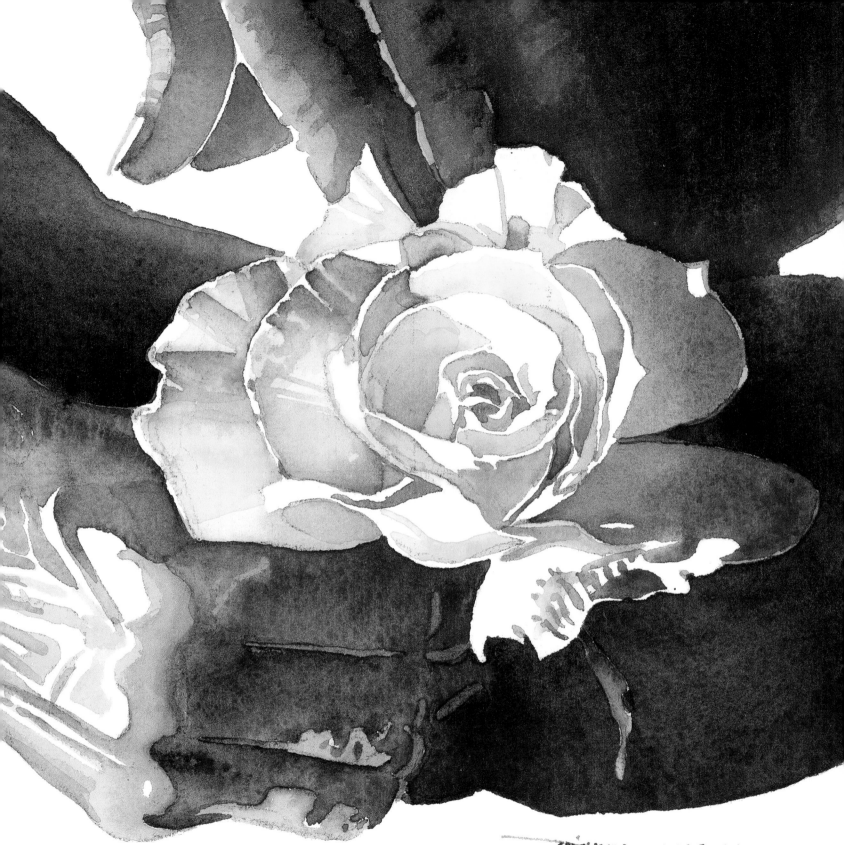

MOTHER'S HANDS WITH ROSE.

WILLARD, WISCONSIN.

2006. Watercolor.

Yet dance the sweet dance in your eye, those dapper dresses and stylish hats and boots—an ax, a gun, bib overalls, bowl haircut—it didn't matter, no New York Vogue the better; you, your friends, the hands around the bent-down camera poses, the smiles. The joy in those hands driving the first Ford at age sixteen (not driving Miss Daisy but herself, her father)—a lifelong freedom, the car a repository for garden tools and rose powder and grub hoes that supported her real love: the loamy land wrenched from stones and glaciers past, the idyllic part the base, the cradle, our mother's Mother Earth, where hands could reach for roots, for beauty, joy—green yes, but black and primal, directly from Africa through a million rifts of births and hands and crunching stones, undeniable, our legacy of color coaxing weedy roots to rose petals. With joy and anticipation for the first spring beauties, yellow marsh marigolds, white trilliums like snow beneath the dark vertical trunks, we made the annual trek to hidden troves of yellow and pink lady slippers, my mother's canaries in the cage—barometers that all is still well with the land.

Mother's hands—swirling a blue dress, an RSP Architects' open house at the Minneapolis Institute of Arts—the swirl erasing six decades from eighty to twenty, a girlish girl restored, the dance of a dream, the dream half full, my memory best.

ORCHID. MINNEAPOLIS.

2005. Pen and color pencil.

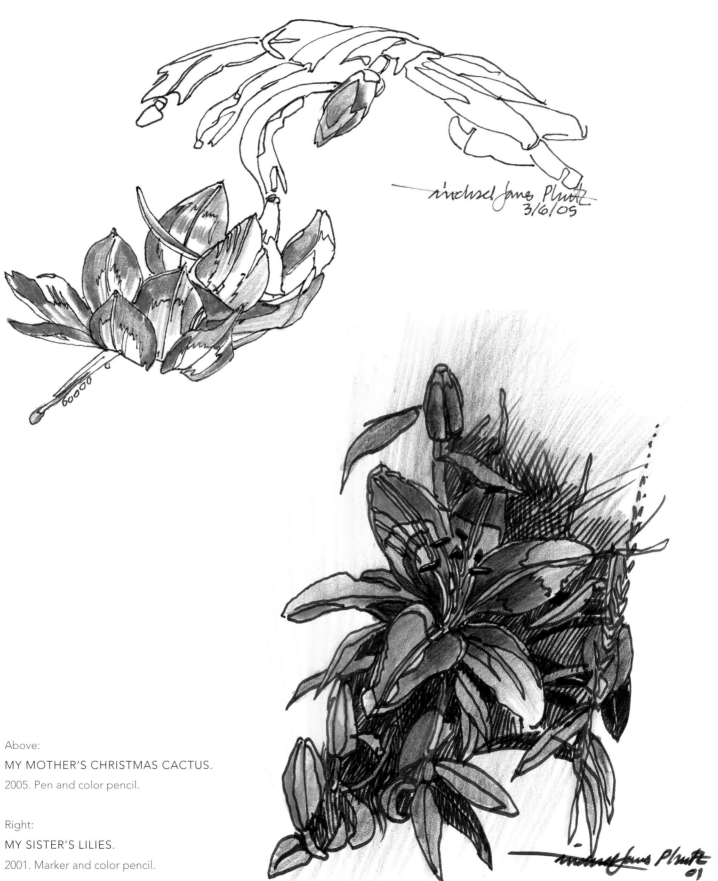

Above:

MY MOTHER'S CHRISTMAS CACTUS.

2005. Pen and color pencil.

Right:

MY SISTER'S LILIES.

2001. Marker and color pencil.

MY GRANDMOTHER'S
CHILDHOOD HOUSE AND
FARM. SLOVENIA.
1985. Pencil.

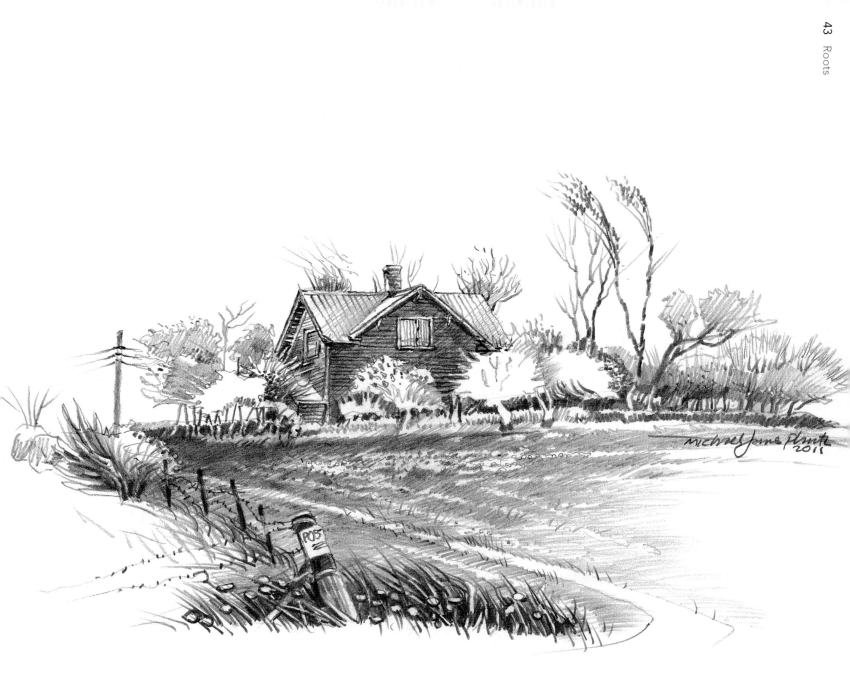

MY FATHER'S HOUSE.
WILLARD, WISCONSIN.
2011. Pencil.

My father, her first husband, the love of her life, grew up in a Sears Robuck house, along with twelve siblings. He and my mother married and built a home for my brother Patrick and me—and later with stepfather Roger for my sister Mary and brother Gene. The road, the woods, the EDGE from which to creep and grow and watch each spring's mantle of green and white and pink rise like the symphony of frogs and calls of cranes and quiet contemplation of running water and sticks and stones and smells and patterns and the north view infinite across the fields, the house to south closed by woods; no Italy there.

Early memories of my father are fleeting glimpses: a sunny wait beneath a tree, squirrel hunting, crappie and bluegill and trout fishing with a fly rod. A construction accident took him away from me at age six and it is the memory of my grandmother and mother on the farm that shaped my early years.

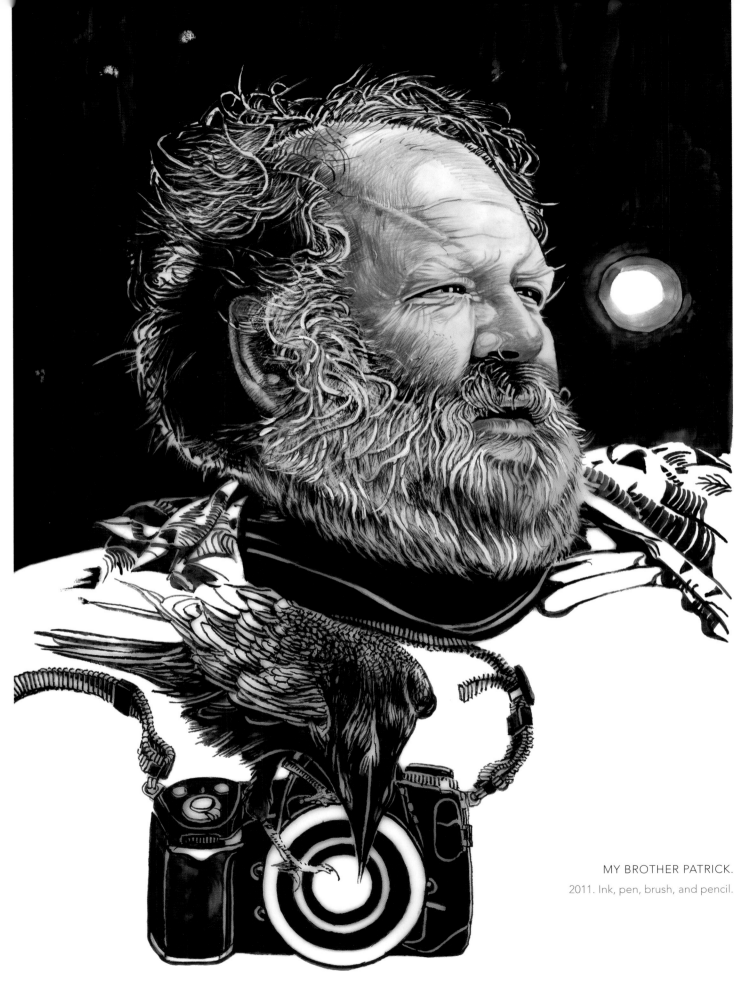

MY BROTHER PATRICK.

2011. Ink, pen, brush, and pencil.

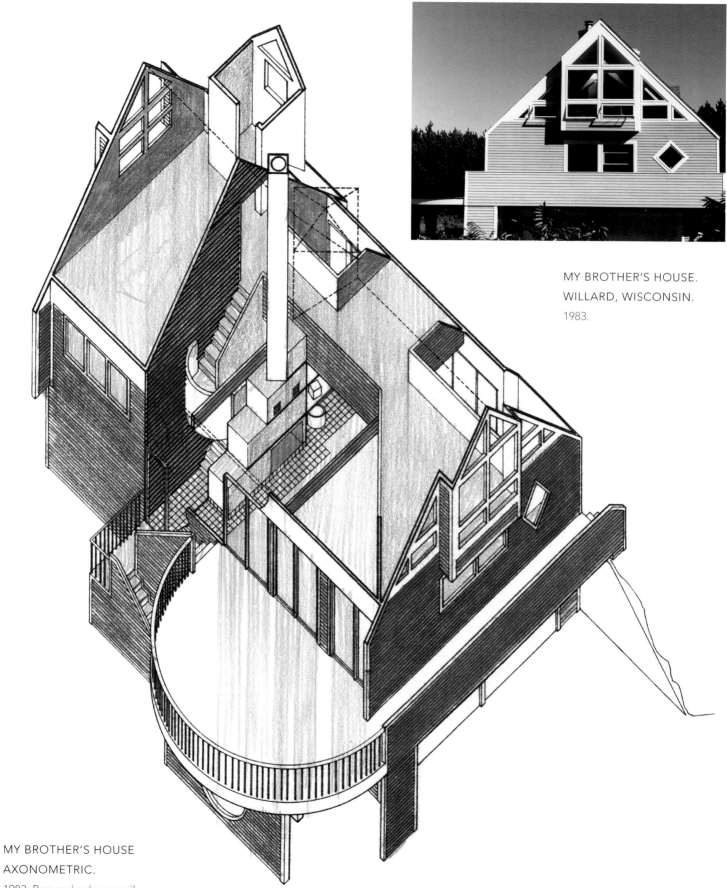

MY BROTHER'S HOUSE.
WILLARD, WISCONSIN.
1983.

MY BROTHER'S HOUSE
AXONOMETRIC.

1983. Pen and color pencil.

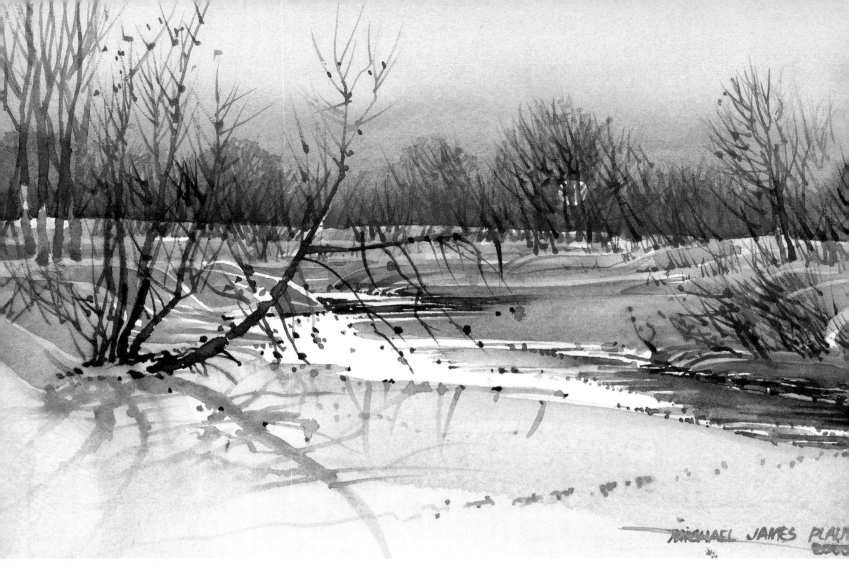

CLOSE TO HOME.
EAU CLAIRE RIVER,
NEAR WILLARD, WISCONSIN.
2000. Watercolor.

Opposite:
SOUTH MOUND
AND FARMS.
WILLARD, WISCONSIN.
2011. Pencil.

The glaciers stopped in this part of central Wisconsin, blessing one farm with myriad stones, a neighbor with pure loam. Slovenian farmers picked the stones, dug out the stumps, and even eventually prospered in spite of the land's checkerboard gifts. Barns and farm buildings, red and weathered gray, steeled in the vernacular; the lines of crops, baby greens and sensual autumnal oranges and browns; a partially frozen January river are burned in my DNA. Ruminations on the arrangements of farmyards, the courtyard—the Greek and Roman atrium compound with courtyard closure, hearth and well (and Wisconsin windmill!) and solar orientation still my favorite archetype for habitation.

Gloria and I bought some land, planted trees, and from it we view South Mound, a prominent landmark in this mixed woodland and farmland terrain. Did I migrate from these glaciated plateaus to the

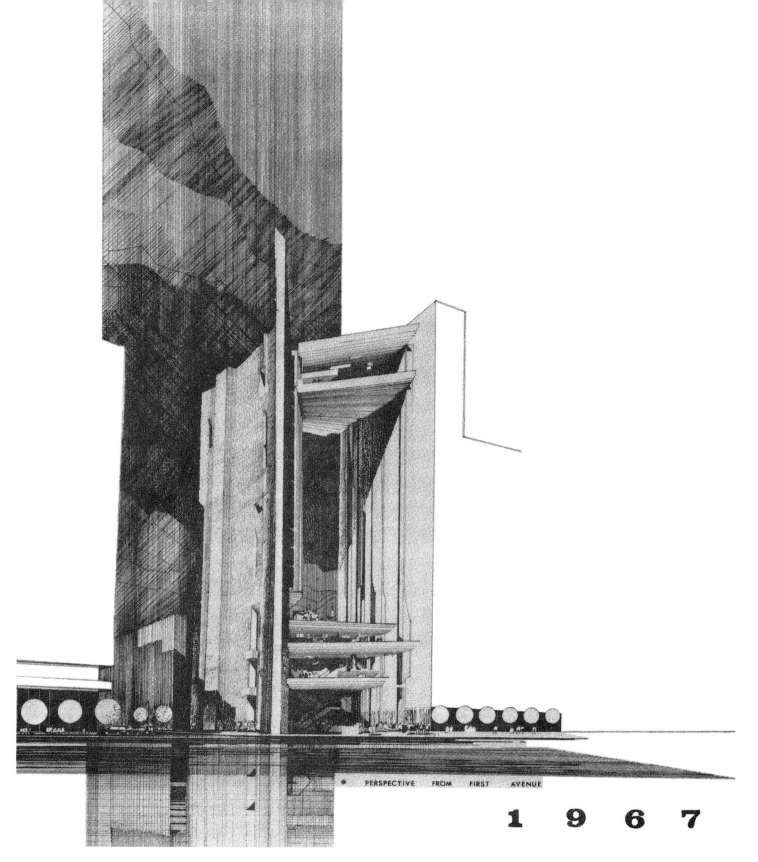

PERSPECTIVE FROM FIRST AVENUE

1 9 6 7

INTERNATIONAL ARCHITECTURAL CENTER FOR NEW YORK.
PARIS PRIZE WINNING ENTRY.
1967. Pen.

Paris survived. Admirably. Our love affair with the city actually began earlier when we spent the summer of 1966 at Fontainebleau, studying architecture (and painting) at the Château. It was here that we were introduced to the rural and urban joys of France, the powerful landscapes, the civilities of culture, food, and wine. In France and across Europe we delightfully discovered the human scale and texture of cities and villages, strong images and memorable senses of *place*, comfortable fusions of the old and the new.

I discovered light. In Santa Fe, in the footsteps of O'Keefe, in the Rio Grande valley, the sky so crystalline blue it hurt the eyes. I found it in those modest mud-brick churches, clay and straw glistening like jewels in the mosques of Isfahan. I listened to the moccasin tracks of the Anasazi along the bubbling creek at Bandelier, in their high kivas, in the stepped arc of Pueblo Bonito at Chaco Canyon.

I found that same light which extracts the soul of Provence in France—villages, fields of lavender, vines that concentrate precious water into wine. I can touch the colors. I can caress them through the iPod of my imagination. I can scroll Van Gogh through Arles and St. Rémy. I can hear the cicadas and smell the wild sage and rosemary. I resonate to the patterns of the landscape, the avenues of plane trees, the contoured hills, the accents of pines, the canes of Cannes, and the lonely mountain-born winds of the mistral.

These early footsteps have been echoed many times in the years since returning time and again to the palette of streets and squares and vistas—dear friends drawn again and again—the Seine a ribbon of light and transparency reflecting all there is to love.

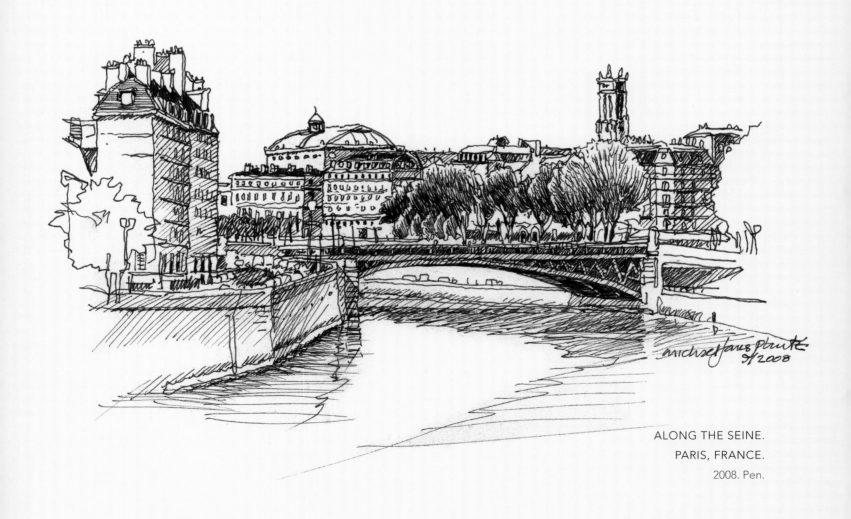

ALONG THE SEINE.
PARIS, FRANCE.
2008. Pen.

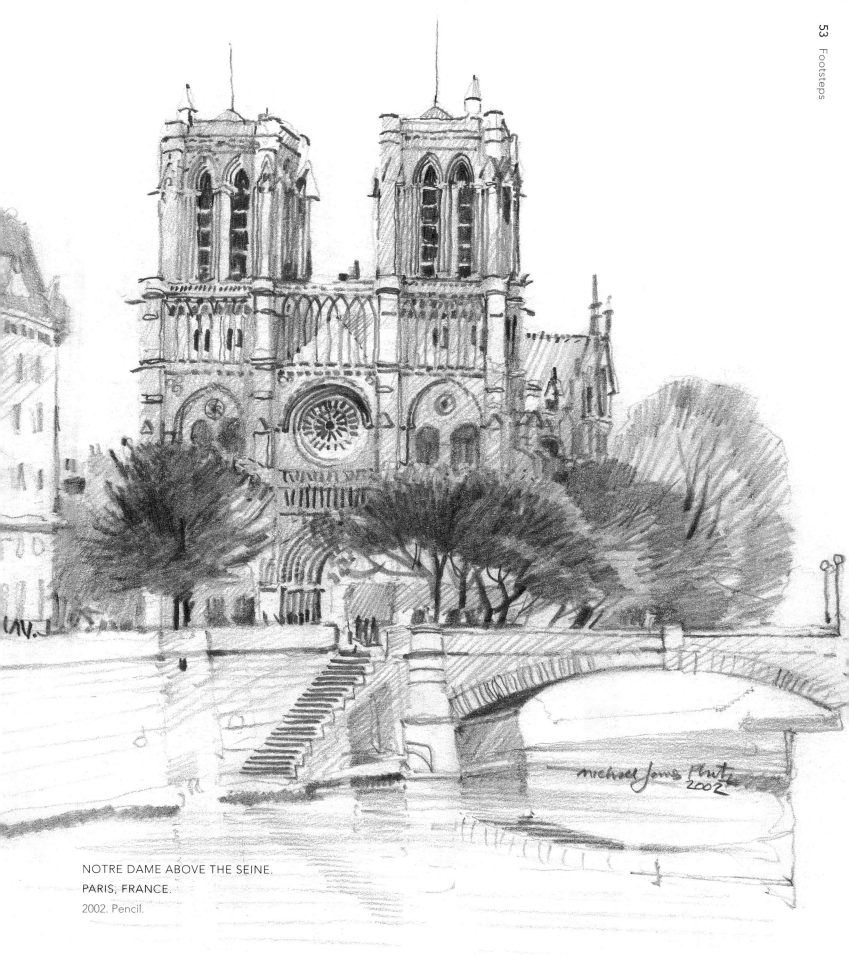

NOTRE DAME ABOVE THE SEINE.
PARIS, FRANCE.
2002. Pencil.

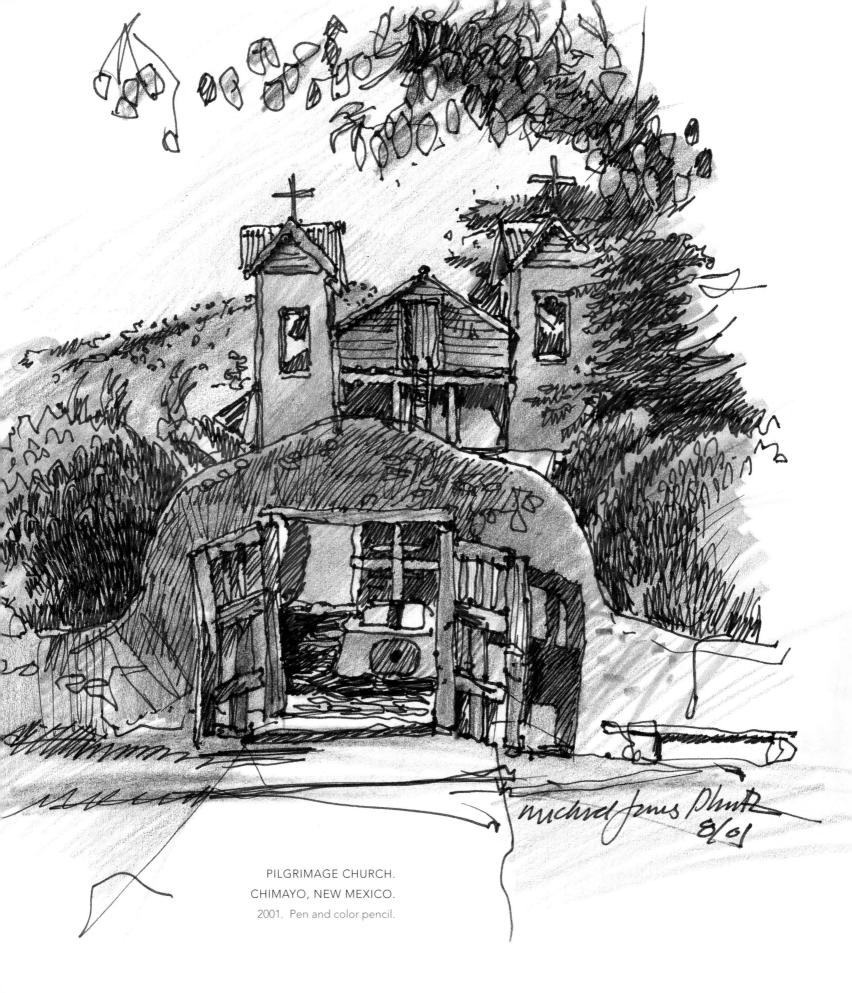

PILGRIMAGE CHURCH.
CHIMAYO, NEW MEXICO.
2001. Pen and color pencil.

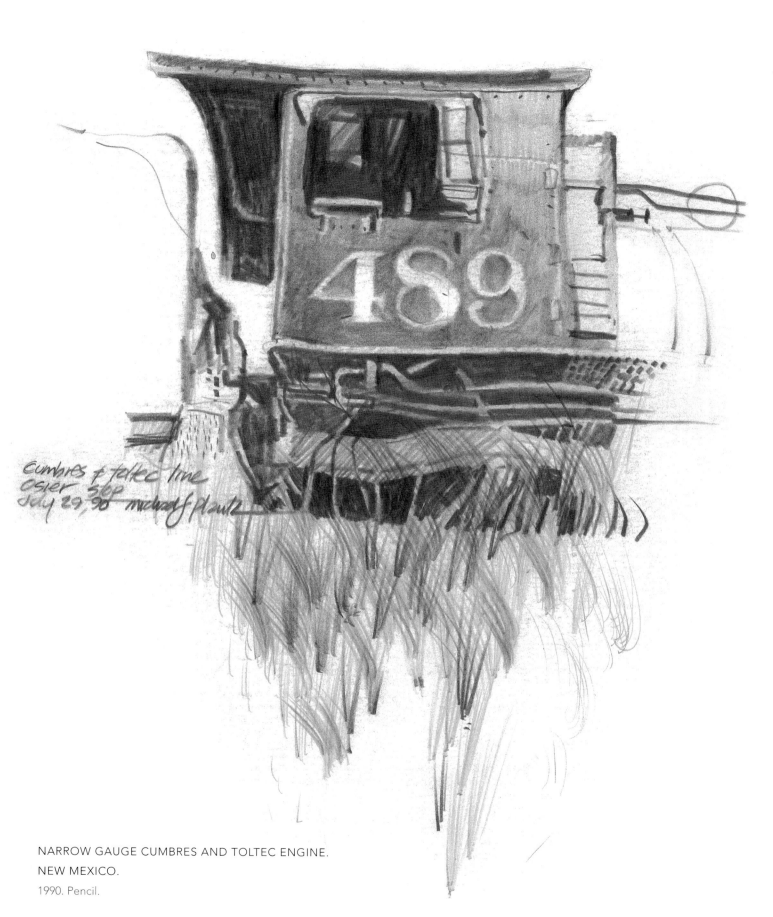

Cumbres & Toltec line
Osier stop
July 29, 90 michael f. blaula

NARROW GAUGE CUMBRES AND TOLTEC ENGINE.
NEW MEXICO.

1990. Pencil.

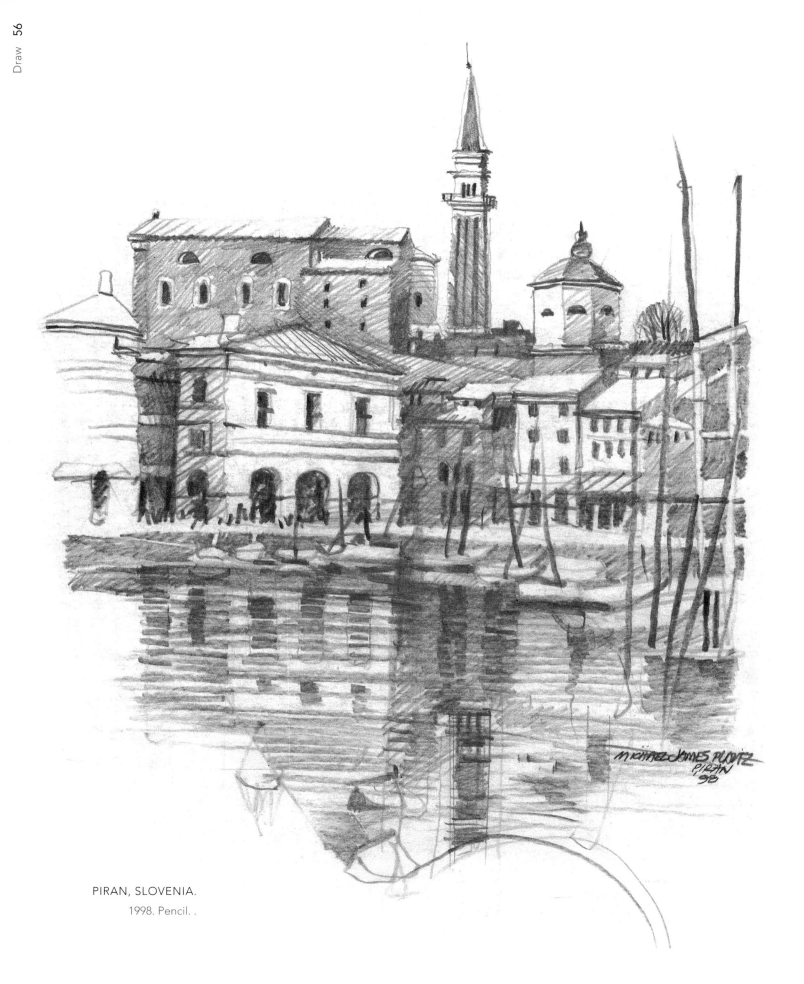

PIRAN, SLOVENIA.

1998. Pencil. .

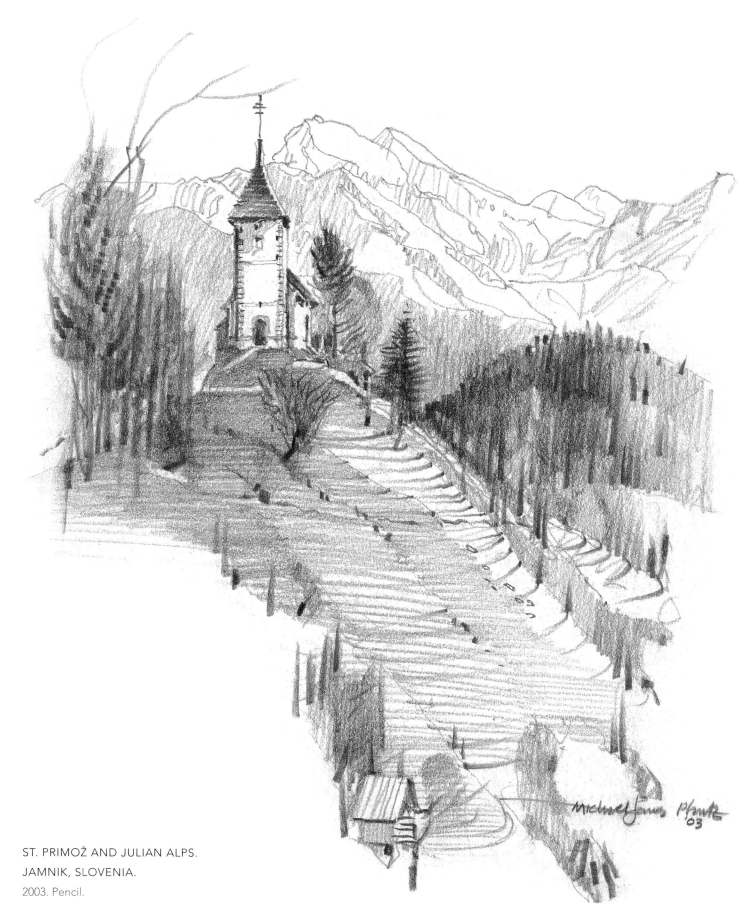

ST. PRIMOŽ AND JULIAN ALPS.
JAMNIK, SLOVENIA.
2003. Pencil.

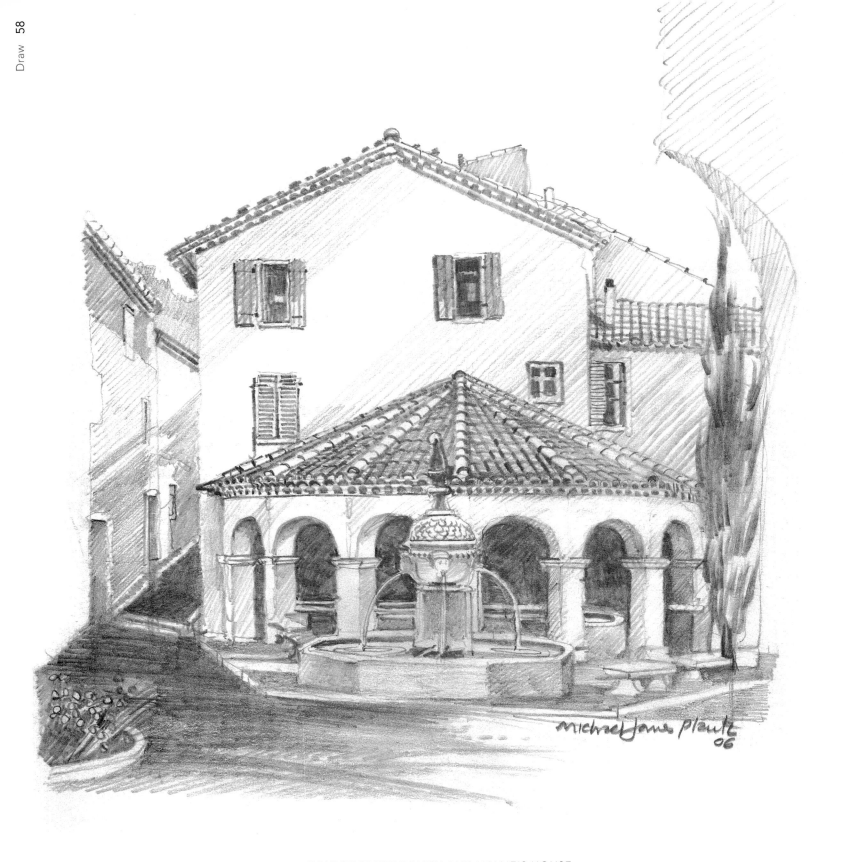

FOUNTAIN NEAR MARY AND HALLIE'S HOUSE.
MOLLANS-SUR-OUVÈZE, DRÔME, FRANCE.

2006. Pencil.

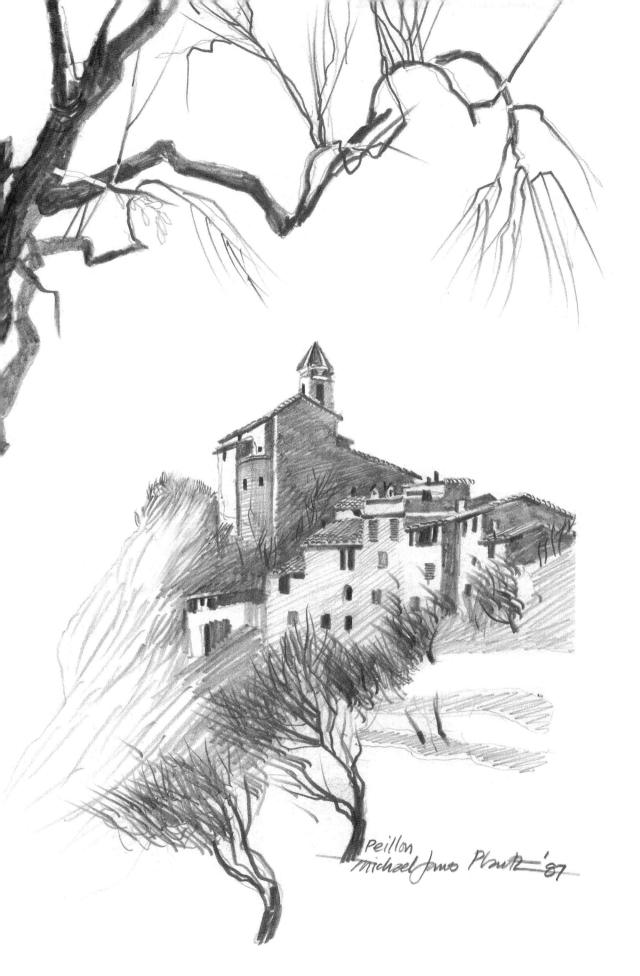

Peillon
michael James Plautz '87

Left:

PEILLON. COTÊ D'AZUR,
FRANCE.

1987. Pencil.

Below:

ROSÉ.
RAINY DAY DIVERSION.
PROVENCE, FRANCE.

1988. Pencil.

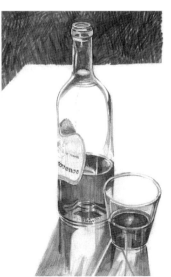

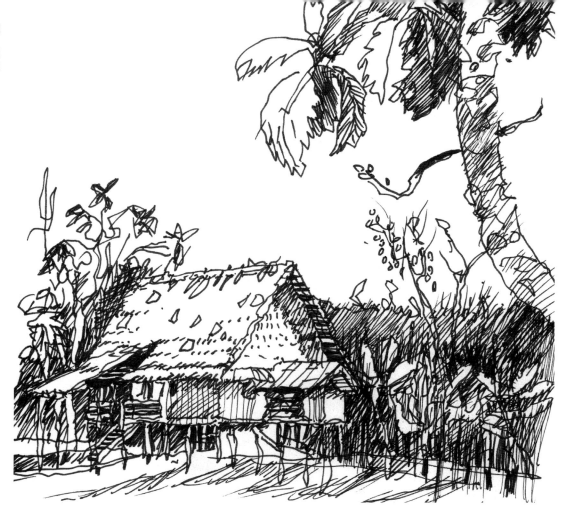

RUM FACTORY FAMILY HOUSE ALONG THE AMAZON. PERU.

2006. Pen.

VILLAGE ALONG THE AMAZON. PERU.

2006. Pen.

NIGHT VISIT ALONG THE AMAZON. PERU.

2006. Pen.

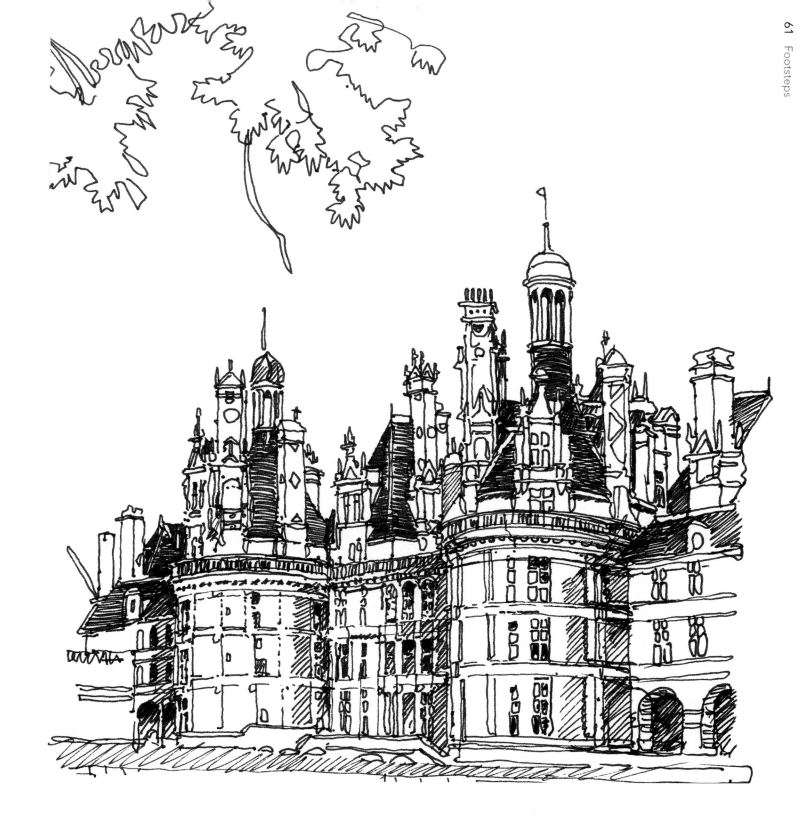

REAR FAÇADE. CHÂTEAU
DE CHAMBORD, FRANCE.
2004. Pen.

CITY HALL.
LILLE, FRANCE.
2009. Pencil.

STREETSCAPE, HOTEL.
LILLE, FRANCE.
2009. Pencil.

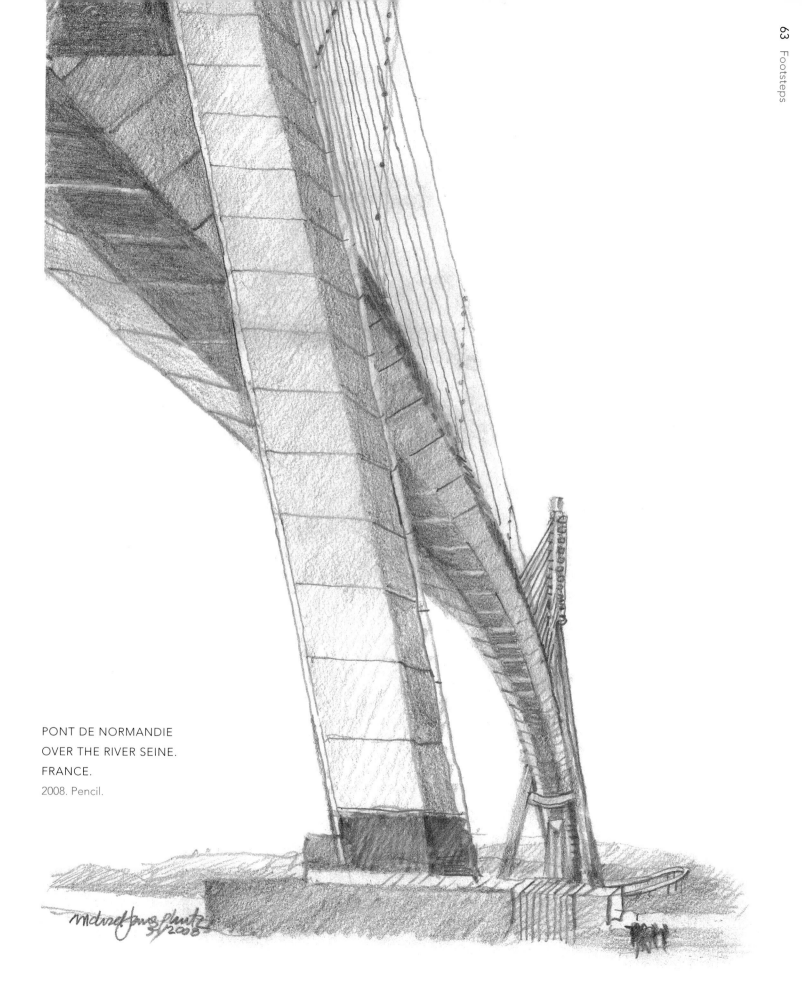

PONT DE NORMANDIE
OVER THE RIVER SEINE.
FRANCE.

2008. Pencil.

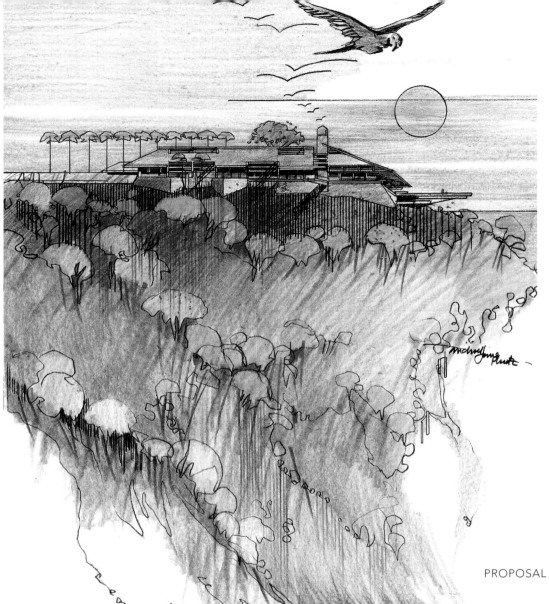

PROPOSAL FOR A VILLA ON THE PACIFIC.
COSTA RICA.
2002. Pencil and color pencil.

ARENAL VOLCANO ERUPTION AT DAWN.
COSTA RICA.
2001. Pencil.

We awoke to red rocks and lava tumbling toward the weak rising sun. The valley mists lift the otherworldly volcanic mass; ideas and inspiration flow from the bounty of nature's forms and lessons, paradigms and metaphors; footsteps have connected my love of drawing—of deconstructing and reconstructing—to creating images, ideas, artifacts, architecture.

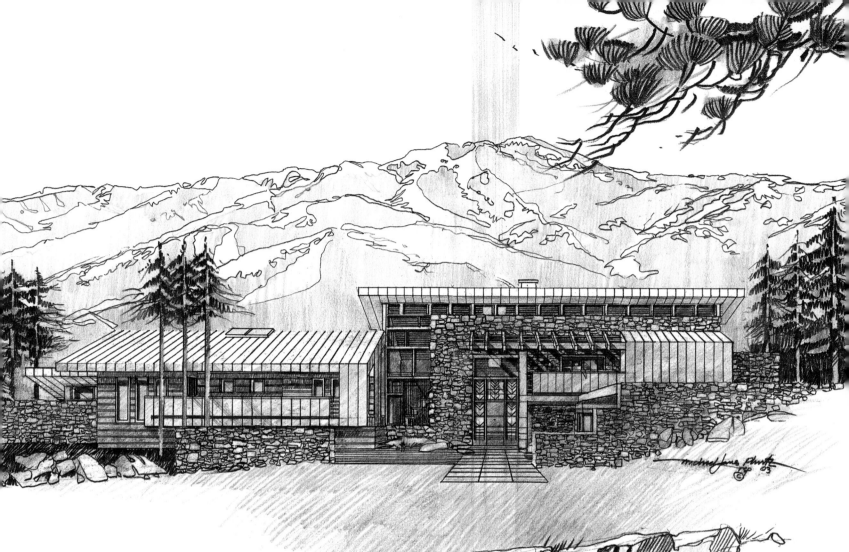

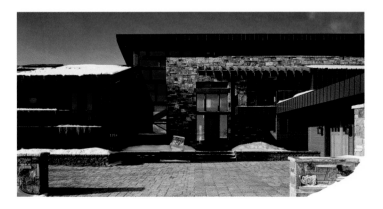

Above:

"inHOME" INSPIRATION HOME
SPONSORED BY ANDERSEN CORPORATION.
PARK CITY, UTAH.
2003. Pencil and color pencil.

Right:

"inHOME." PARK CITY, UTAH.
2004.

"BUTTERFLY" VILLA
CONCEPT SKETCH
ROOF FORMS
CATCHING BREEZES.
COSTA RICA.
2002. Pen and color pencil.

The organic flora and fauna forms in Costa Rica, especially the butterflies and turtle shells, are very inspiring for design. A series of villas for the Four Seasons Resort in Papagayo overlooking the Pacific Ocean were conceived using the thatched "butterfly" roof forms which provide shelter from the sun and capture cooling breezes coming up from the ocean. This interpretation relates to the traditional use of thatched roofs throughout the country. This motif was used in the design of the Vertin Residence on Otter Tail Lake in western Minnesota. The residence consist of three pavilions linked by glass walkways with variations of curved and straight "butterfly" roof forms and has a tree house.

"BUTTERFLY" VILLA.
COSTA RICA.
2002. Pen and color pencil.

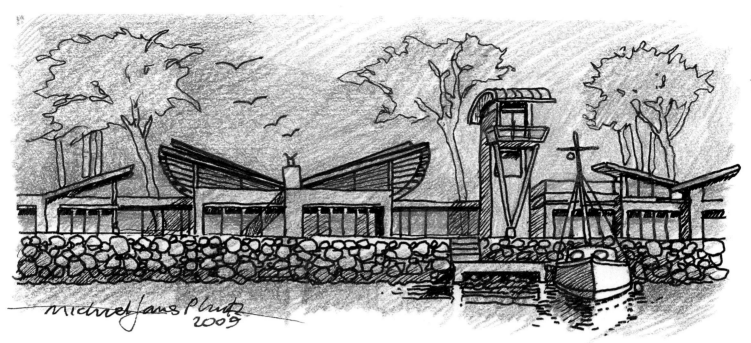

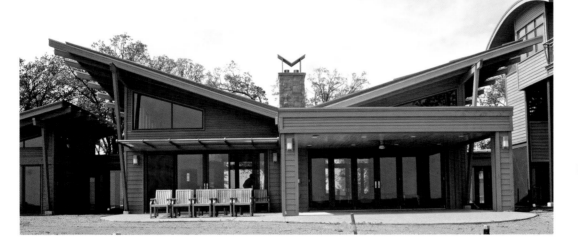

VERTIN RESIDENCE
CONCEPT SKETCH.
OTTER TAIL LAKE,
MINNESOTA.
2009. Pen and color pencil.

VERTIN RESIDENCE
MAIN LIVING PAVILION AND
LAKESIDE TREE HOUSE.
OTTER TAIL LAKE,
MINNESOTA.

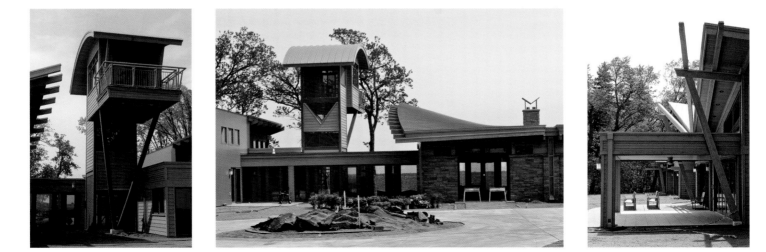

Above:

VIEW OF THE PALATINE FROM FORUM.

ROME, ITALY.

2005. Pen.

Right:

OLDEST BRIDGE OVER THE TIBER.

ROME, ITALY.

2005. Pen.

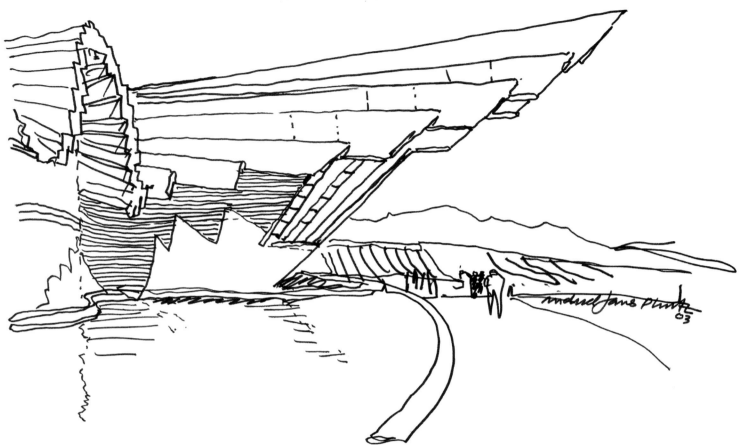

WINERY, RIOJA COUNTRY. SPAIN.

2003. Pen. Winery designed by Santiago Calatrava.

GRAZALEMA, SPAIN.

2002. Pencil.

NORTHERN HARRIER.
WOLF RIDGE
2009 CALENDAR.
Watercolor.

The hawk burst forth from the side of the road, flew a short distance, and somehow understanding my need, teased me along a series of fence and power-line posts until I was able to capture with my camera a pose to translate into the marsh marigold–filled Sawtooth Valley on the Wolf Ridge campus.

Footsteps north. I fell in love with the Wolf Ridge Environmental Learning Center in Finland, Minnesota, which was founded and directed by Jack Pichotta. I did some fundraising concept sketches for Jack for a series of new buildings on their campus, and was fortunate to become the architect for the center's residences, classrooms, assembly spaces, and a remote forest ecology building. The center is underpinned by Jack's core philosophy of environmental stewardship through the enrichment education primarily of grade-school children who spend a week on the campus overlooking Lake Superior. The program touches more than 15,000 students each year from the Midwest region.

CLASSROOM.
WOLF RIDGE
ENVIRONMENTAL
LEARNING CENTER.
FINLAND, MINNESOTA.

"Our designs take their cue from the architectural vocabulary of the original Wolf Ridge buildings."

Michael J. Plautz, Founding Partner, RSP Architects, Ltd.

One of the students' many self-help funding mechanisms is the annual creation and sale of 8,000 to 10,000 calendars. I was the artist for the 2009 calendar.

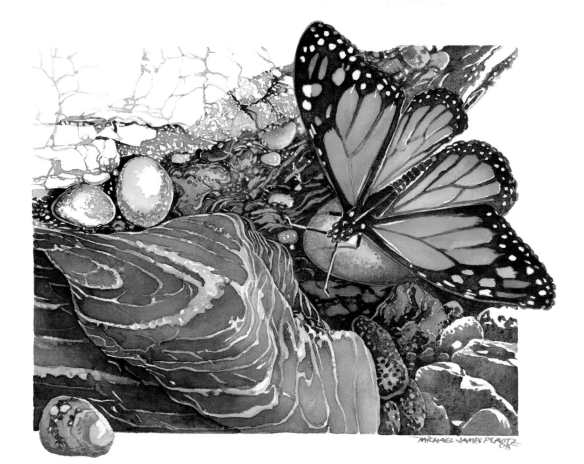

VERNAL POOL MONARCH.
WOLF RIDGE
2009 CALENDAR.
Watercolor.

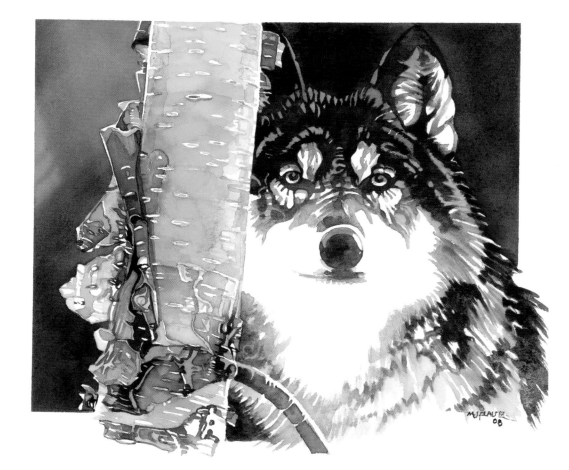

GRAY WOLF.
WOLF RIDGE
2009 CALENDAR.
Watercolor.

The peeling birch tree next to the wolf is real—and a teaching aid. Students are asked to find a single natural object that contains as many colors as possible that match a paint-sample book. This tree was the winner with forty-two.

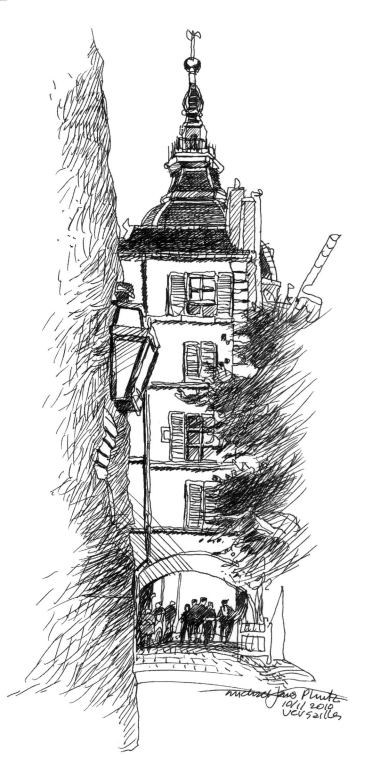

In 1983, my professor, mentor, and friend, Professor Alec Notaras, invited me to continue a program started by architect Larry Perkins of Perkins+Will in Chicago for the University of Illinois' study abroad program in Versailles. Each September approximately fifty American architecture students arrive in France and spend the academic year sharing studio space with a French school of architecture housed in the renovated former royal stables across from the Château at Versailles. And so for nearly thirty years I have spent several weeks per year sketching with architecture students during their independent study breaks. We have worked the streets and squares of Paris and Versailles, the lemon tree slopes and the sea at Amalfi, documented walking sequences in the villages of Tuscany and Provence, the towers of San Gimignano, the Adriatic coasts of Slovenia and Croatia, the cubistic villages of Greece. We work in fields, in the streets, and even slept in a Tuscan nunnery. We review and share each other's work in the midst of poppy fields, under temple porches, or over wine in cafes when the rain drove us in.

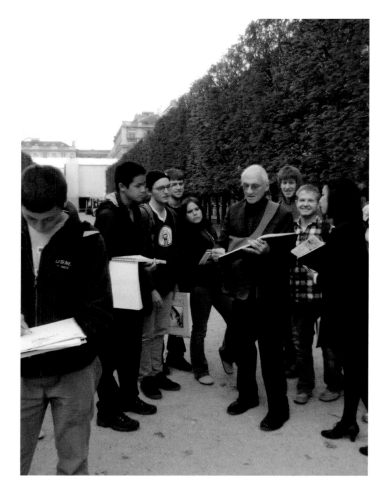

STUDENTS SKETCHING. PASSAGE SAINT-LOUIS,
VERSAILLES, FRANCE.
2010. Pen.

WITH UNIVERSITY OF ILLINOIS STUDENTS.
ROYAL GARDENS, PARIS, FRANCE.
2010.

Teachers learn the most; the best teachers are lifelong students. The best gift is to instill the love and passion to *see*, not merely look; to never break that sense of wonder and discovery we have as children in our early drawings. Picasso said that we can all draw, but most of us spend our entire lives never recouping the gifts we had at age six.

We the mammals of the opposing digits; we the mammals who have recognized, evolved, and invented tools; we who have advanced our cognitive skills through mind-to-hand manifestation grasp the power of using graphite sticks to make our exploratory marks—to *draw* and connect the dots and the two halves of our brains. It is my belief that the incorporation of art in all curricular endeavors is an essential right-brain couplet and a powerful tool as crucial to learning and equal to the more traditional and pervasive left-brain emphasis typically found in most schools. The process of observing, defining, and understanding phenomena through *art* solidifies concepts in the forms we see around us. Engaging in art is a non-passive act involving **selection** (frame with a camera, decide what to draw); observing **relationships** (head to wing to foot—when you draw a bird, you understand wind and rain, the flight of an airplane, how to shingle a roof); and the identification of **patterns** (the family of forms, the Fibonacci intervals, the mystic spirals, the sensuous math that finds commonality in the face of a sunflower, the scales of a trout, the intervals of plant stems as they reach for the sun). My pen, pencils, and sketchbook have given me perpetual intimacy to every drawing, however long ago. I can remember the light, the sounds around me, and even the smells. The thread from eye to brain to hand is a powerful loop.

If you want to build a ship, don't drum up the men to gather wood, divide the work and give orders. Instead, teach them to yearn for the vast and endless sea.

—Antoine de Saint-Exupery

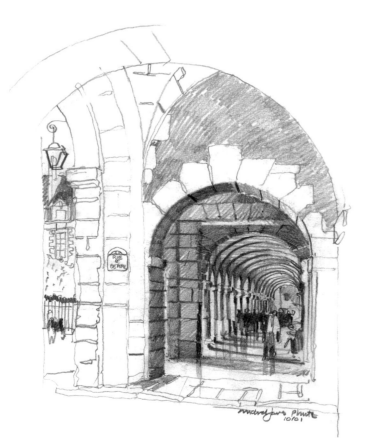

STUDENTS SKETCHING IN ARCHED ARCADE.
PLACE DES VOSGES, FRANCE.
2001. Pen.

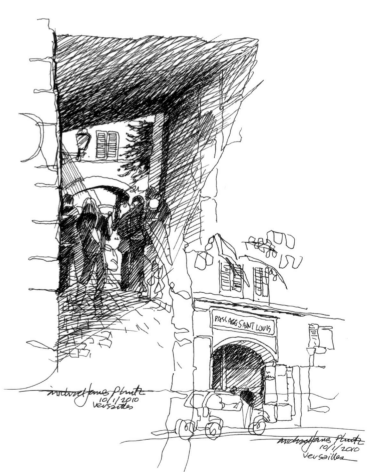

STUDENTS SKETCHING. PASSAGE SAINT-LOUIS,
VERSAILLES, FRANCE.
2010. Pen.

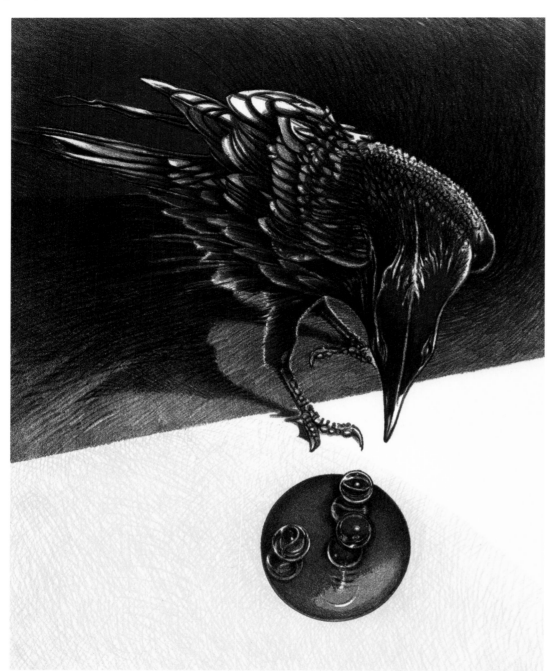

TEMPTATION.
2010. Lithograph.
Printed by Landfall Press,
Santa Fe, New Mexico.

Raven is a mythical creature in Native American culture, often the trickster and/or the creator. Raven has inspired me to create numerous sketches and paintings. My lithograph "Where's the Water?" was my first in this medium and the drawing features Raven, who is the ombudsman for the resources of water for humans on the earth, suggesting the historic and future implications of not husbanding our resources.

An ancient story told on the Queen Charlotte Islands recounts how Raven the creator stole the sun, moon, stars, fire, and fresh water. He stole these things from Gray Eagle, who hated humans and kept them in darkness. Raven fell in love with Gray Eagle's daughter. Enchanted by his then-pure white feathers, she invited him into Gray Eagle's house. Raven discovered the sun, moon, and stars and he stole them from Gray Eagle

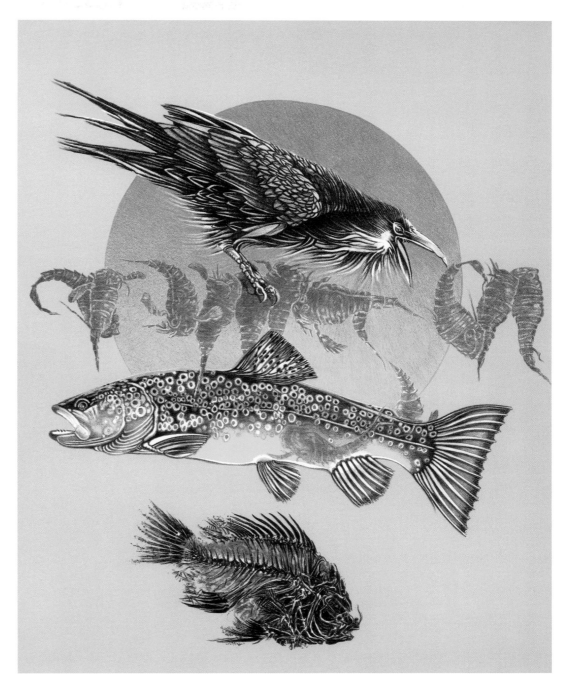

WHERE'S THE WATER?
2009. Lithograph.
Printed by Landfall Press,
Santa Fe, New Mexico.

and moved them to the sky. He stole fire and gave it back to the humans, and was burned black in the process. He also stole water from Gray Eagle and dropped it to Earth to create the source of all freshwater streams and rivers. I can imagine that Earth will someday look like Mars, barren and dusty.

From sea to womb to shining brow we lose our water.

—Michael James Plautz

In another legend from the Pacific Northwest, Raven was the one who brought light from darkness. In the lithograph "Temptation," Raven contemplates shining marbles and the release of light from the small opening of the sky. I remember my grandmother telling me stories of how their pet crow on the farm would ride on her shoulder as she went to get the cows in the pasture and how he liked shiny objects and tormenting the pigs.

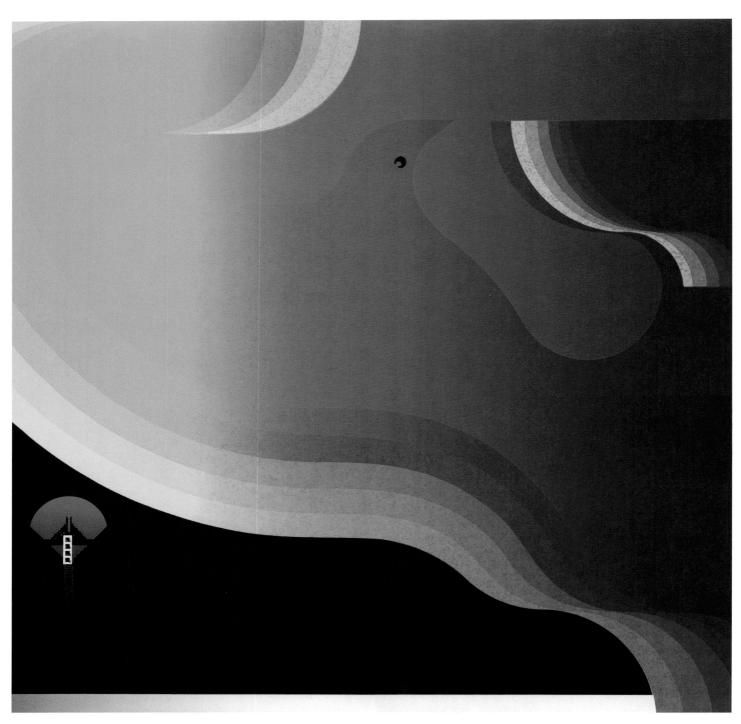

BIRD OVER THE RIO GRANDE GORGE.

1985. Silkscreen.

Silkscreen "Bird over the Rio Grande Gorge" and " Eclipse" are part of an on-going dialogue in images under the notion of "conversations." These two silkscreens deal with the relationship between design and technology and their impact upon the environment. In "Bird over the Rio Grande Gorge" a mythical bird is startled to see that mankind would have the audacity to build a stair/step/bridge/house spanning the Rio Grande Gorge with views to the setting sun, the river some eight hundred feet below. We can build anything—should we?

ECLIPSE.
1985. Silkscreen.

"Eclipse" references our ability through the web of technology to kill creatures (in this case whales) at an alarming rate—we have become very efficient as Orion the Hunter with the brilliance of minds like Di Vinci's.

BREAKFAST AT JULIETTE'S.
PARIS, FRANCE.
2011. Pencil.

Many of my friends are in this drawing: Juliette's Parisian apartment, full of memories and warmth and her youth in Afghanistan; my dear wife Gloria, reading Emmanuel Guibert's book, *Le Pavé de Paris*; dinners with Juliette's beautiful and talented daughter, Alexandra; Emmanuel, Donatella, and daughter Cecilia; our dear friend David Hanser, physicist Bruno, and others; the bread that sustains us; the mystery outside of the possibilities; and the promise of light from another day.

JEAN'S STUDY.
VERSAILLES, FRANCE.
2011. Pencil.

Footsteps to friends: Jean Castex's apartment is a pure reflection of his eminence as a superb scholar, teacher, artist, and chef. He hosted Gloria and me many times in this simple but elegant space that bridges Avenue de Saint-Cloud and the back garden of the Lycée Hoche in Versailles. Jean and I, like mad dogs and Englishmen, have sketched kivas and pueblos in one-hundred-degree heat in the American Southwest. We have sketched the stones and monasteries of Patmos, Greece, the light of Provence, and many other places of the mind.

*I think survival is at stake for all of us all the time . . . every poem,
every work of art, everything that is well done, well made, well said,
generously given, adds to our chances of survival.*

—Philip Booth

*We do this work because we can, and because we have to. It's as
essential to our collective survival as reproduction, and it comes from
the same ancient place within.*

—Kim Denise

Here are our endangered species. We must draw them all close to us.

MOUNTAIN GORILLA EATING LEAVES.
VOLCANOES NATIONAL PARK, RWANDA.
2010. Pencil.

I want to stand as close to the edge
as I can without going over.
Out on the edge you see all kinds of
things you can't see from the center.

—Kurt Vonnegut

4 EDGES

We all like to be on the edge: a high place, near water, facing a strong landscape, a forest, looking at the stars, a point of perspective. It is why I like hill towns with their strongly delineated perimeters, their strong senses of place, and how they contrast with the surrounding countryside. It is why people love New York and its skyline, and San Francisco, or Paris along the Seine, or their front-row seat at a concert. We dream at the edges between sleeping and waking, we need the daily rhythm of events with edges, starting and stopping points, things to cross off our lists.

Strong edges create strong memories and are essential to place-making. Architecture is the resolution between landscape and building, between technology and the natural world; edges help us preserve the beauty of both the built and the unbuilt.

The most wonderful edge is that gradation between shadow and light where the magic and mystery lie—those powerful edges to explore between, where the black dots of night mix with the light, wave, or particle, never static, like the shaft of sunlight guiding the clash of armies in a Kurosawa film, the kiss of sunlight on a rose petal, and the eternal dance reflected in the Seine.

SANTA MARIA DELLA SALUTE. VENICE, ITALY.

2000. Pencil.

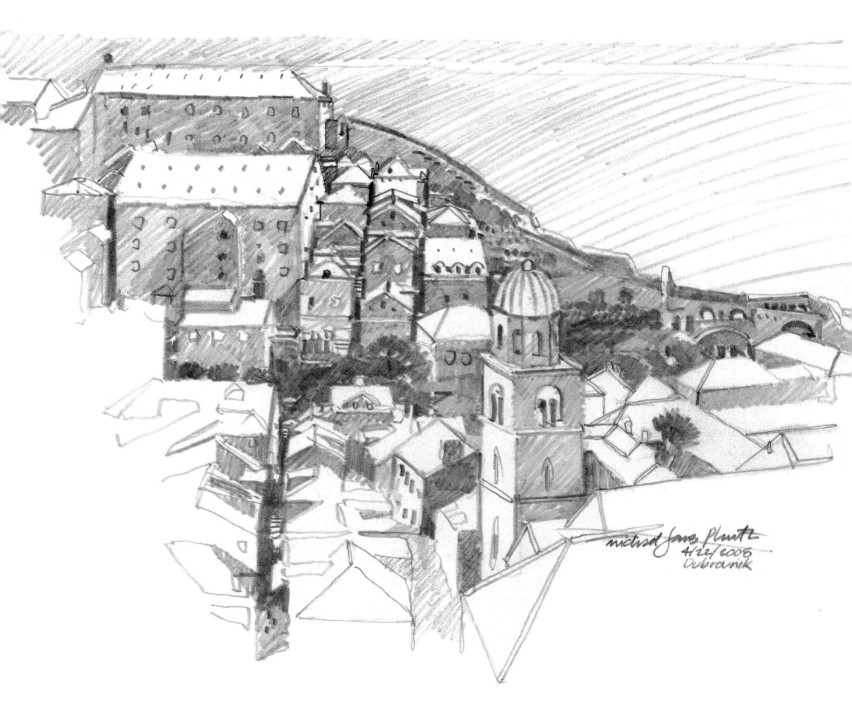

DUBROVNIK FROM CITY WALL. CROATIA.

2008. Pencil.

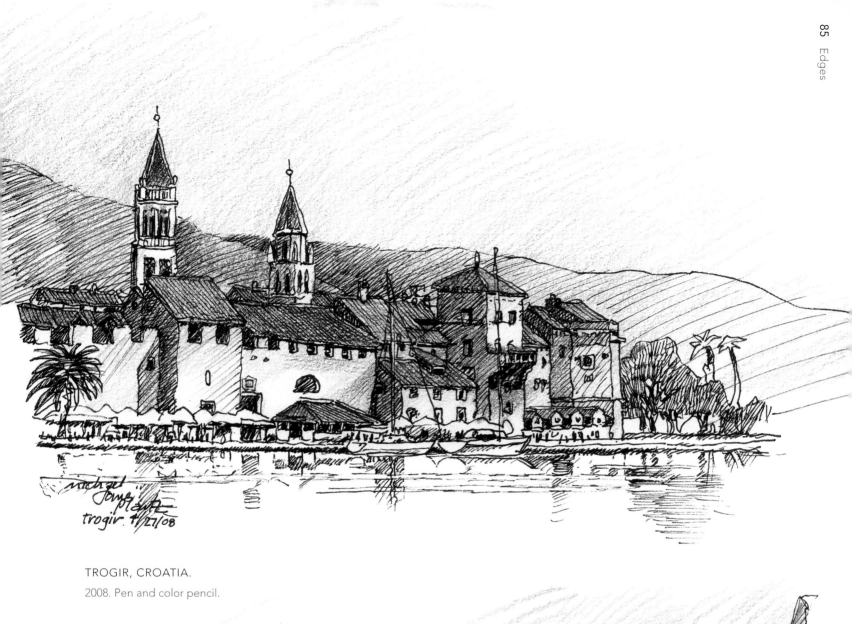

TROGIR, CROATIA.

2008. Pen and color pencil.

ROOFTOPS FROM CITY WALL.
DUBROVNIK, CROATIA.

2008. Pen and color pencil.

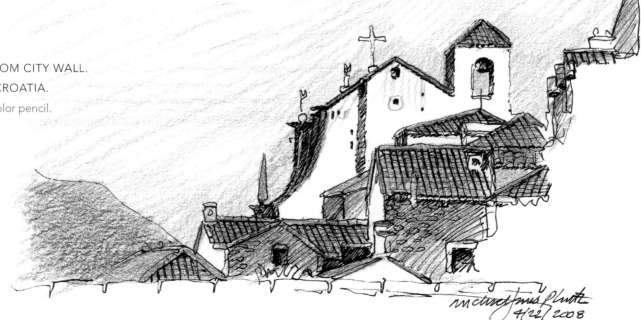

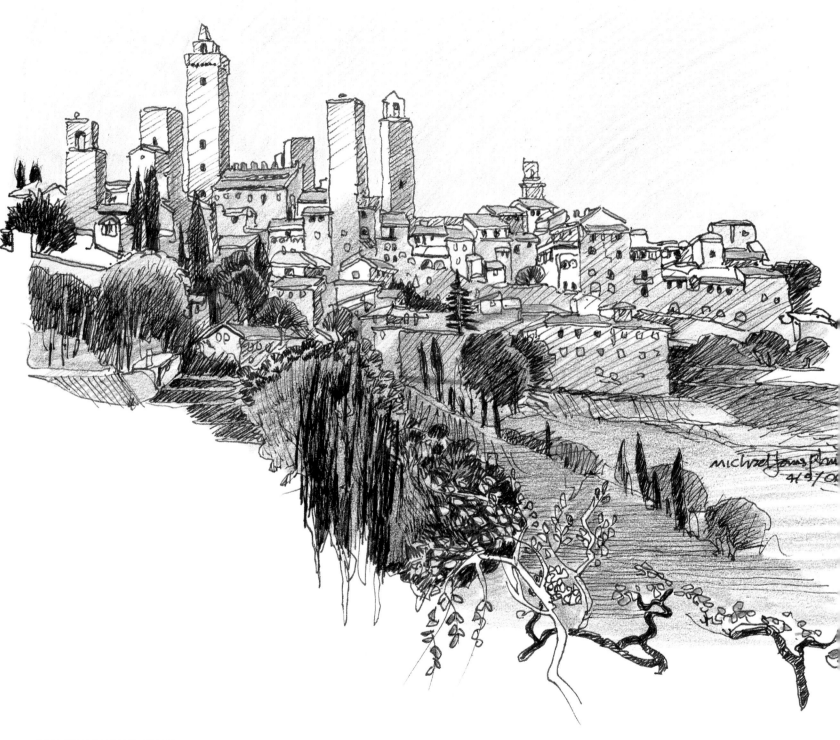

SAN GIMIGNANO, ITALY.

2006. Pen and color pencil.

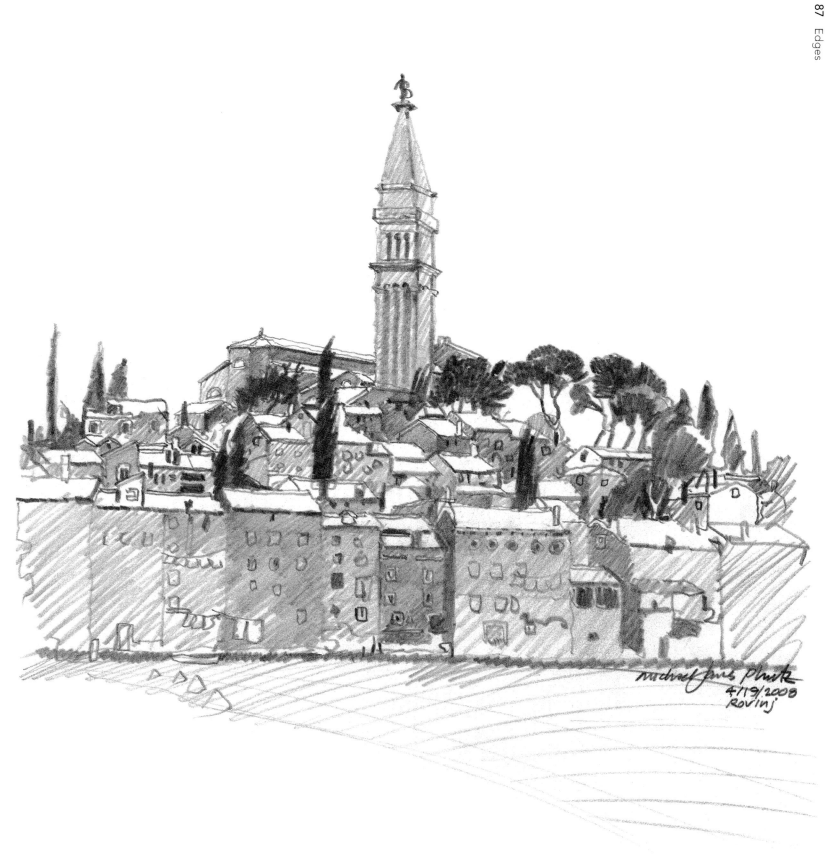

ROVINJ, CROATIA.

2008. Pencil.

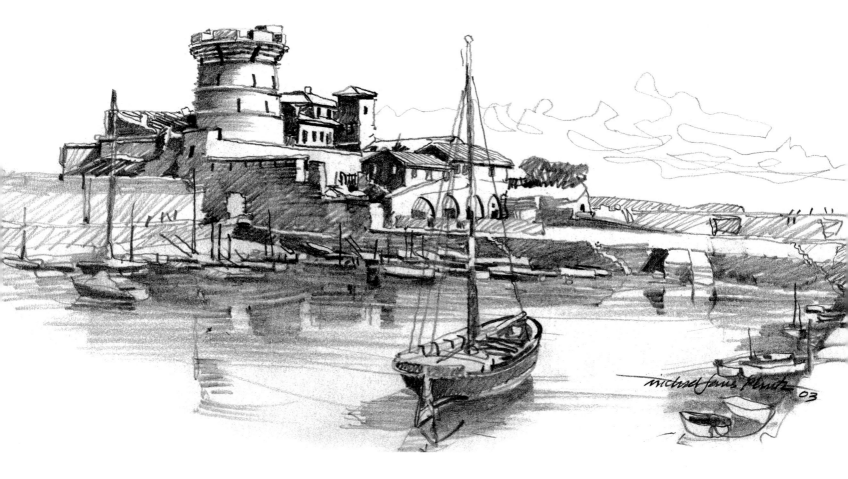

HARBOR. SAN SEBASTIÁN, SPAIN.

2003. Pencil.

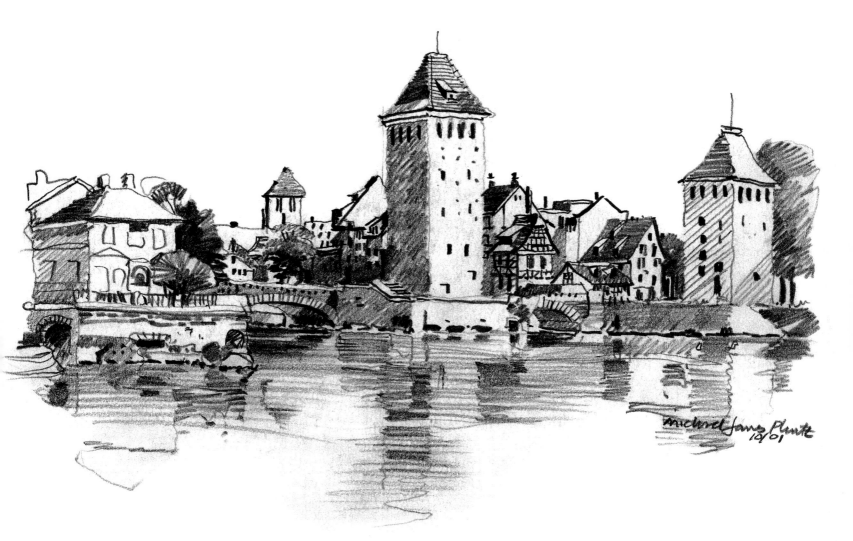

CITYSCAPE WITH CANALS. STRASBOURG, FRANCE.
2001. Pencil.

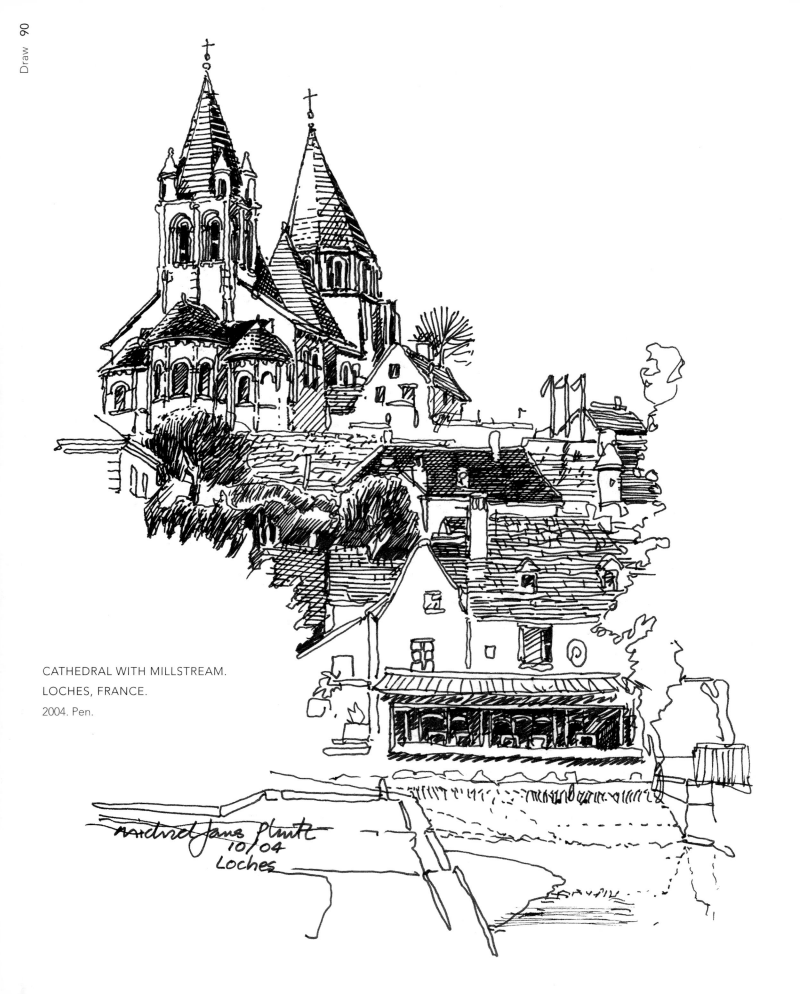

CATHEDRAL WITH MILLSTREAM.

LOCHES, FRANCE.

2004. Pen.

CISTERCIAN ABBEY.
SÉNANQUE, FRANCE.
1999. Pencil.

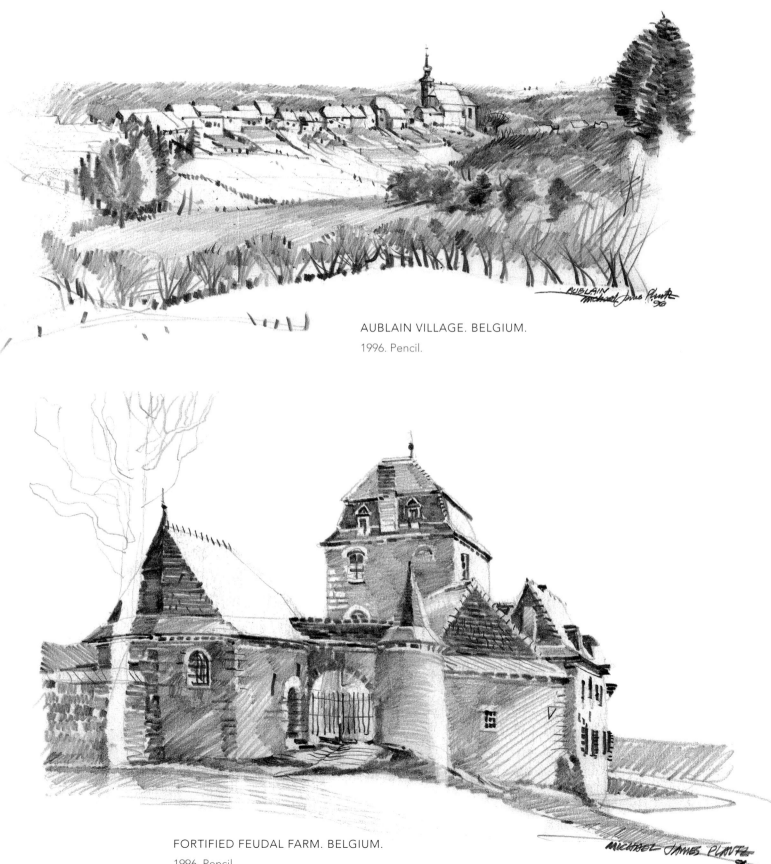

AUBLAIN VILLAGE. BELGIUM.
1996. Pencil.

FORTIFIED FEUDAL FARM. BELGIUM.
1996. Pencil.

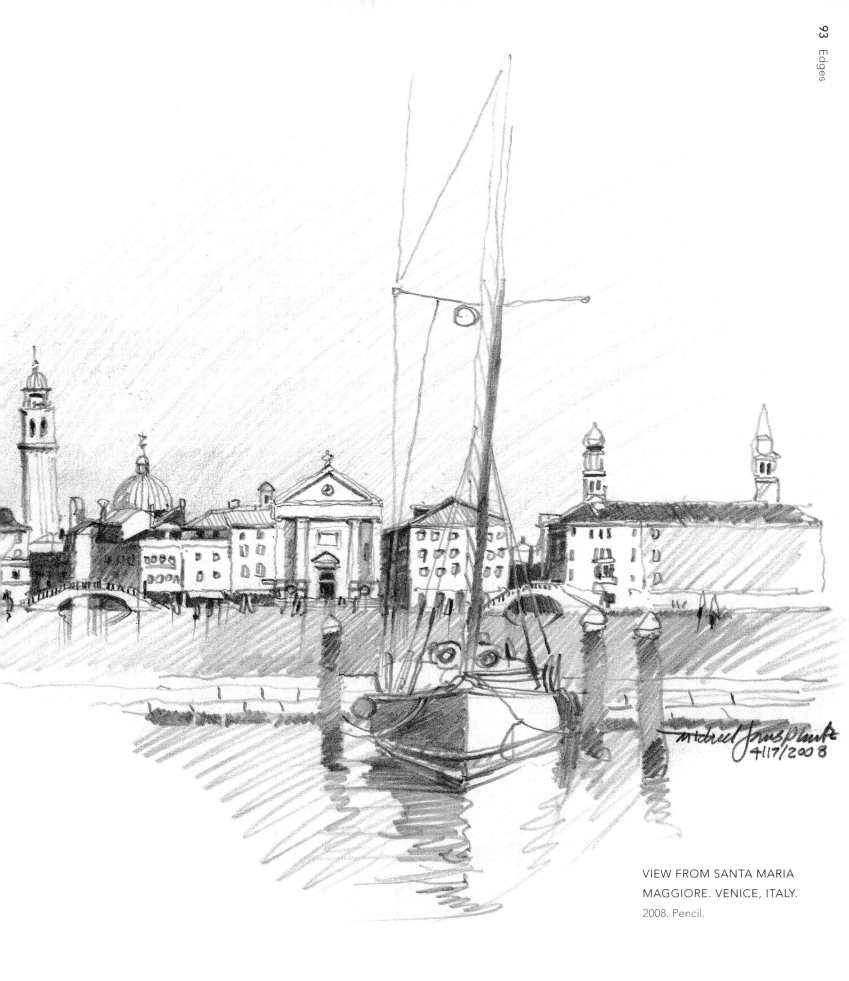

VIEW FROM SANTA MARIA
MAGGIORE. VENICE, ITALY.
2008. Pencil.

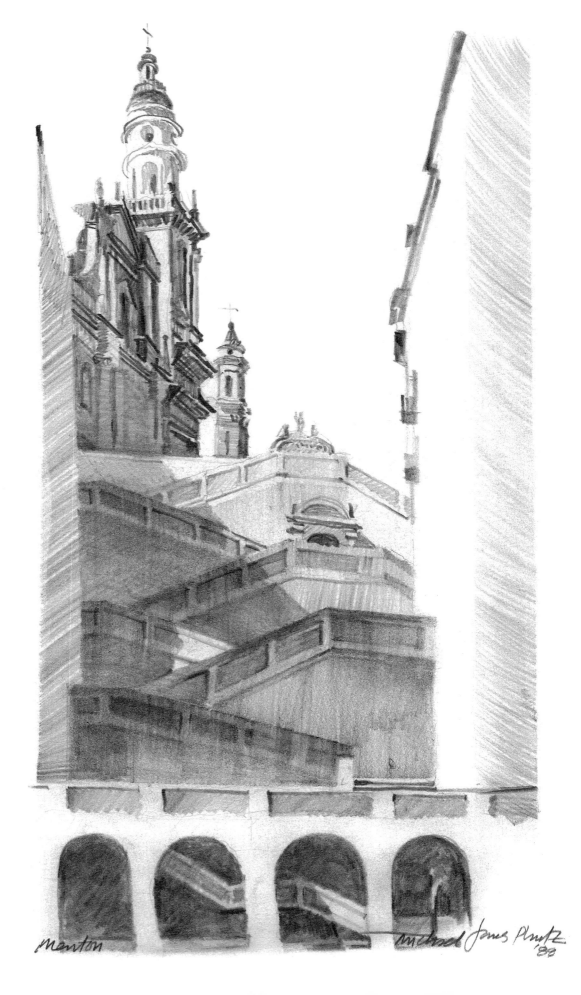

STAIR TO HIGH PLAZA.
MENTON, FRANCE.
1988. Pencil.

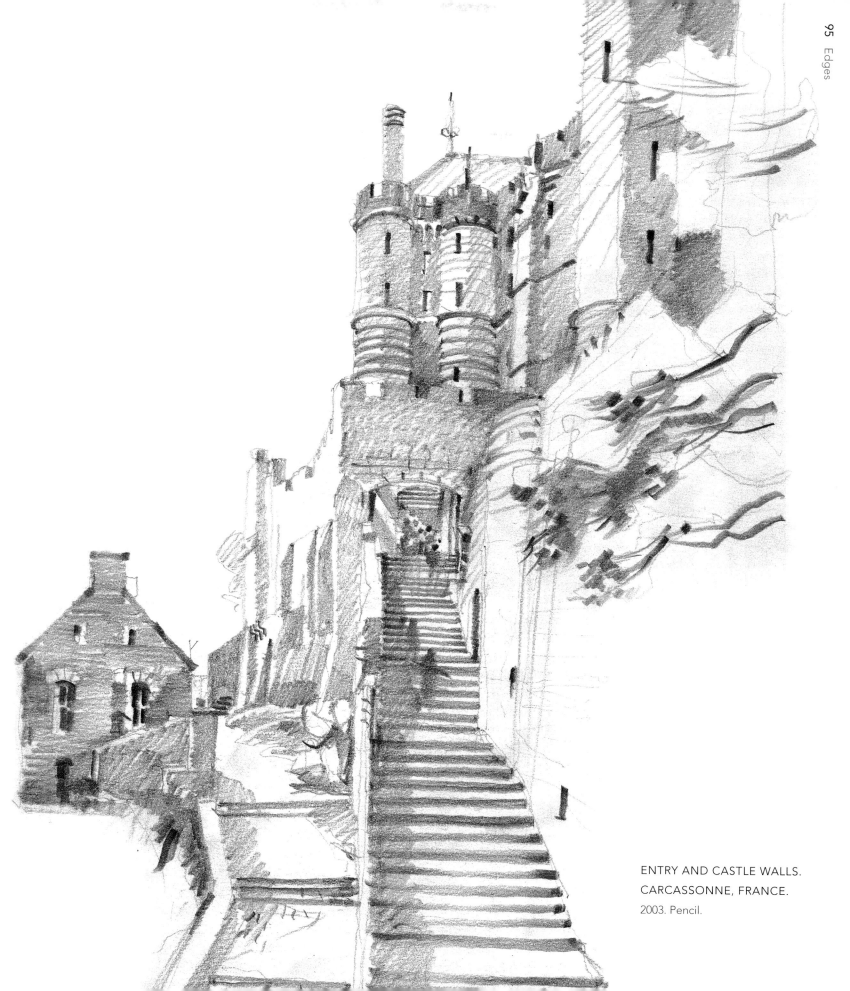

ENTRY AND CASTLE WALLS.
CARCASSONNE, FRANCE.
2003. Pencil.

BRIDGE AND CONCIERGERIE.
PARIS, FRANCE.
2008. Pencil.

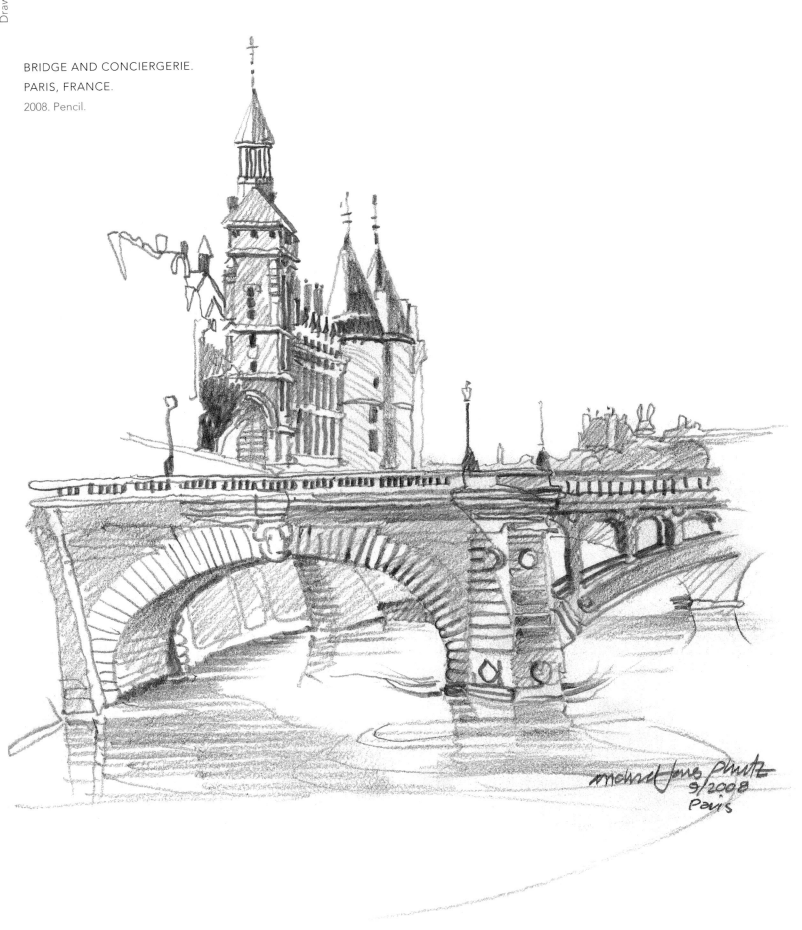

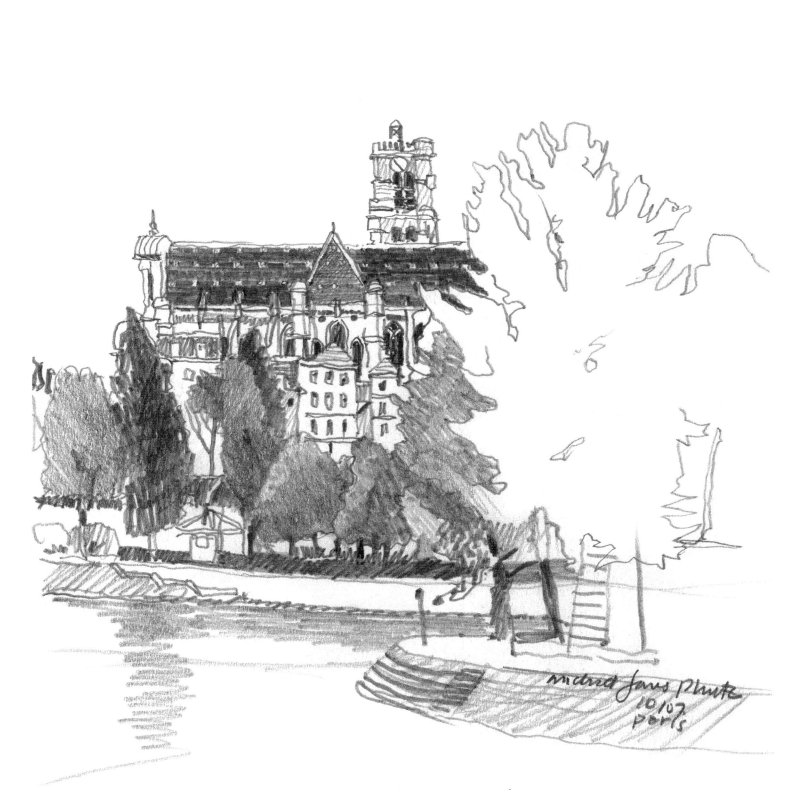

OFF THE POINT OF ÎLE
SAINT-LOUIS. PARIS, FRANCE.
2007. Pencil.

There are things known and there are

things unknown, and in between

are the doors of perception.

—Aldous Huxley

5 PORTALS

Gateways. Passage. Entry. Defining the character of a sector of space. The pull of arriving and departing—what's around the next bend? The frame for a new adventure, lifetime changes, a link to the stars, the core of a flower, or the soul of a lover's face.

The Ponte Vecchio bridging the Arno in Florence introduces a powerful pedestrian experience. First the entry to the bridge and its shops; the midpoint opening back to the river; then on to the arched entrance of the Uffizi Gallery courtyard which frames the Piazza della Signoria with Michelangelo's *David* beneath the bell tower.

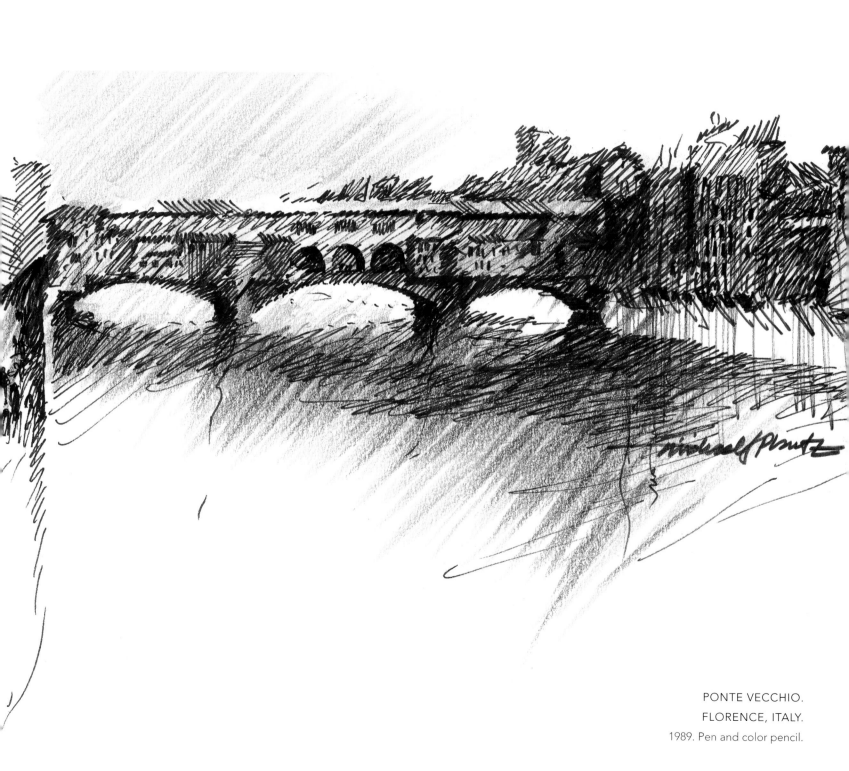

PONTE VECCHIO.
FLORENCE, ITALY.
1989. Pen and color pencil.

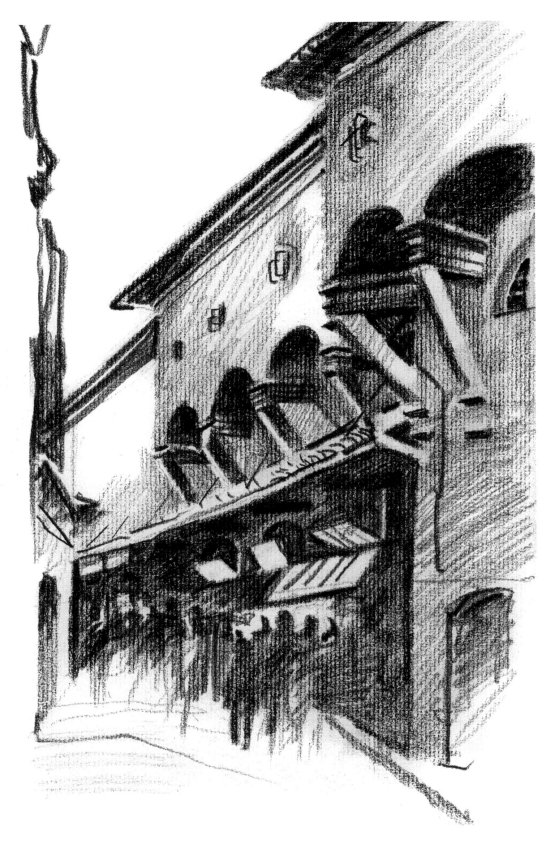

PONTE VECCHIO "STREET" OVER
THE ARNO. FLORENCE, ITALY.
1989. Charcoal.

UFFIZI GALLERY.
FLORENCE, ITALY.
1984. Pen and color pencil.

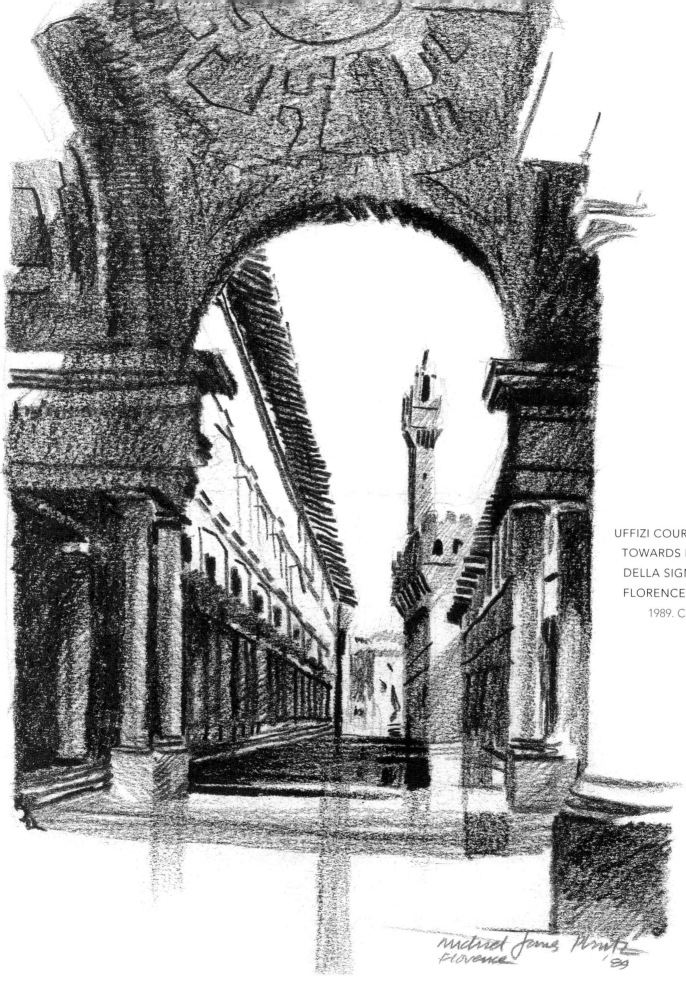

UFFIZI COURTYARD
TOWARDS PIAZZA
DELLA SIGNORIA.
FLORENCE, ITALY.
1989. Charcoal.

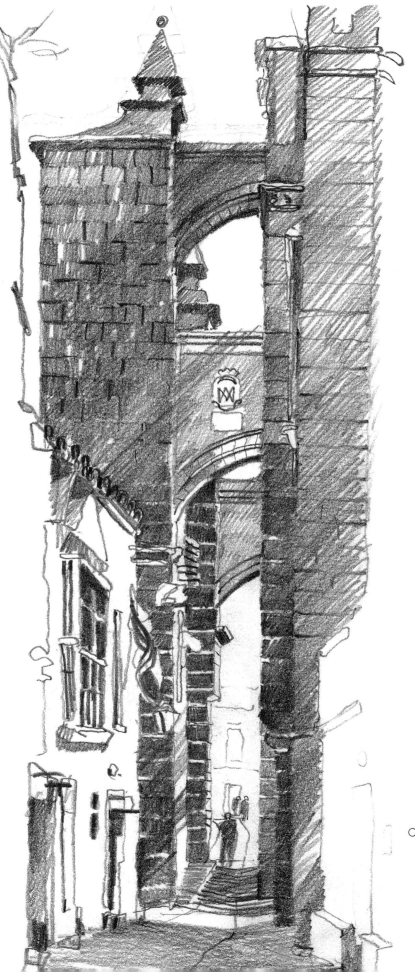

CHURCH BUTTRESS AND
STREET. ARCOS DE LA
FRONTERA, SPAIN.
2002. Pencil.

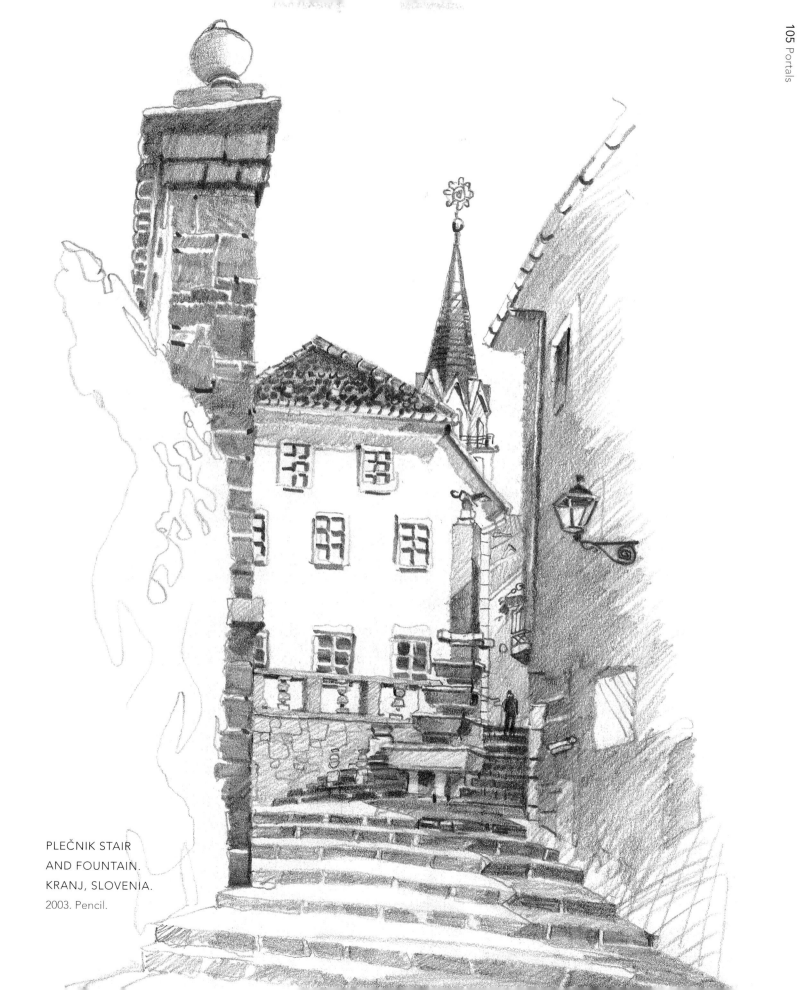

PLEČNIK STAIR
AND FOUNTAIN.
KRANJ, SLOVENIA.
2003. Pencil.

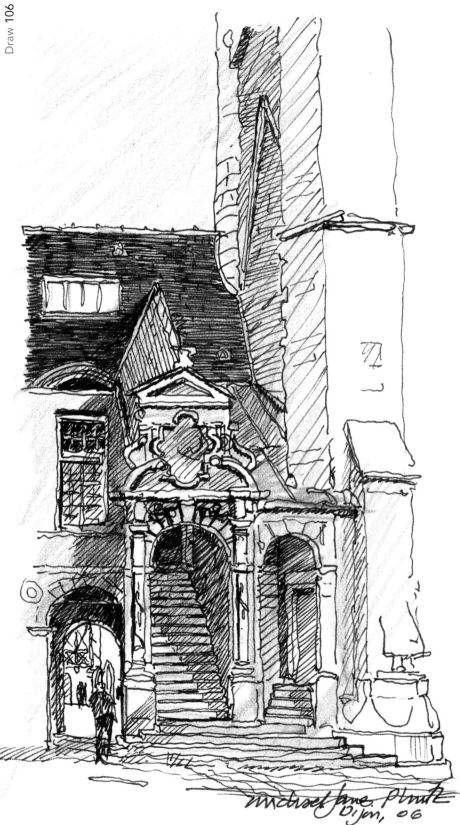

ENTRY STAIR. DIJON, FRANCE.

2006. Pen and color pencil.

CITY GATE. ROUEN, FRANCE.

2008. Pencil.

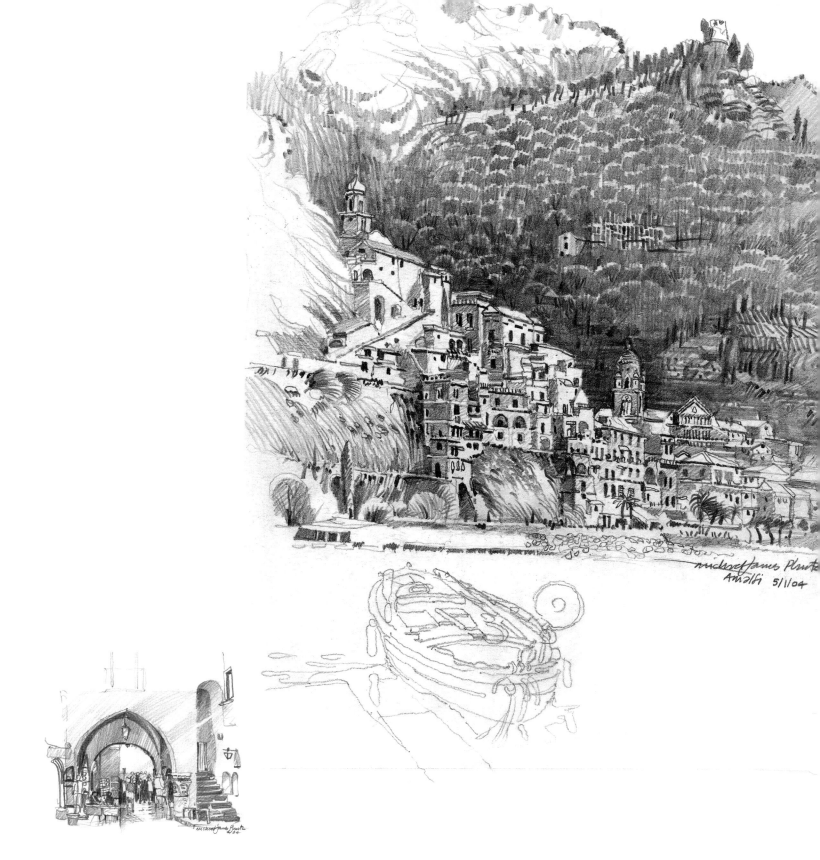

CITY GATE TO THE SEA.
AMALFI, ITALY.
2004. Pencil.

CITYSCAPE.
AMALFI, ITALY.
2004. Pencil.

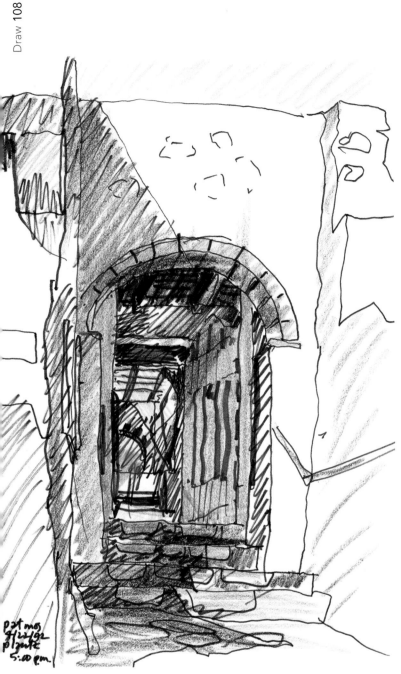

ENTRY TO COURTYARD
HOUSE. PATMOS, GREECE.
1992. Marker and color pencil.

What's behind the blue door? The ship captains on the Greek island of Patmos profited greatly from their special trade status sanctioned by the Holy Roman Empire in Constantinople. In order to camouflage their magnificent dwellings from pirates they concentrated on the interior, assembling sequences of spaces that looked small and modest on the exterior while celebrating interior courtyards and green, light-filled chambers.

The whitewashed streets are narrow and mysterious. I never tired of wandering those stepped and winding passages, sketchbook in hand, out for my morning's collection of sketches, and returning like a bee full of pollen to work in the midday shade of our terrace. Sometimes I would go back to the same spot later in the afternoon, where I actually noted the time of day on my sketches as each click of my watch changed the composition before me and served as an endless parade of possibilities. Drawing Patmos is like playing Bach's *The Well-Tempered Clavier* over and over again, with new layers of meaning unveiled each time.

STREET. PATMOS, GREECE.
1992. Marker and color pencil.

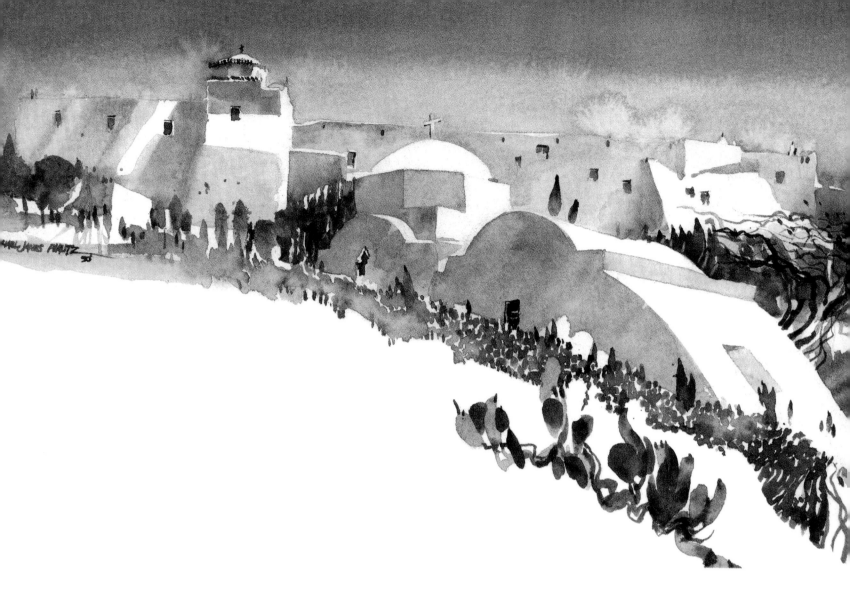

Patmos. Sketching inside a nunnery with Professor Alec Notaras. Mother Superior had just given us a tour, from the chapel to the individual cells occupied by the nuns. One room with only a small window in the door had been shared by two nuns for the past sixty-five years. The previous occupants had been in the same room seventy years, and one of them was twelve years old at the start of the American Civil War. Two lifetimes shared in a twelve-by-twelve-foot space on a small island near Asia Minor. How does one measure a life?

Time warps. Silence, cicadas, and lizards accompanied me as I sat sketching on the steps. A Greek coffee and a biscuit silently appeared; I never saw who brought it. Not many men ever come here, but then, at the gate below, Mother Superior was welcoming an entourage of high priests with gilded cross and incense come to say a mass. Mother's ring kissed. The eternal rituals—she was cool.

NUNNERY AND CHURCH.
PATMOS, GREECE.
1992. Watercolor.

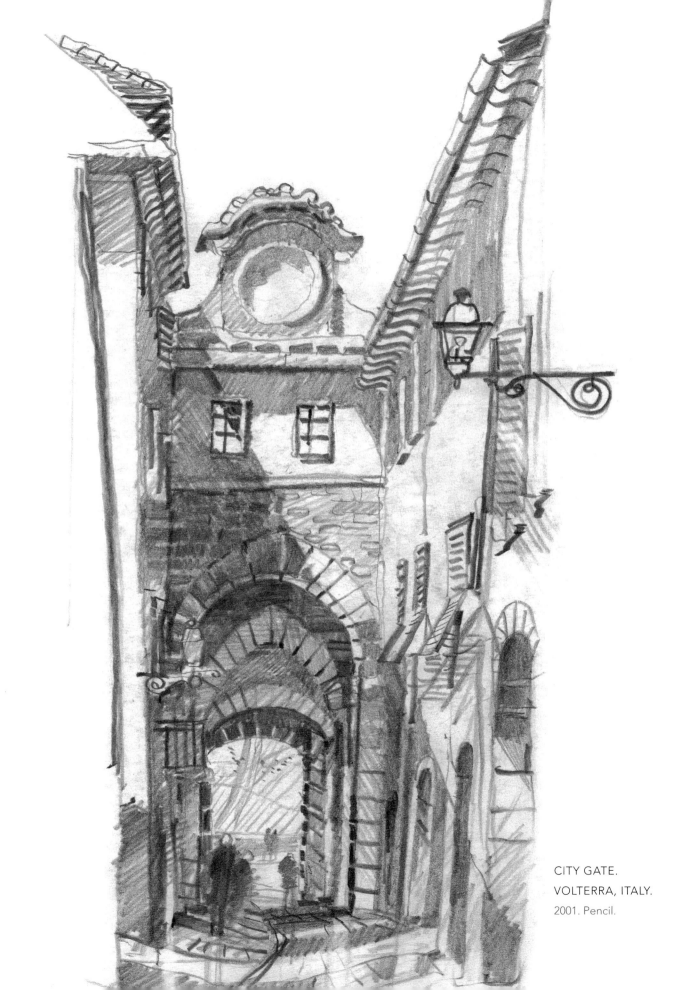

CITY GATE.
VOLTERRA, ITALY.
2001. Pencil.

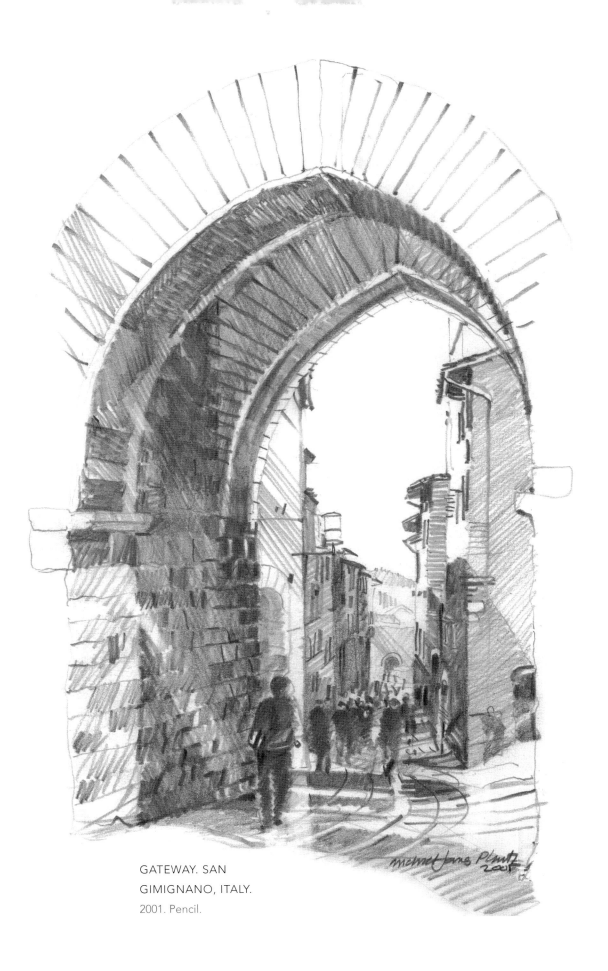

GATEWAY. SAN
GIMIGNANO, ITALY.
2001. Pencil.

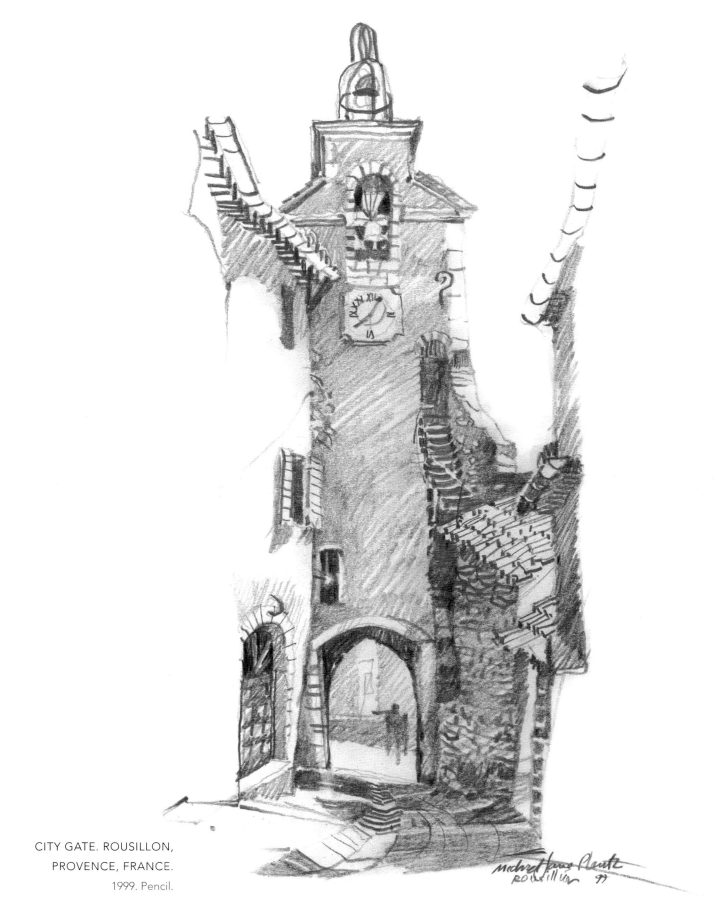

CITY GATE. ROUSILLON,
PROVENCE, FRANCE.
1999. Pencil.

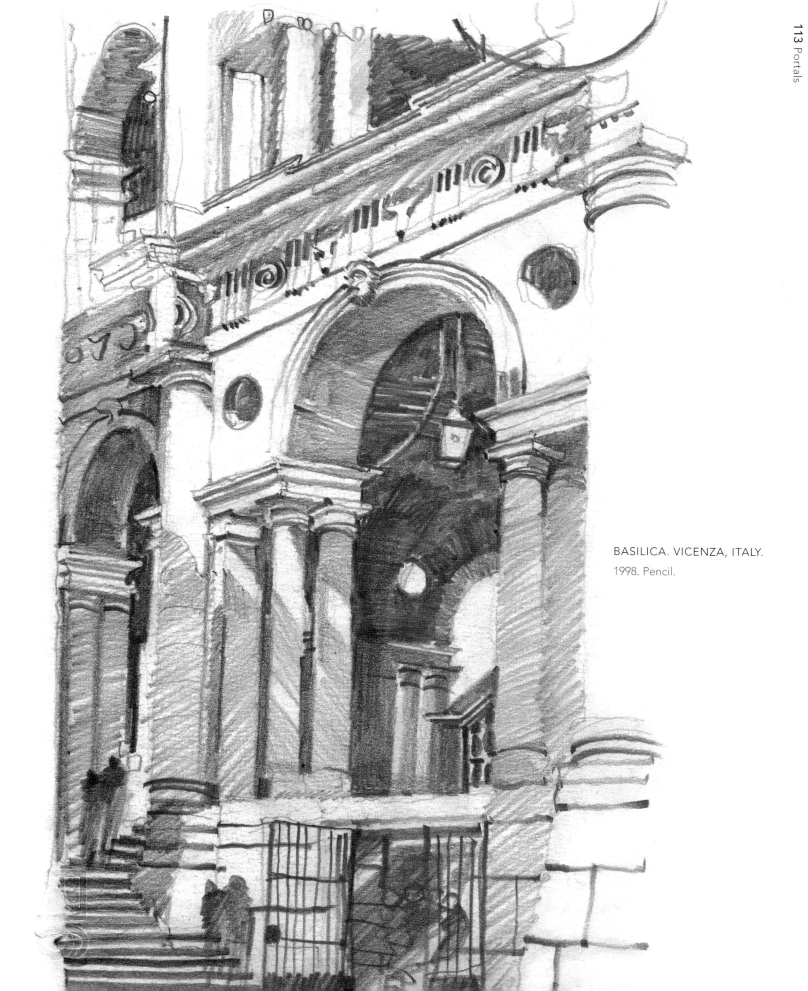

BASILICA. VICENZA, ITALY.
1998. Pencil.

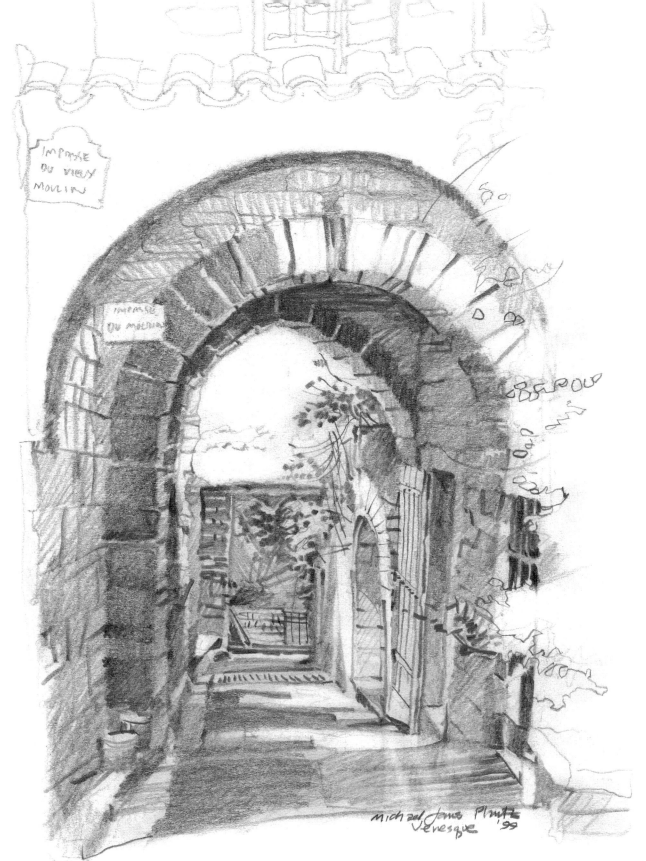

PORTAL.
VENASQUE, FRANCE.
1999. Pencil.

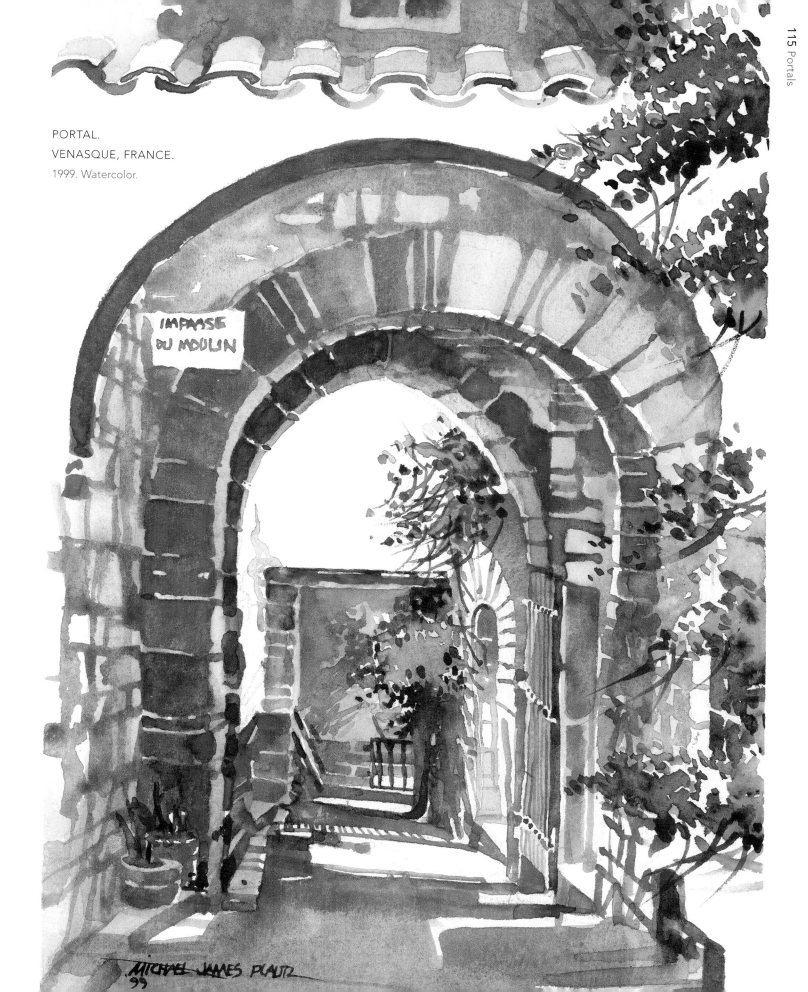

PORTAL.
VENASQUE, FRANCE.
1999. Watercolor.

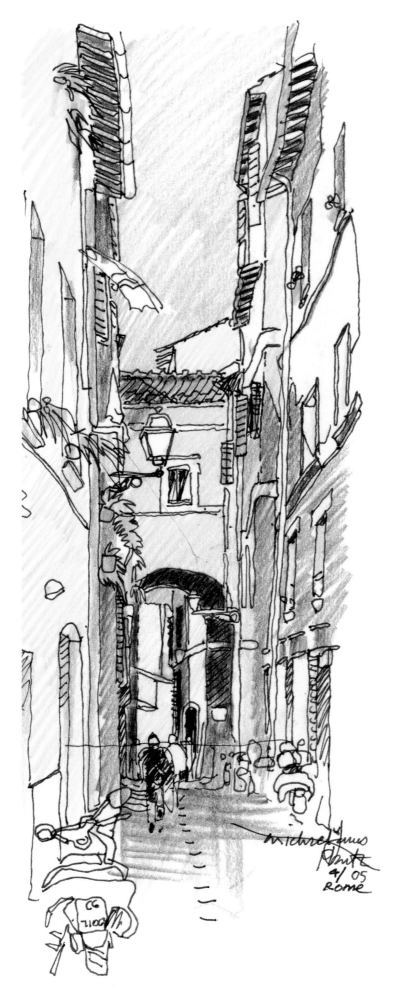

Left:
STREETSCAPE. ROME, ITALY.
2005. Pen and color pencil.

Opposite left:
NARROW STREET.
DUBROVNIK, CROATIA.
2008. Pen.

Opposite right:
STREETSCAPE.
DUBROVNIK, CROATIA.
2008. Pen and color pencil.

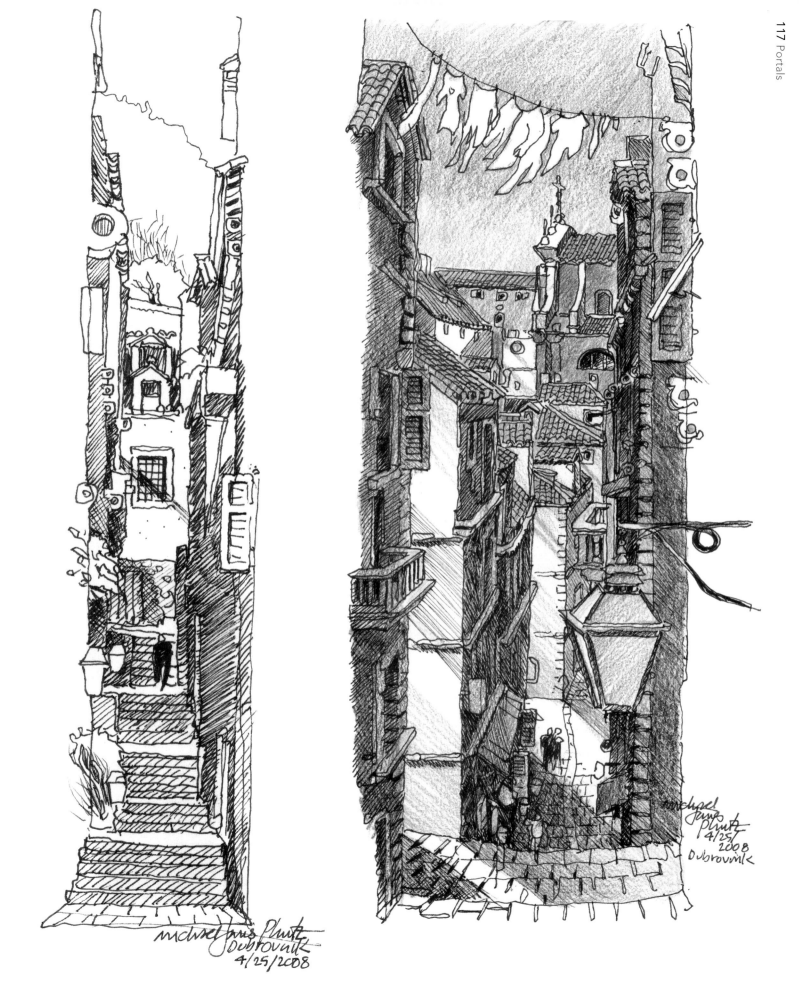

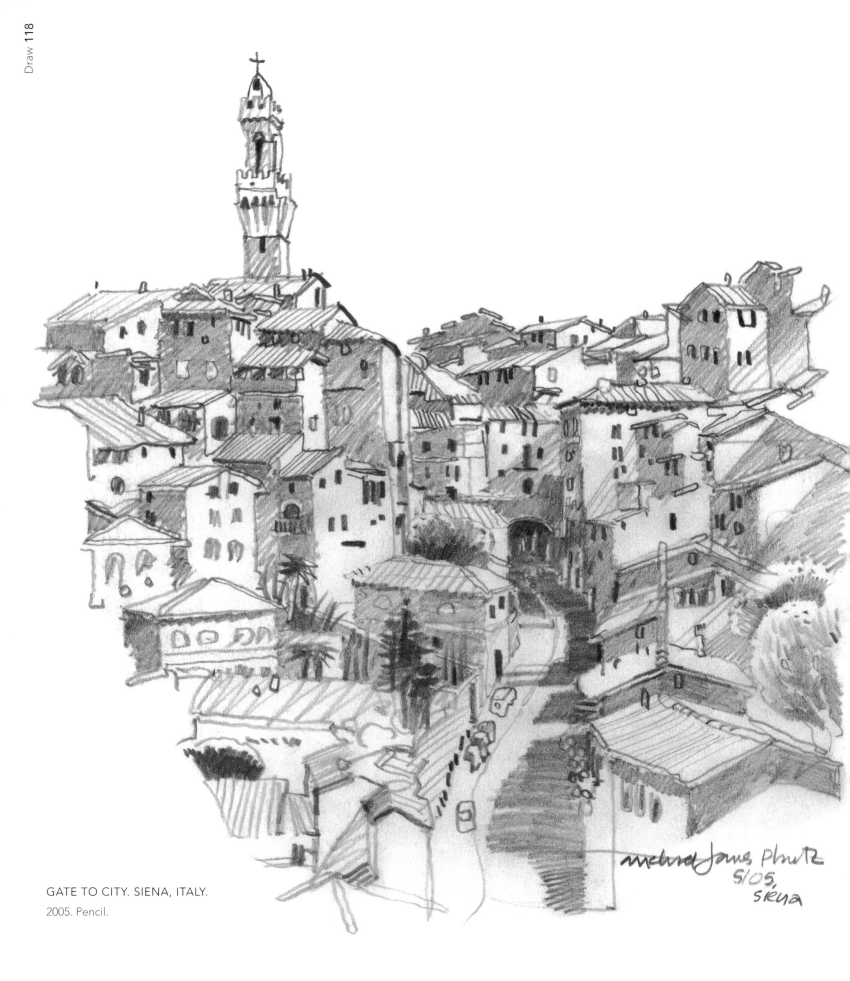

GATE TO CITY. SIENA, ITALY.

2005. Pencil.

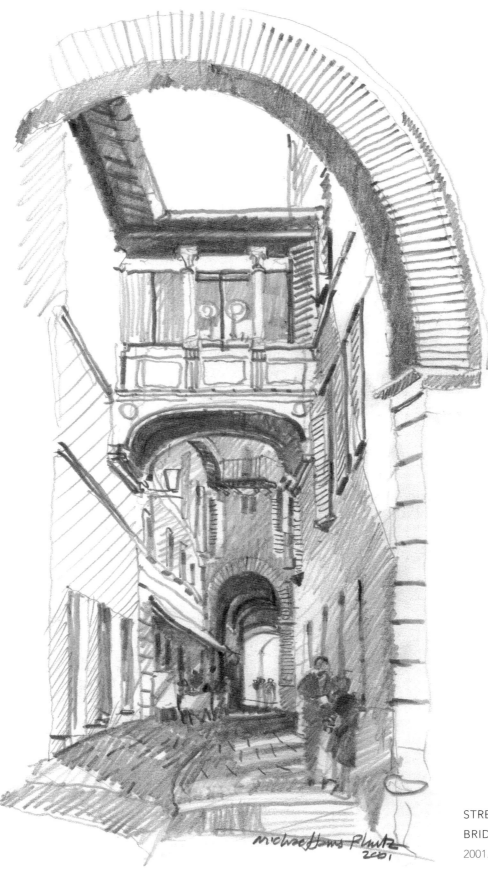

STREETSCAPE WITH
BRIDGE. SIENA, ITALY.
2001. Pencil.

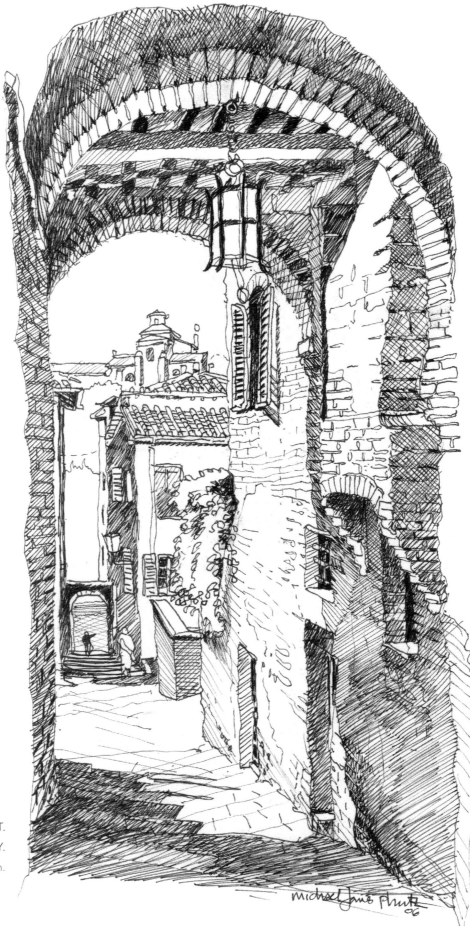

COVERED STREET.
SIENA, ITALY.
2006. Pen.

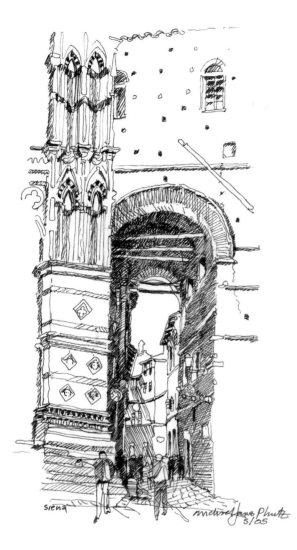

STREET BY CATHEDRAL.
SIENA, ITALY.
2005. Pen.

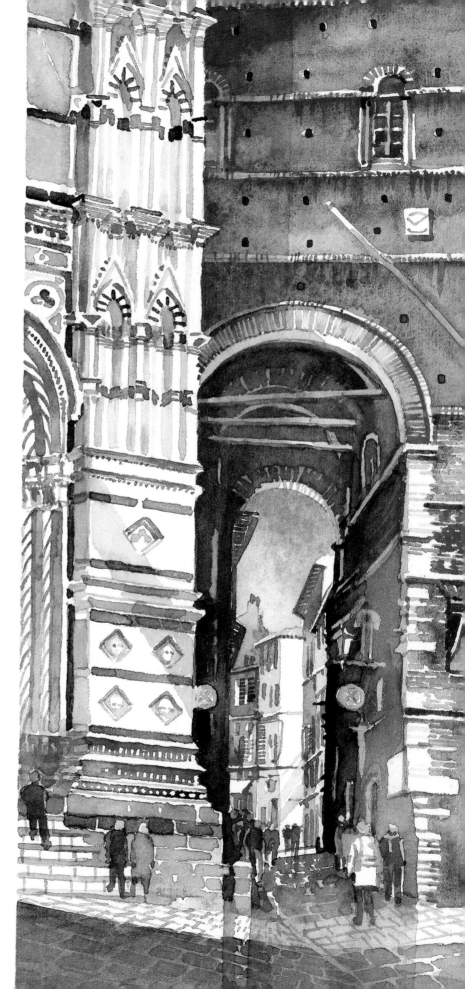

CATHEDRAL STREET.
SIENA, ITALY.
2006. Watercolor.

Oh, what a void there is in things.

—Aulus Persius Flaccus

6 VOIDS

Voids. Shafts of spaces in between, those important spaces that give meaning to the surrounding elements, forms, words, and thoughts. The vastness of space makes grand the compression of stellar dust into the rings of Saturn. The infinitesimal flecks of white paper between the dusts of graphite create observable form—the pregnant gap between the fingers of God and Adam on Michelangelo's Sistine ceiling have powered a billion eyes and minds.

Voids. Drawing is the endless joy of seeking the meaningful spaces between; interiors like the Pantheon, the Gothic cathedrals; squares like St. Peter's, Place des Vosges, and Michelangelo's Campidoglio; chasing the five-minute pulses of sunlight from sun to earth; a forest clearing; the soul of a flower. It is searching for the tiny flecks of white paper between graphite strokes to capture the light of my granddaughter's face. It is learning the lesson of when to leave something out, to leave the paper white.

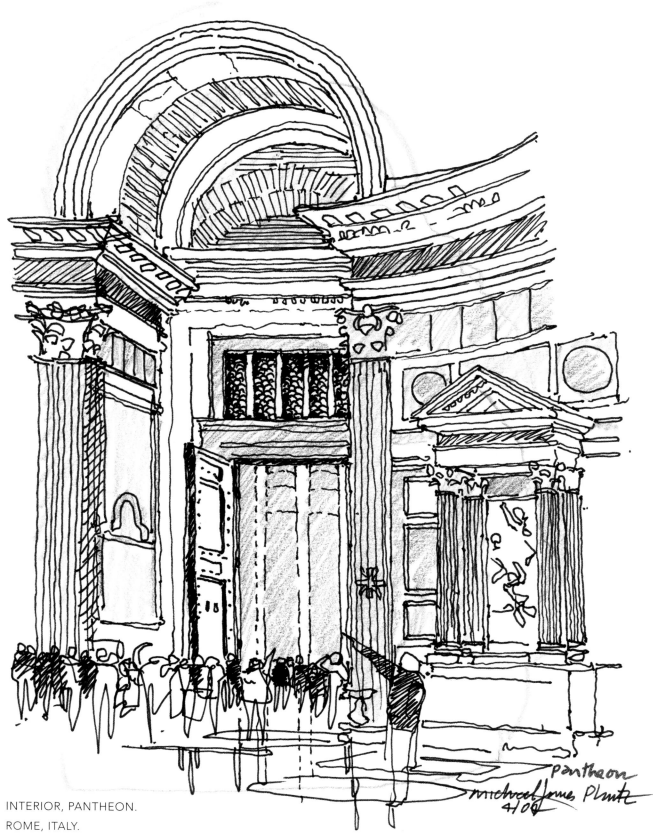

INTERIOR, PANTHEON.

ROME, ITALY.

2002. Pen and color pencil.

PLACE DES VOSGES. PARIS, FRANCE.
2002. Pen.

Place des Vosges in Paris. The old Rennaisance square is a perfect archetype for living, an introverted space with commerce below in the covered arcade, residential above, and greenery in the middle. The residential square is both intimate and monumental, with red brick and stone-arched entry points, a copse of trees in the center, fountains in the four corners, and picturesque roofs and chimneys. Victor Hugo lived here in the nineteenth century. In 1968 it was quite rundown. Now it is one of the most fashionable residential squares in Paris. It is the perfect laboratory for what makes a place timeless and memorable. An example of a place to which I have returned many times with my students to always find something new to learn.

NORTH ENTRY. PLACE DES VOSGES. PARIS, FRANCE.
2002. Pen.

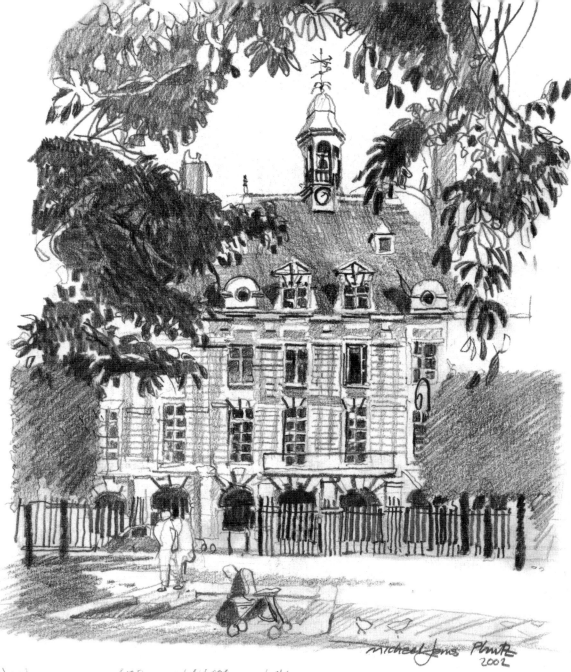

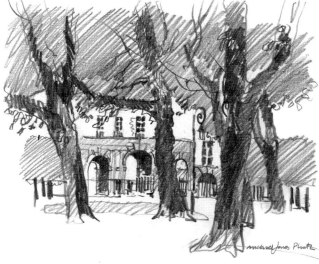

Above:

TYPICAL RENAISSANCE FAÇADE.
PLACE DES VOSGES. PARIS, FRANCE.
2002. Pencil.

Left:

VIEW TO NORTH ENTRY.
PLACE DES VOSGES. PARIS, FRANCE.
2006. Pencil.

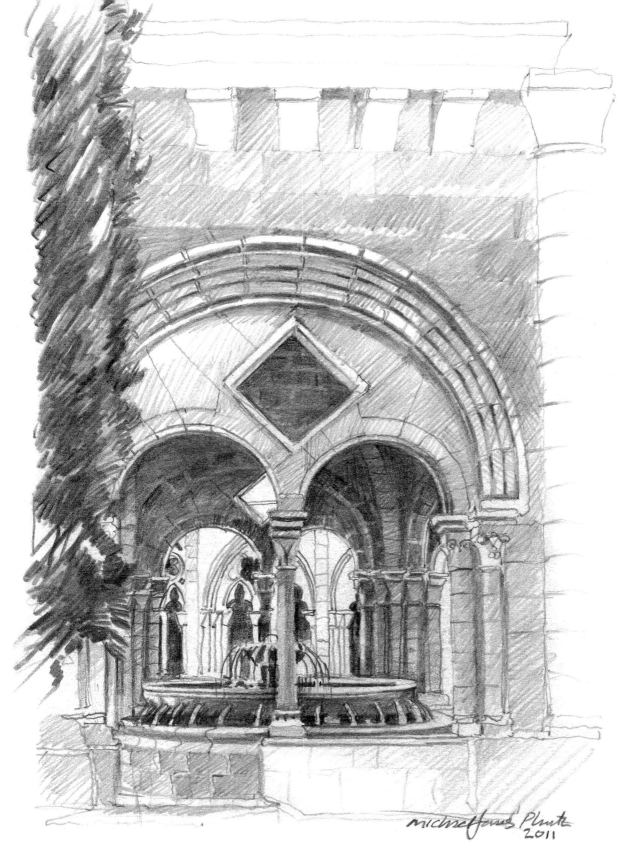

FUENTE. CISTERCIAN ABBEY.
POBLET, SPAIN.

2011. Pencil.

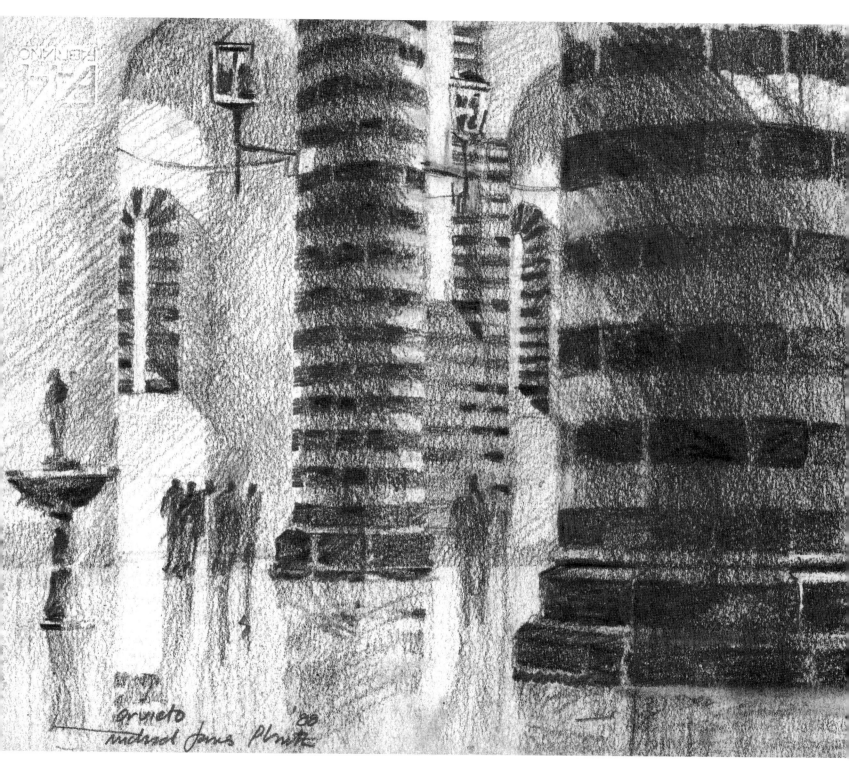

INTERIOR CATHEDRAL.
ORVIETO, ITALY.
1988. Pencil.

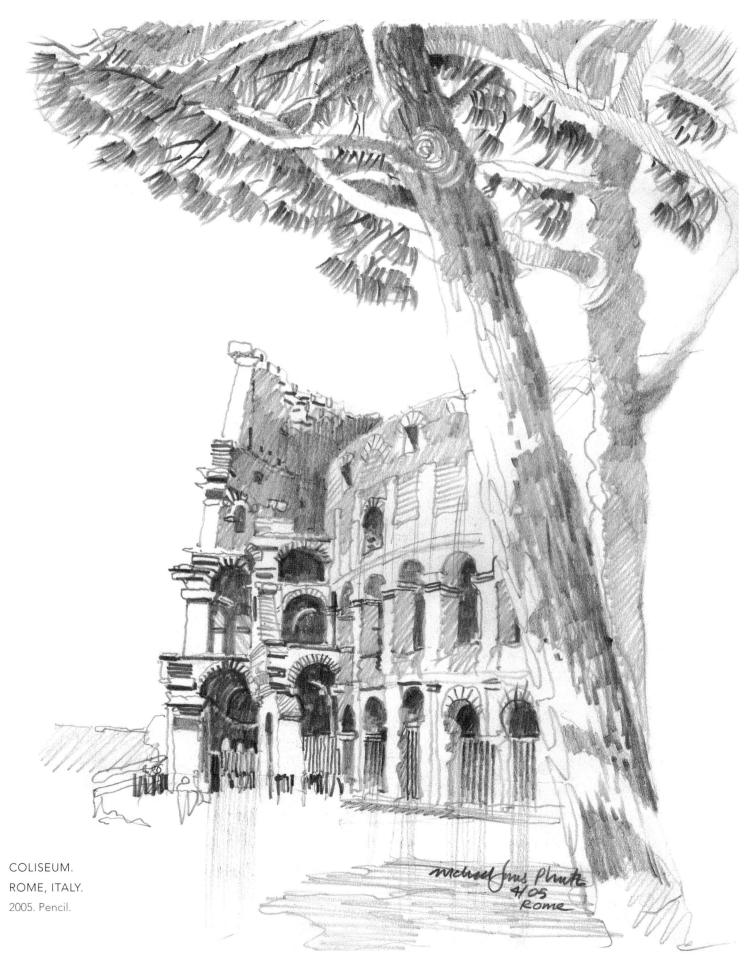

COLISEUM.
ROME, ITALY.
2005. Pencil.

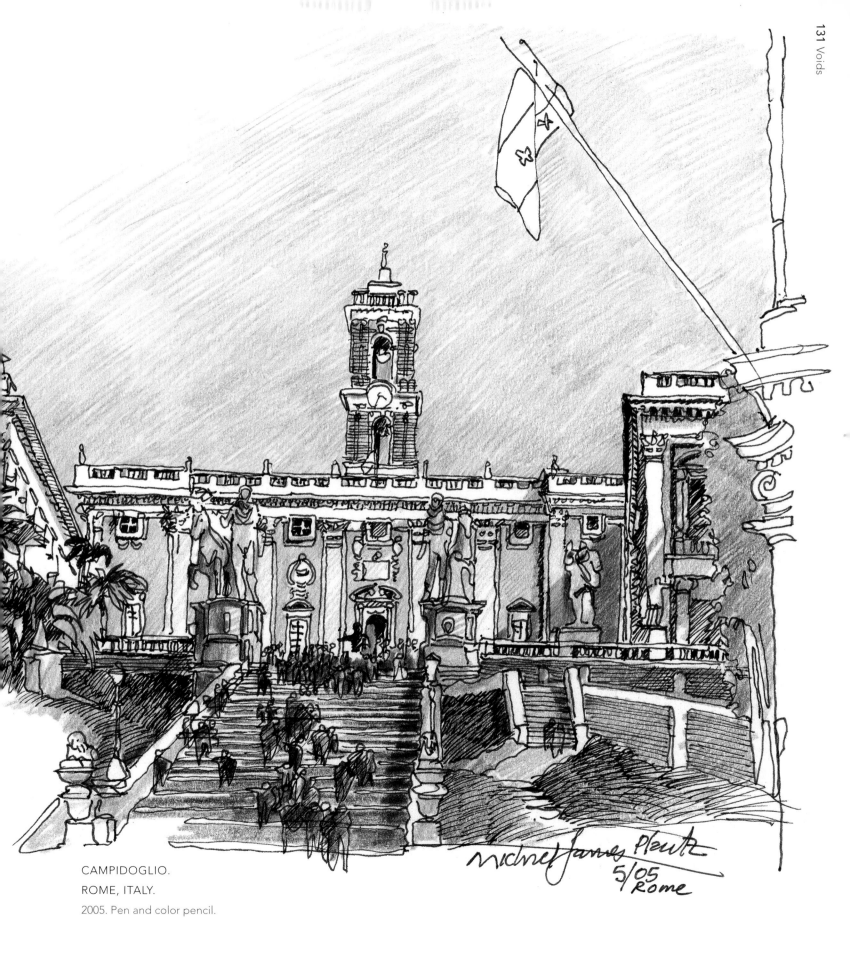

CAMPIDOGLIO.
ROME, ITALY.

2005. Pen and color pencil.

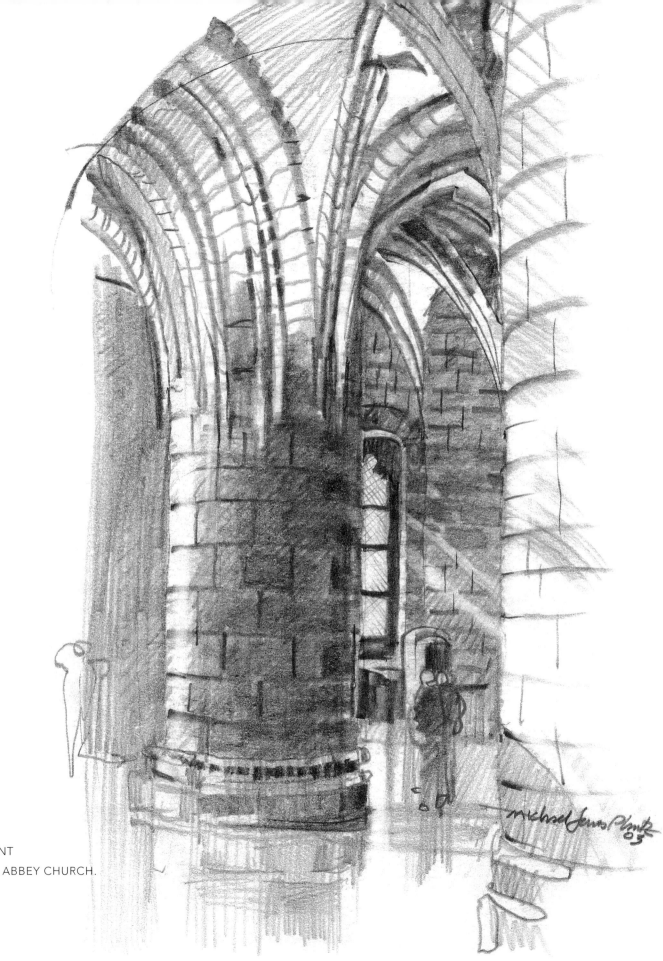

CRYPT, MONT
ST. MICHEL ABBEY CHURCH.
FRANCE.
2003. Pencil.

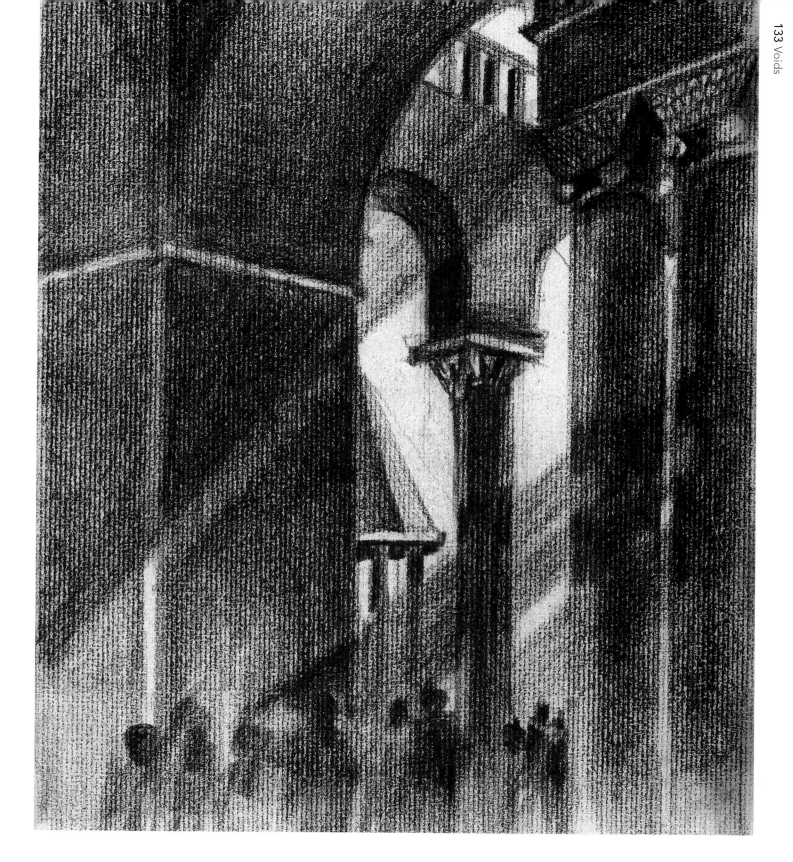

INTERIOR, ST. MARK'S CATHEDRAL.
VENICE, ITALY.
1986. Charcoal.

A garden must combine the poetic and the mysterious with a feeling of serenity and joy.

—Luis Barragan

7 IN A GARDEN

Like Monet, who made an external garden to paint his internal world, I could live, draw, and paint in a garden happily all my days.

The sunflower mirrors in miniature the mystic spiral of the sky's galaxies. Swirling petals of sun forming and growing to the elegant math of Fibonacci are science and art entwined.

Gloria's orchids rest at my fingertips, sharing light at the edge of my drawing table from the big skylight above. They are welcome companions in the sun, light, and shadow through their sensuous faces and complex surfaces, offering lessons in growth and form, and inspiration for design.

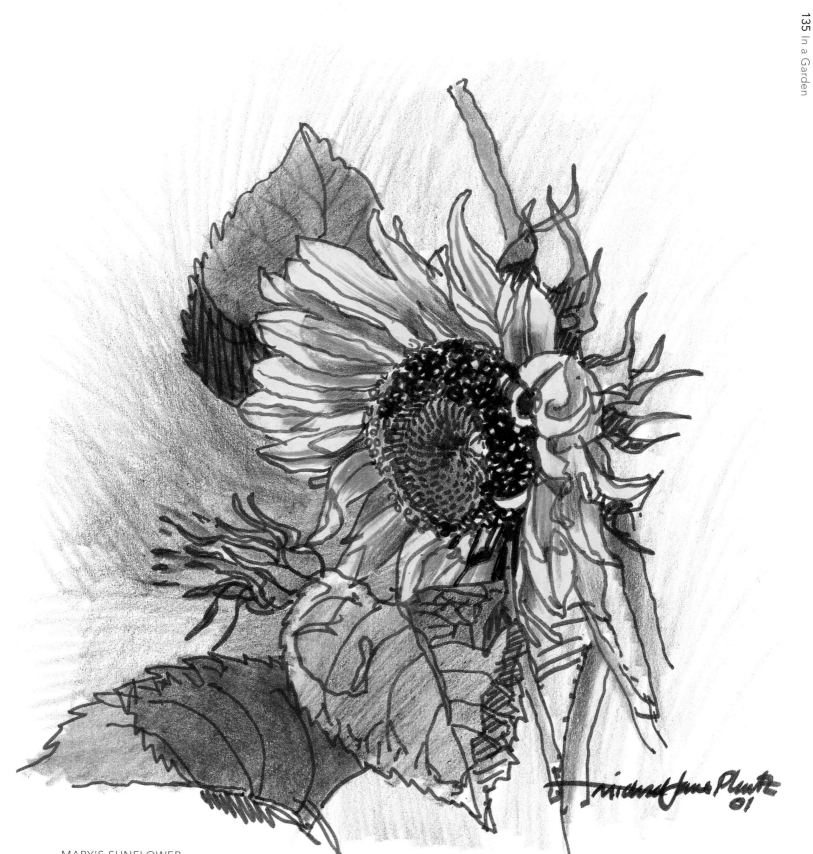

MARY'S SUNFLOWER.

WILLARD, WISCONSIN.

2001. Pen and color pencil.

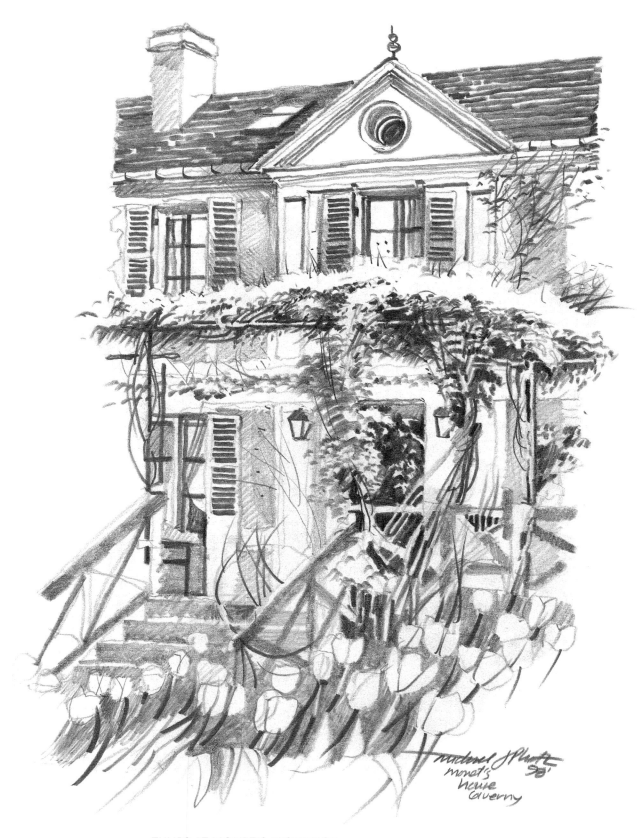

TULIPS AT MONET'S RESIDENCE.
GIVERNY, FRANCE.

1998. Pencil.

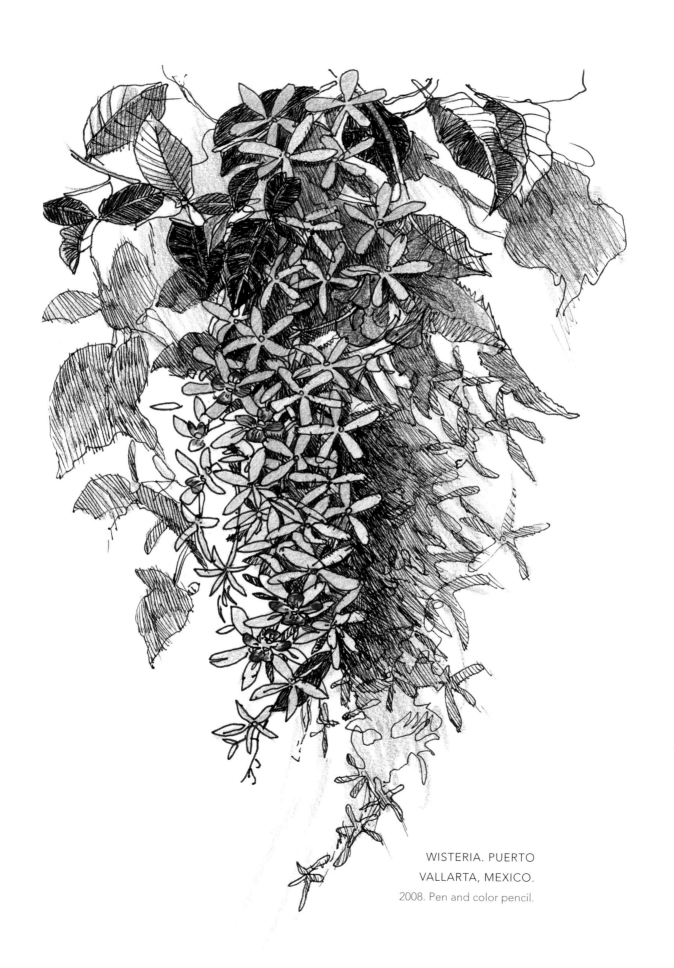

WISTERIA. PUERTO
VALLARTA, MEXICO.
2008. Pen and color pencil.

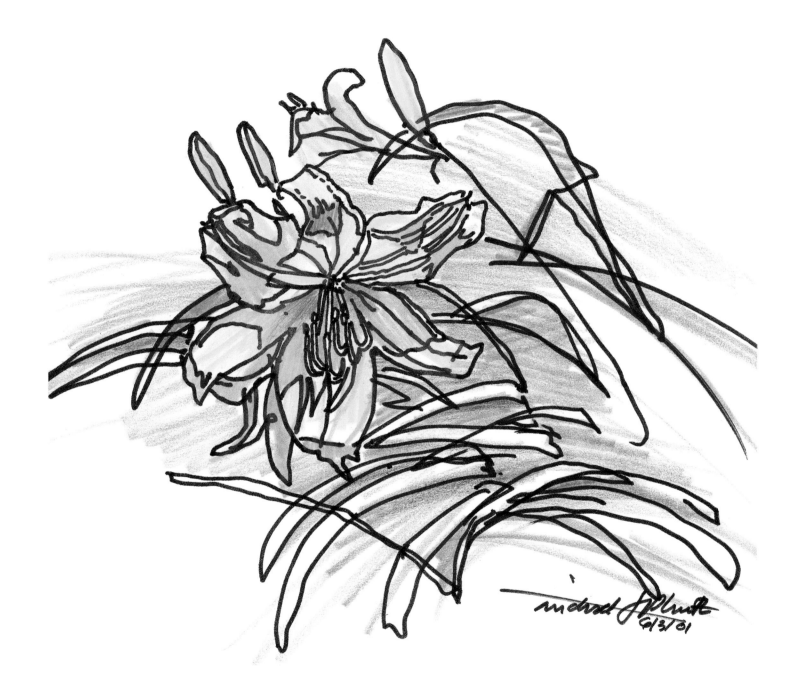

MOTHER'S LILIES.

2001. Pen and color pencil.

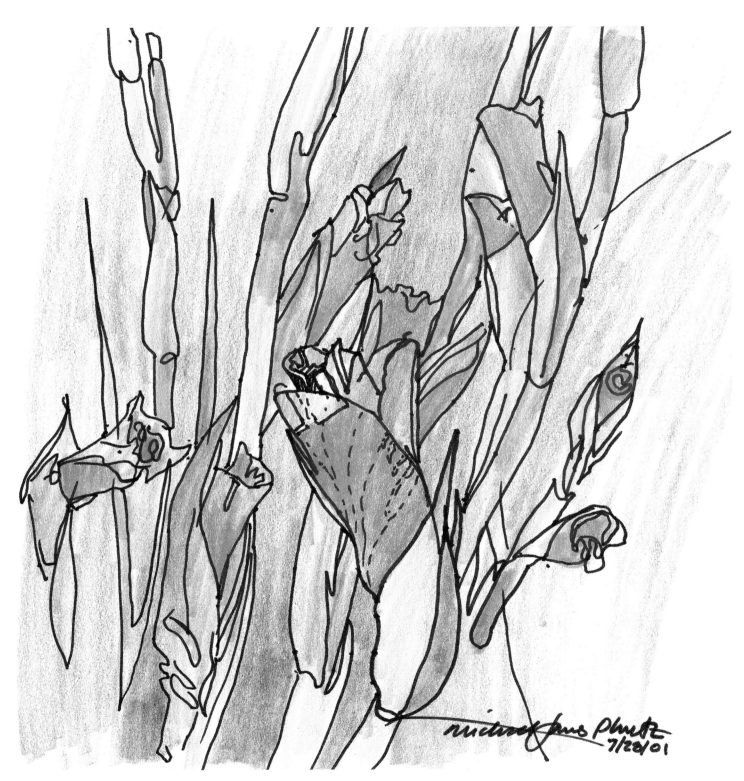

GLADIOLAS.

2001. Pen and color pencil.

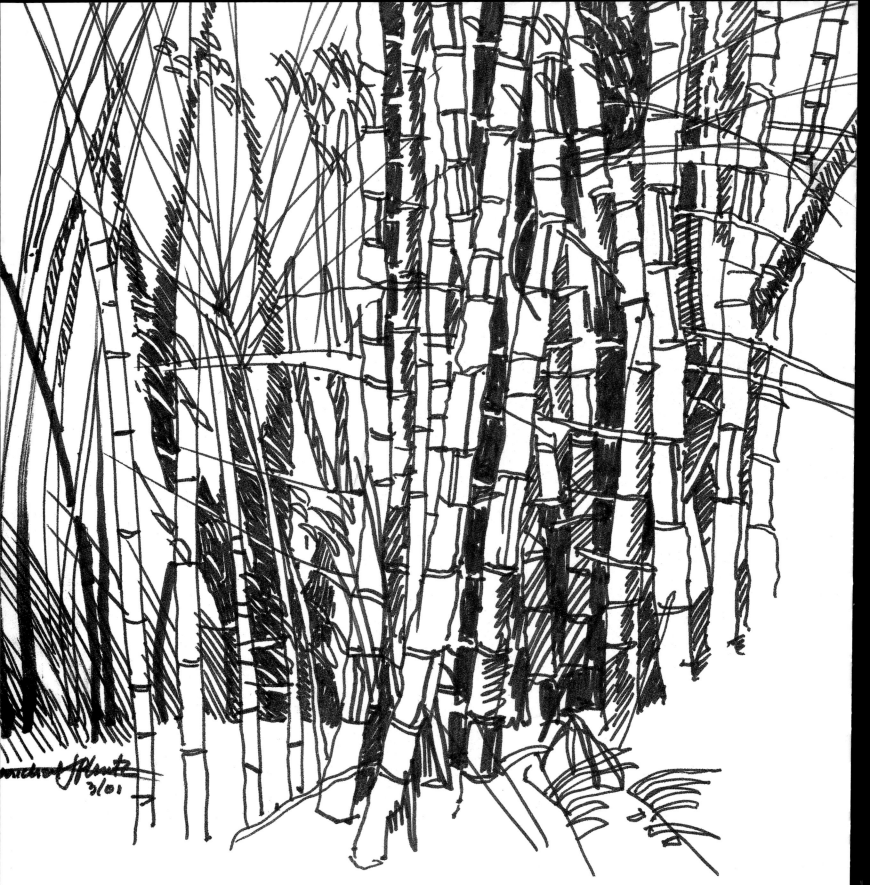

BAMBOO. COSTA RICA.

2001. Marker.

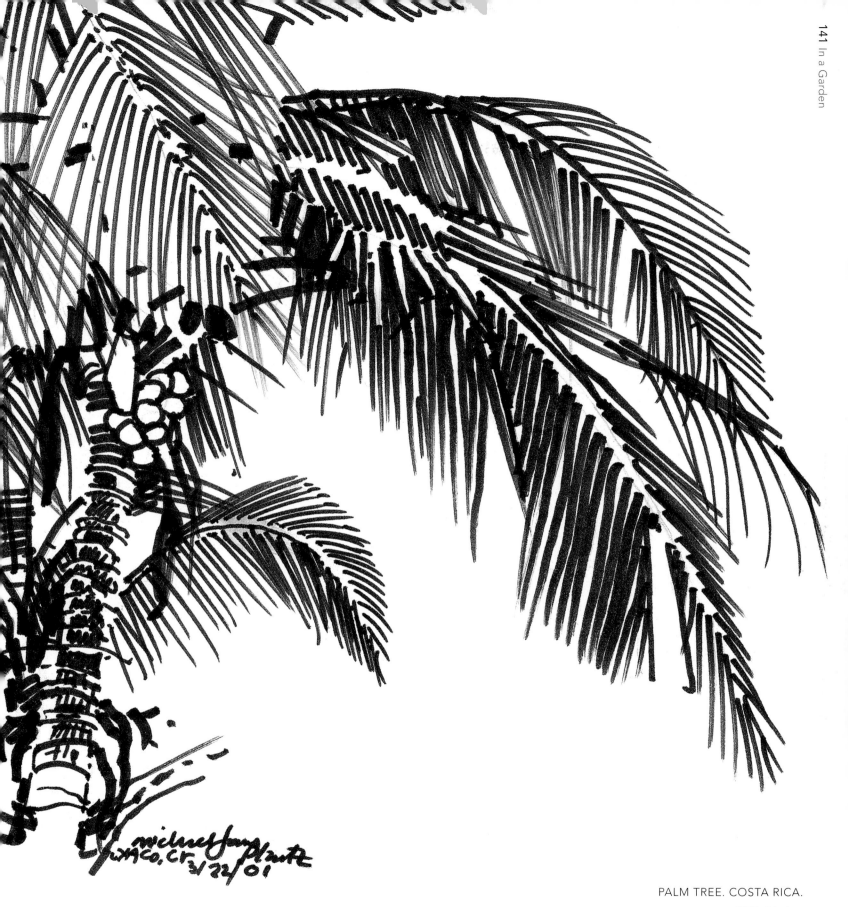

PALM TREE. COSTA RICA.

2001. Marker.

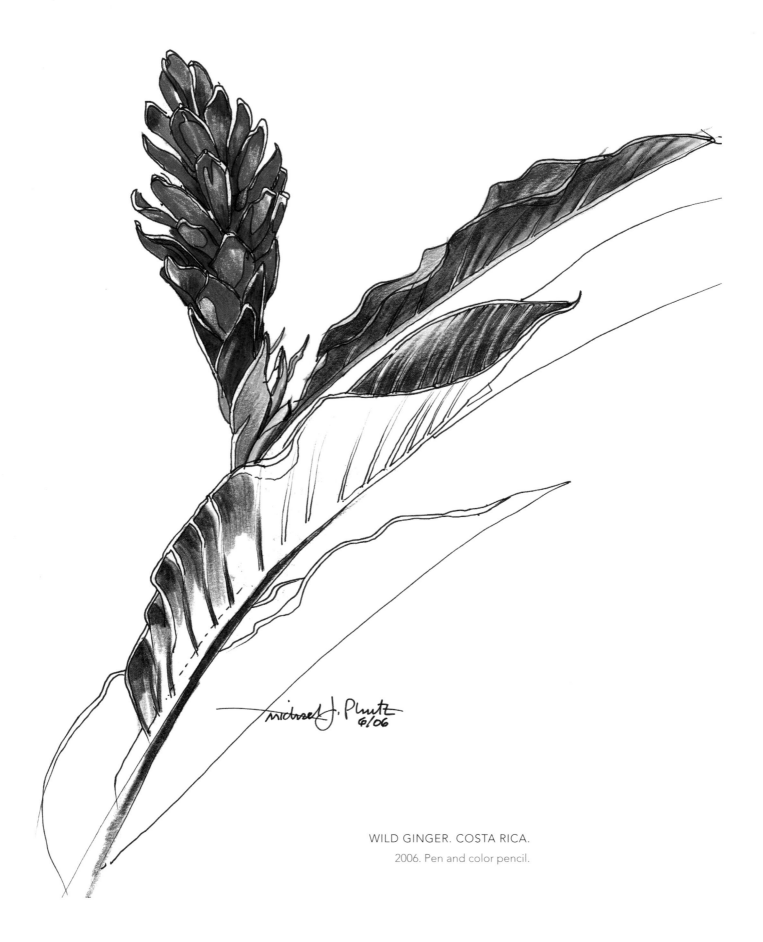

WILD GINGER. COSTA RICA.

2006. Pen and color pencil.

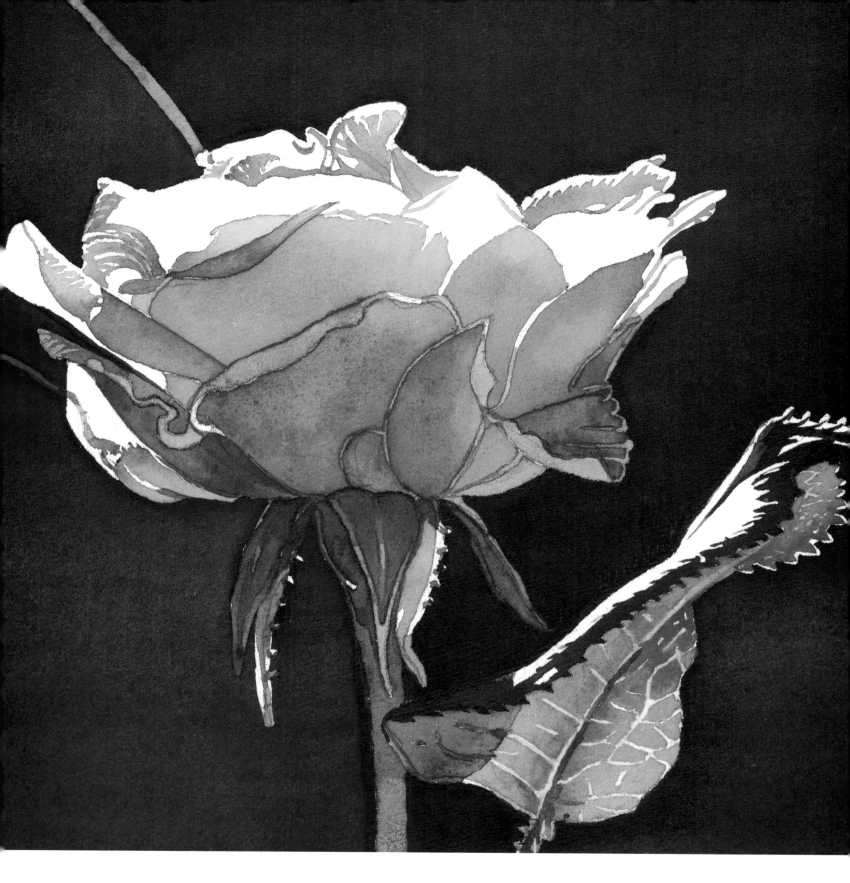

SUZY ROSE. SANTA FE, NEW MEXICO.
2006. Watercolor.

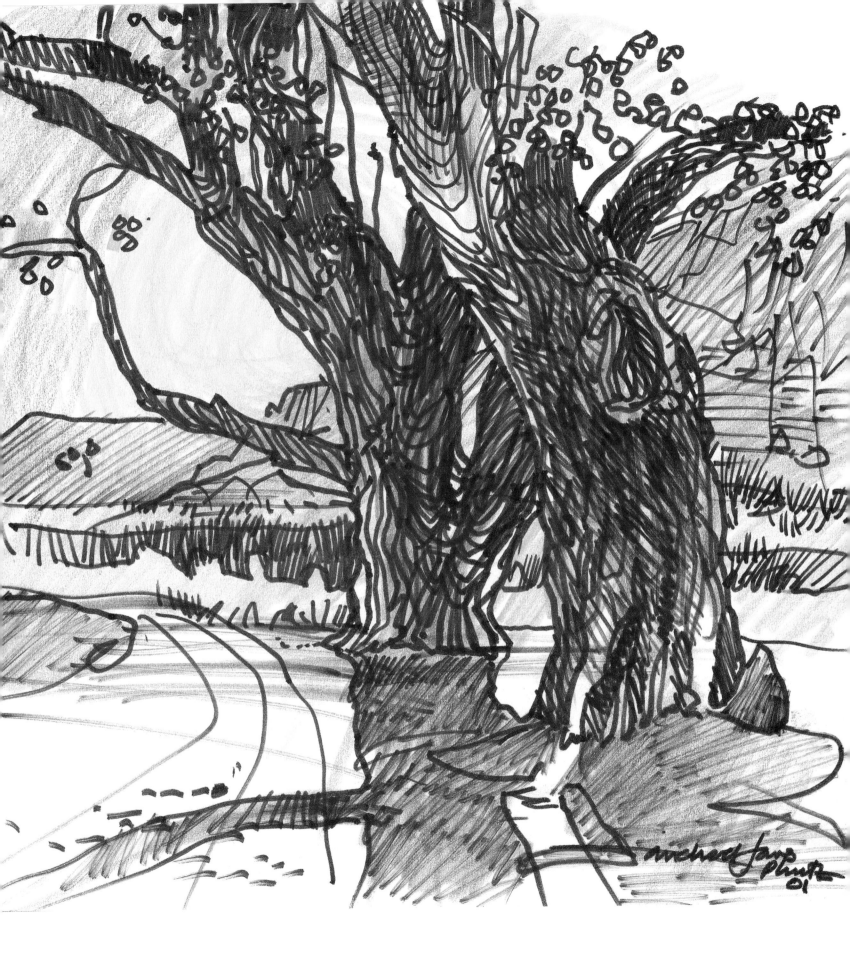

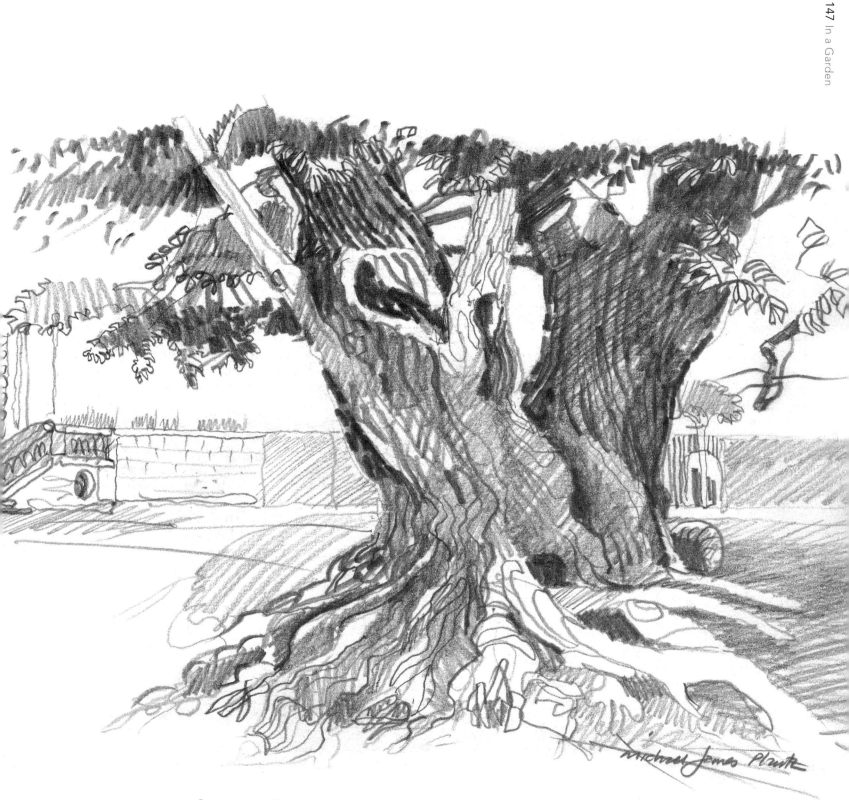

Opposite: Above:

COTTONWOODS TREE, VERSAILLES GARDENS.

BY THE FREMONT RIVER. VERSAILLES, FRANCE.

TORREY, UTAH. 2009. Pencil.

2001. Marker and color pencil.

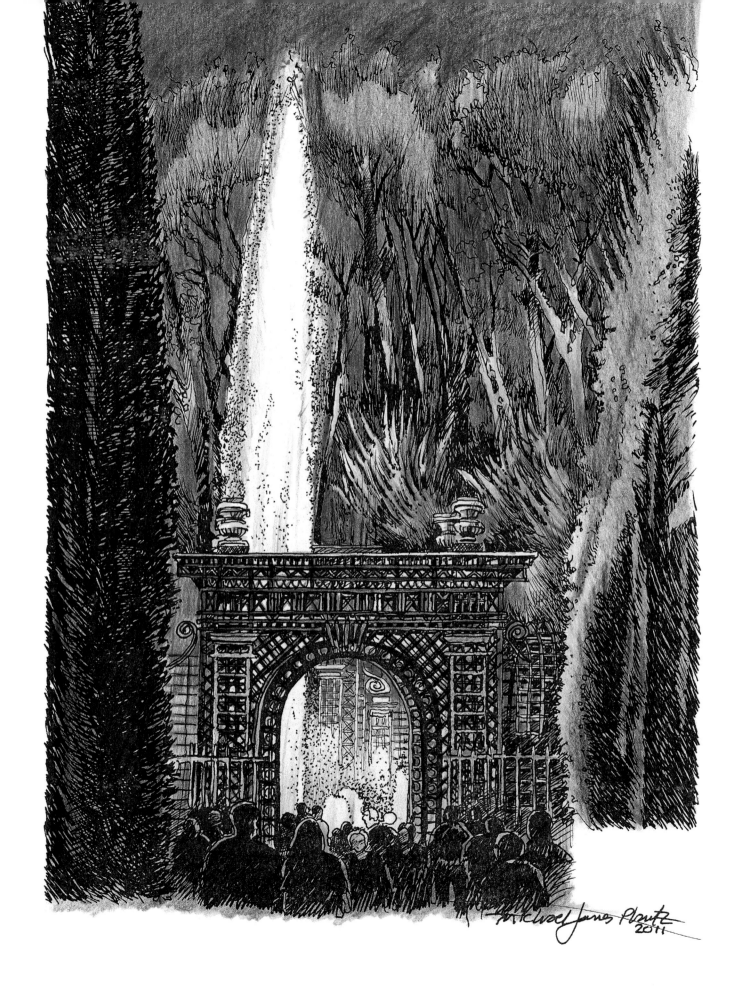

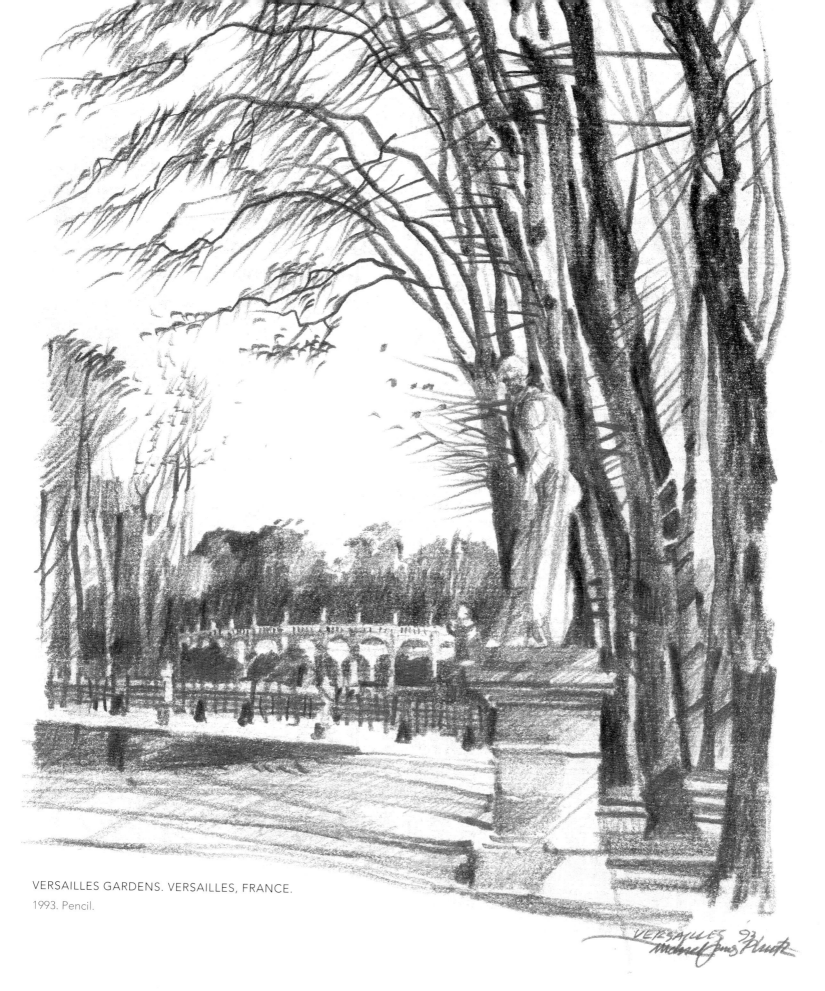

VERSAILLES GARDENS. VERSAILLES, FRANCE.

1993. Pencil.

Eventually, all things merge into one,

and a river runs through it.

—Norman Maclean

8. RIVERS

I love being near or in water; the latter mostly when I am wading for trout or chasing miniature worlds just below the surface with reflections from the sky. Water is the source and the sustainer of life—it is certainly sacred.

I put down my fly rod occasionally and sketch the river and the trout. The water makes a small trout even more beautiful than a larger trout as the density of scales on a smaller trout has more pixels per unit of surface. Each scale is a miniature glass mosaic like the walls and ceilings of St. Mark's in Venice, or Hagia Sophia in Istanbul. Each scale is a perfect example of art and science fused into a coat of many colors, the Fibonacci math captivating my retinas.

Yes, there are the canals of Venice and Strasbourg, the Seine in Paris—chameleons of light and opacity.

Yes, there is the Nile, that ribbon of light splitting the sands of fire and making a green country several miles wide stretched for thousands of miles.

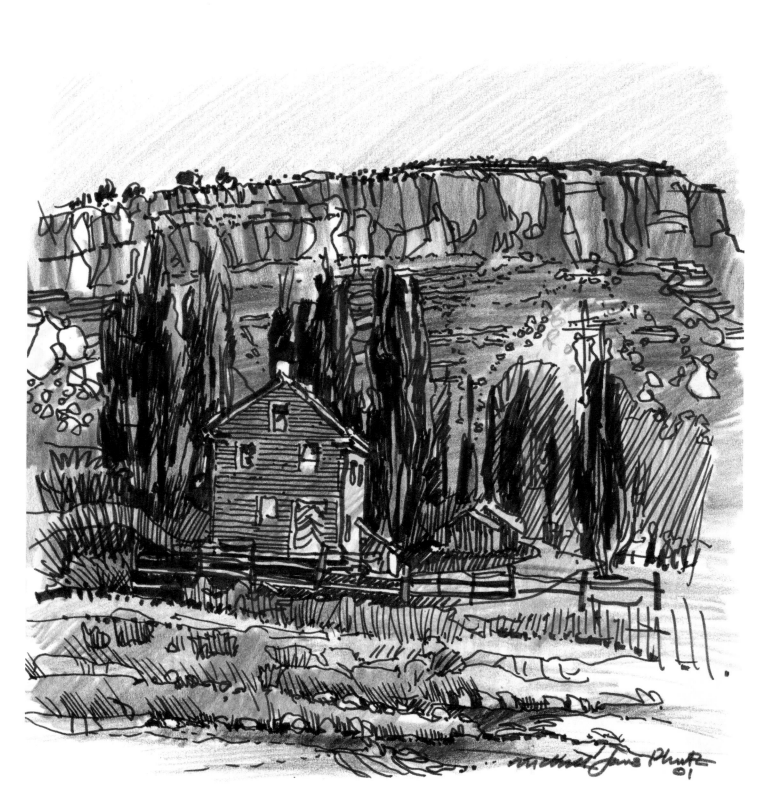

HISTORIC MILL ON THE FREMONT RIVER.

TORREY, UTAH.

2001. Marker and color pencil.

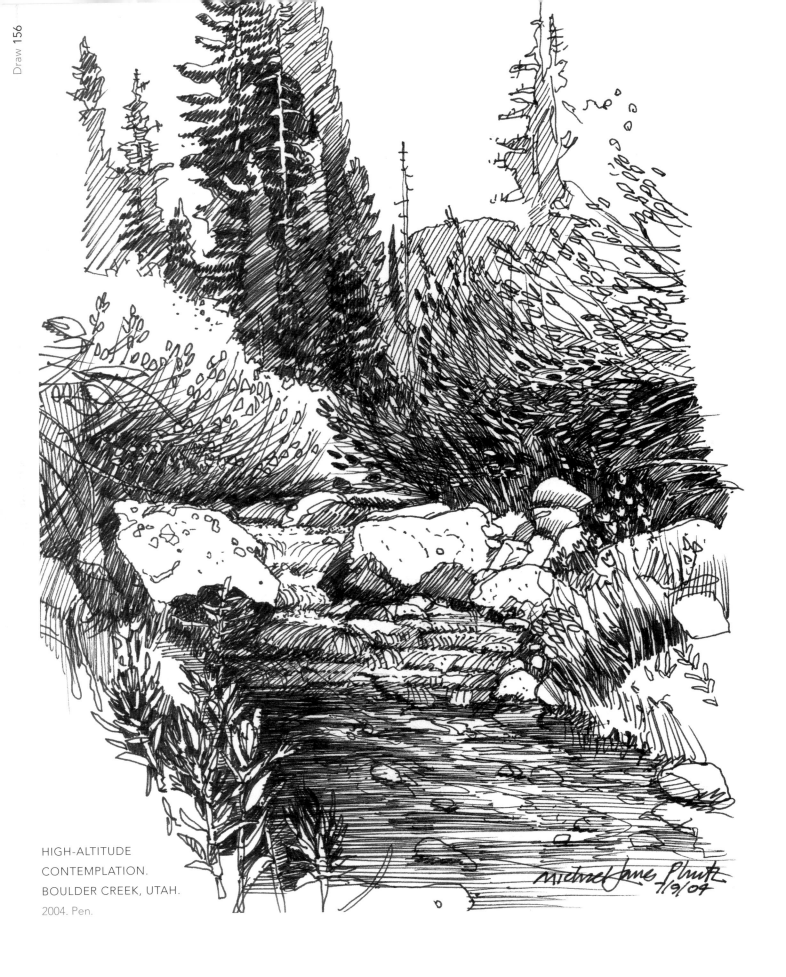

HIGH-ALTITUDE
CONTEMPLATION.
BOULDER CREEK, UTAH.
2004. Pen.

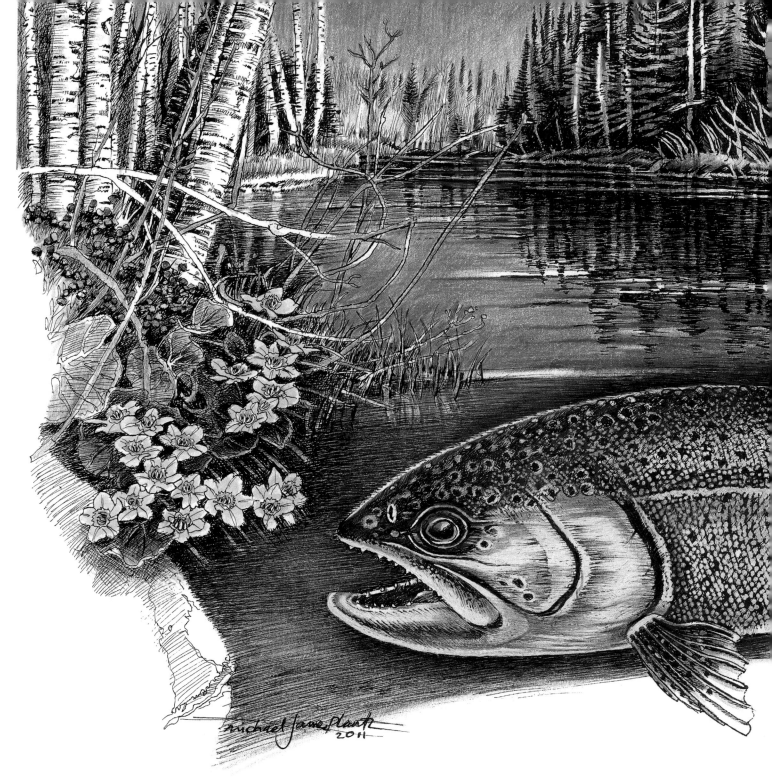

**STEELHEAD
ON THE BRULE RIVER.
WISCONSIN.**

2011. Pen and color pencil.

Solitude on the silver blue river
Spring bursting like a slow pointillist painting
Light,
cold and tempering
framing dots of yellow marsh marigolds
and pinpricks of violet
Delicate green backlit birches,

Silver,
like the ten big steelhead
all female
all spawned out
all safe heading downstream
to the Superior Sea
None for Mrs. Eagle watching me

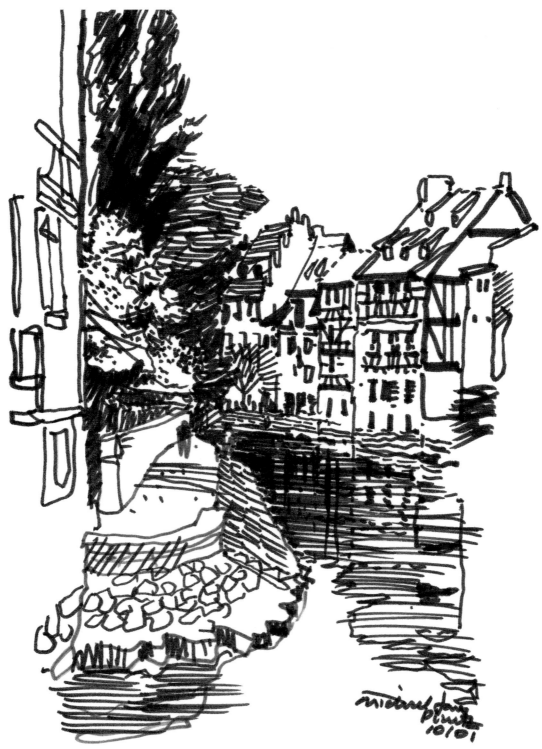

CANAL WITH HOUSES.
STRASBOURG, FRANCE.
2001. Marker.

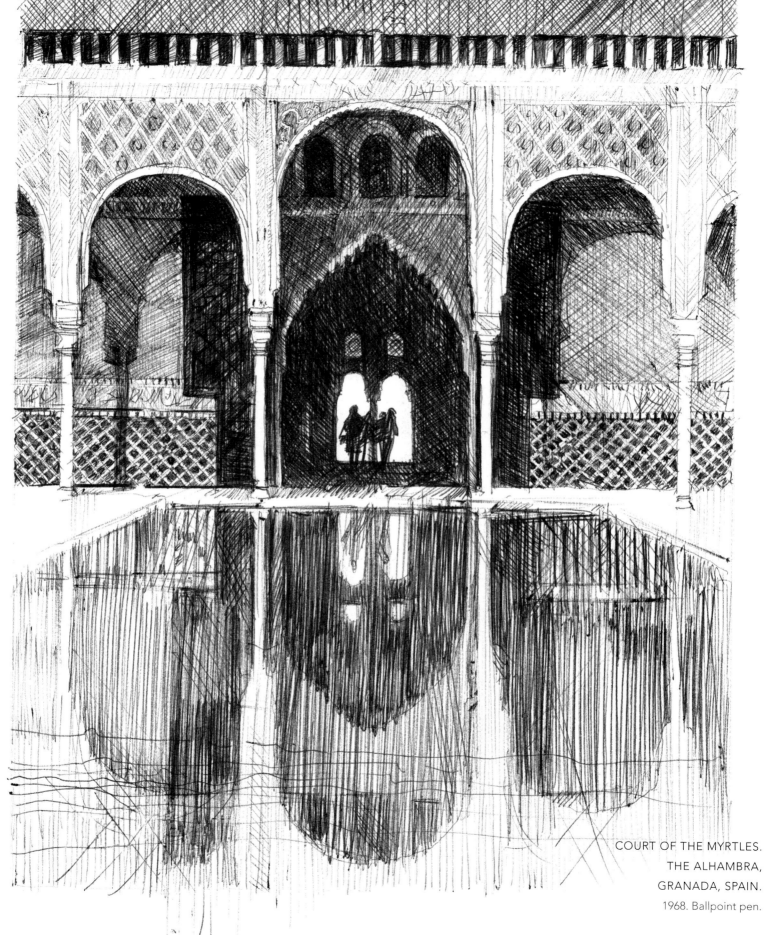

COURT OF THE MYRTLES.
THE ALHAMBRA,
GRANADA, SPAIN.
1968. Ballpoint pen.

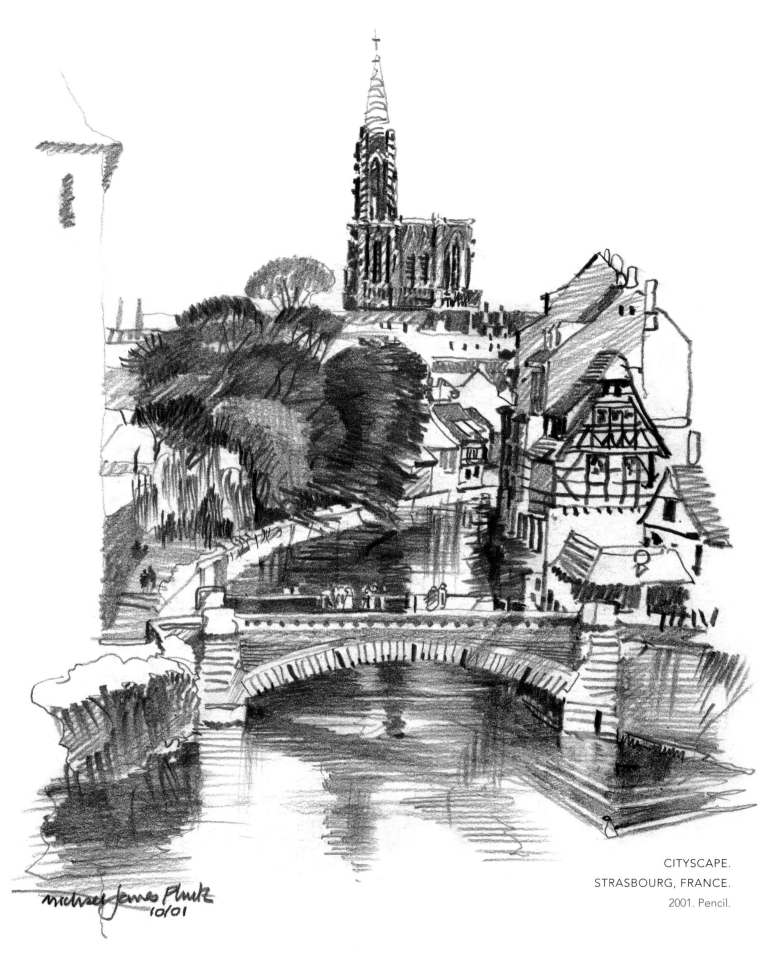

CITYSCAPE.
STRASBOURG, FRANCE.
2001. Pencil.

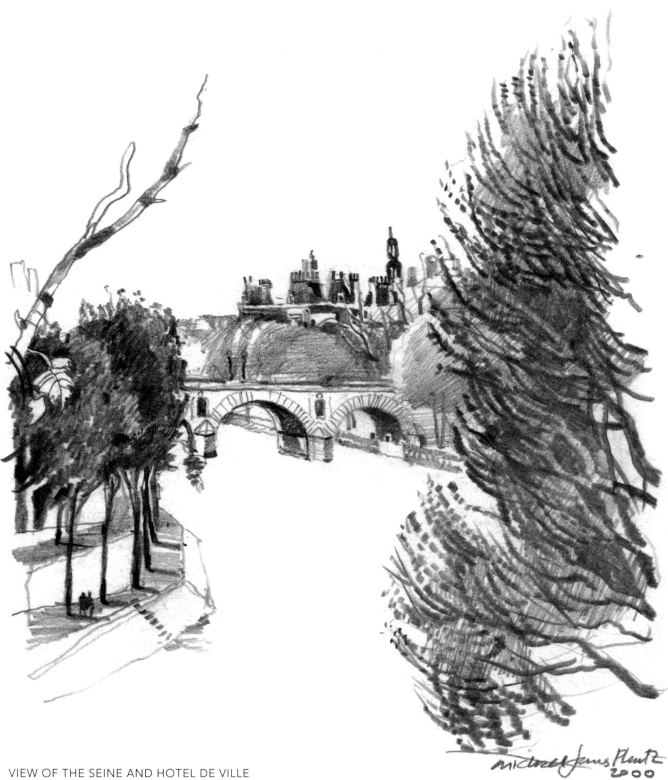

VIEW OF THE SEINE AND HOTEL DE VILLE
FROM APARTMENT ON RUE HENRI IV. PARIS, FRANCE.
2000. Pencil.

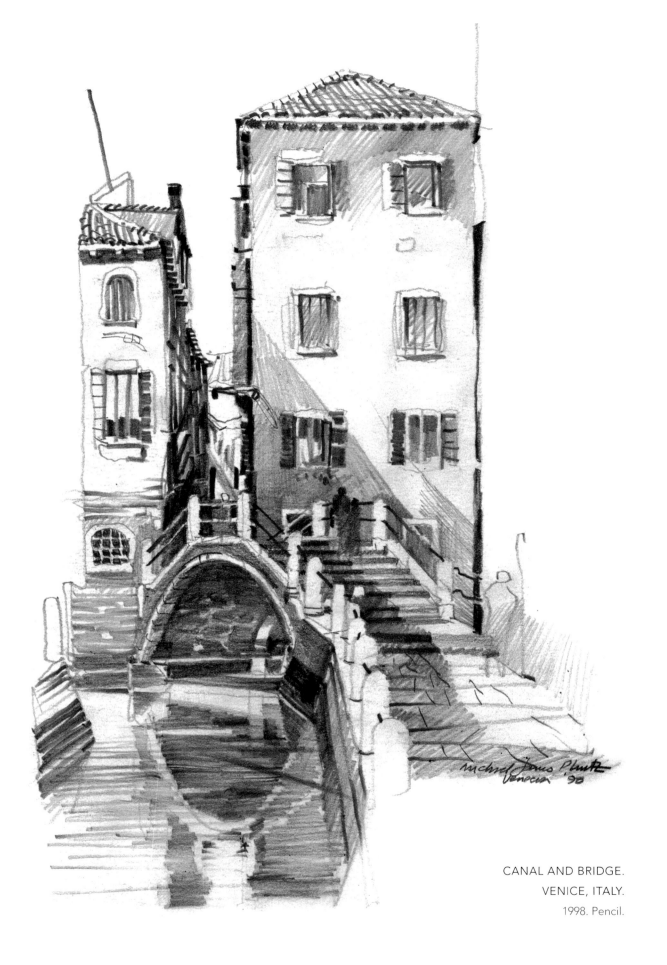

CANAL AND BRIDGE.
VENICE, ITALY.
1998. Pencil.

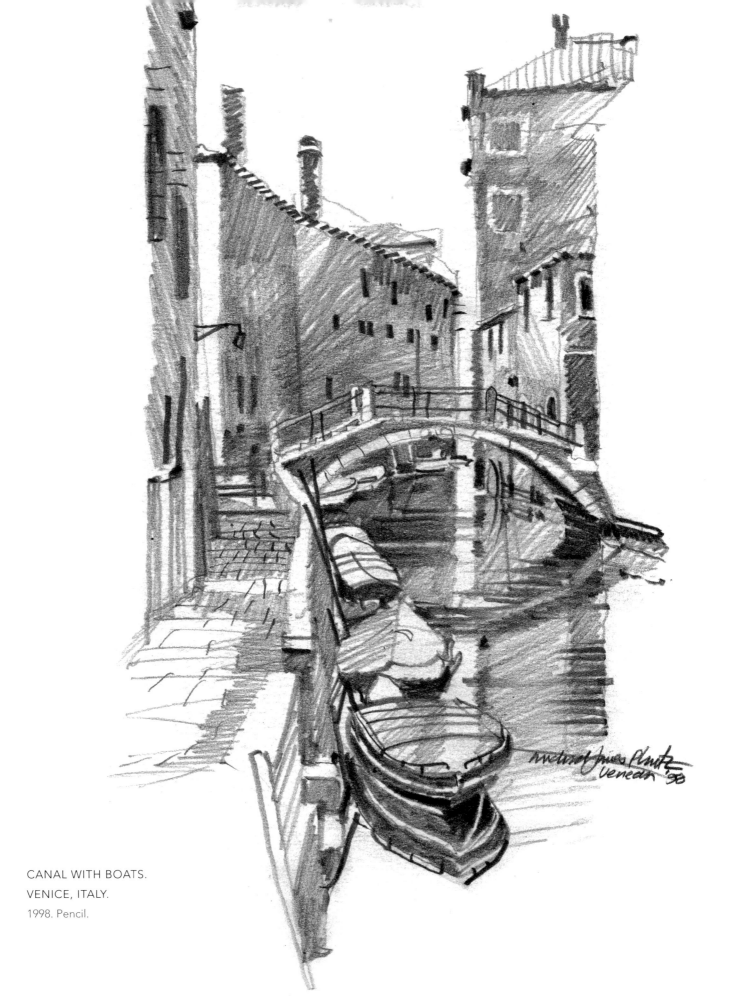

CANAL WITH BOATS.
VENICE, ITALY.
1998. Pencil.

CANAL VIEW TOWARD
SAN GIORGIO MAGGIORE.
VENICE, ITALY.
2008. Pencil.

Opposite:
CANAL VIEW TOWARD
SAN GIORGIO MAGGIORE.
VENICE, ITALY.
2009. Watercolor.

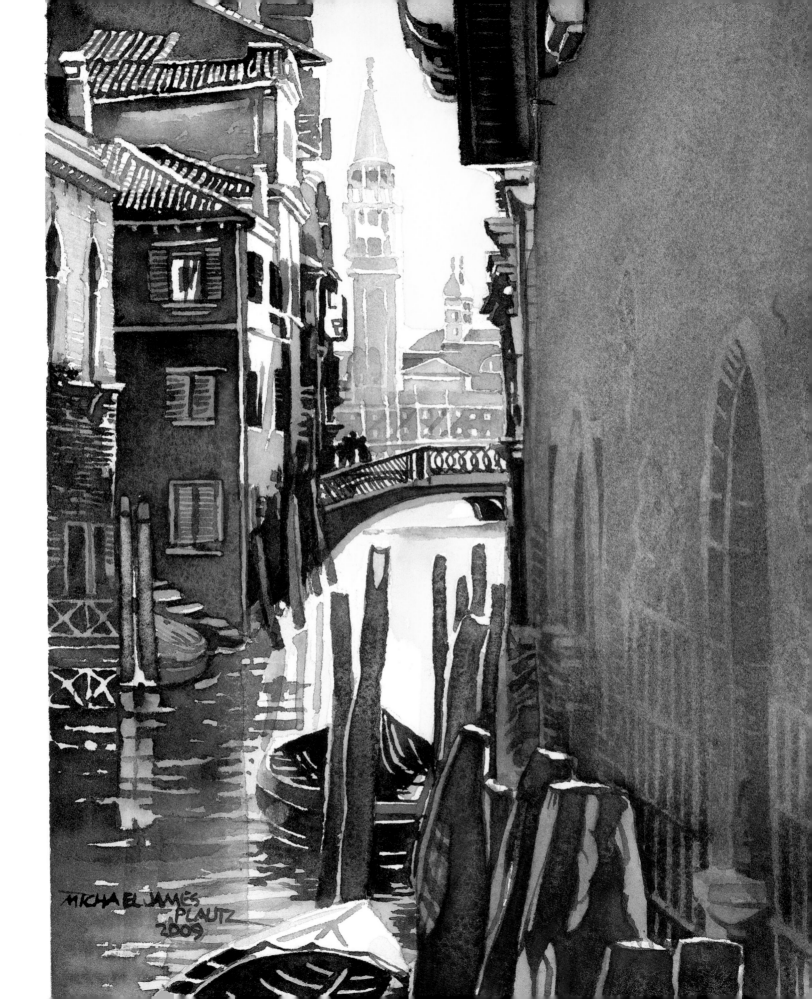

The artist is a receptacle for emotions that come from all over the place: from the sky, from the earth, from a scrap of paper, from a passing shape, from a spider's web.

—Pablo Picasso

9 CREATURES

We are all sacred spaces or have the potential to become sacred in this wonderful connected web within and around us. I seek to draw into significance the gifts we all have and the miracle of creation.

Thus I draw:
the rhythm and power of the spinal torso;
the curve of a breast;
the languid grip of a sloth high in a tree;
a Rwandan mother and her infant;
the intense acuity of an eagle's posture;
the wisdom of elephants;
the ponderous yet delicate shielding by a mother hippo of her baby.

The 1979 edition of the *World Book Dictionary* defines a creature as "any living person or animal; anything *created*; something produced by or developing from something else." The broad-based definition widens its net to creature comforts, "especially wine and food." Shakespeare's words cast the net a bit farther—"Good wine is a good familiar creature." The Bible defends wine as one of earth's creatures in passage 1 of *Timothy 4:4* "Every creature of God is good."

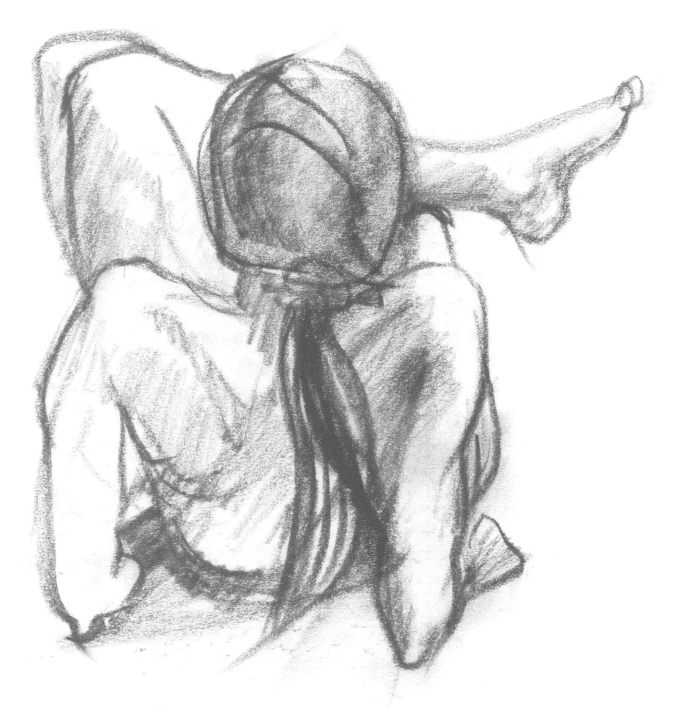

FIGURE STUDY #1.

1995. Conté crayon.

JAZZ FEST SPECTATOR.
JAZZ FESTIVAL,
NEW ORLEANS, LOUISIANA.
2007. Pen.

I believe every molecule of air, every plant, and every handful of loam is a creature—a kind of pantheistic notion of god or God everywhere including in all of us.

In *Genesis* it says that God said to man, "Be fruitful and multiply; fill the earth and subdue it; have dominion over the fish of the sea, over the birds of the air, and every living thing that moves on the earth."

This is an obsolete paradigm—all creatures must teach and learn from each other and evolve simultaneously to a cooperative synthesis so that we don't find ourselves with deadly monocultures, pollution of water and air, alteration of ocean currents, extinction of plants and animals crucial to our mutual survival. The mother of Santa Fe artist Linda Lomahaftewa told Linda to keep drawing the spirits of animals to save them from extinction. I endorse that sentiment.

I can't explain the wondrous mystery of creation and the universe. I ponder with endless curiosity the twin streams of scientific investigations of the limits of the galaxies on the one hand and the gestalt notions of a supreme intelligence, both wanting to stream to a single unified theory.

What I do know is that every particle of me is part of the larger creation. I know that when I am no longer in my current form I will be here: perhaps back as a beautiful but gullible brook trout, a wily and colorful brown trout, and then maybe a tree learning to love carbon dioxide. As a tree, perhaps my journey will resemble that of Baucis and Philemon, the old couple who gave hospitality to Zeus and Hermes in disguise and were rewarded for their humble gifts and granted their wish to live together forever as trees—Gloria a linden tree and me an oak. Perhaps finally we will all become photons of light that make the five-minute trip downward from our sun to the earth and touch the minds of the young Einsteins and Picassos; to Gasindikira, adolescent mountain gorilla and to my granddaughter Zoe, our collective future, in the end all that we really have.

Right:

FIGURE STUDY #2.

2000. Conté crayon.

Far right:

FIGURE STUDY #3.

2000. Conté crayon.

Below:

FIGURE STUDY #4.

2000. Conté crayon.

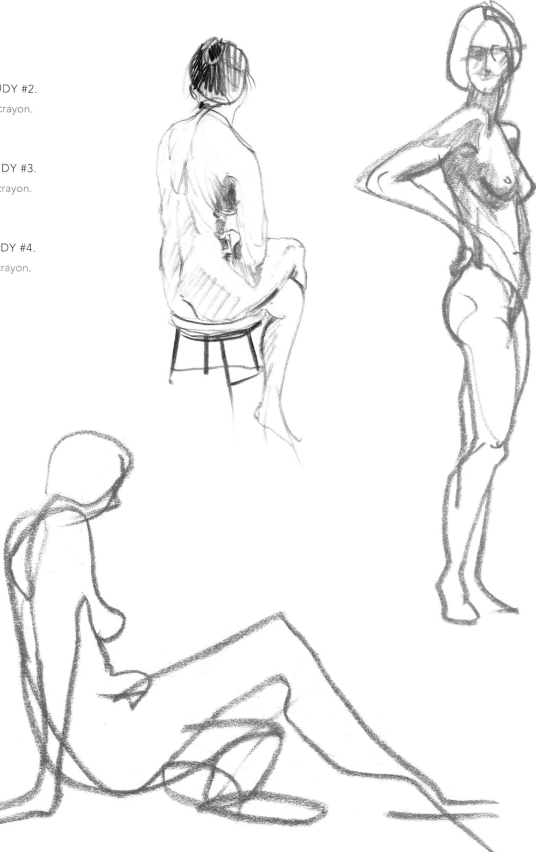

AFRICAN BIRD FOR ZOE'S COLORING BOOK.
QUEEN ELIZABETH PARK, UGANDA,
2011. Pen.

WISE ELEPHANT FOR ZOE'S COLORING BOOK.
QUEEN ELIZABETH PARK, UGANDA,
2011. Pencil.

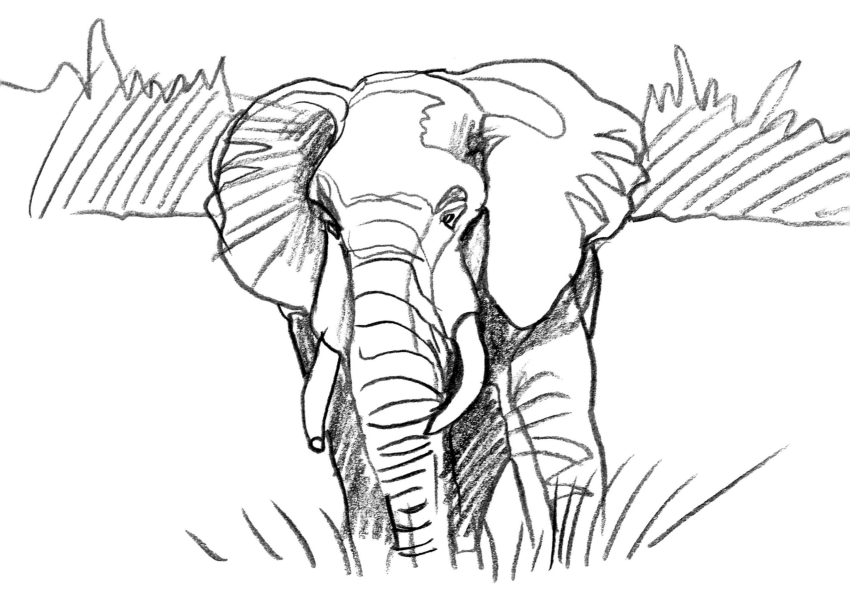

AFRICAN EAGLE FOR ZOE'S COLORING BOOK.
QUEEN ELIZABETH PARK, UGANDA.
2011. Pencil.

MOTHER HIPPO WITH BABY FOR ZOE'S COLORING BOOK.
QUEEN ELIZABETH PARK, UGANDA.
2011. Pencil and color pencil.

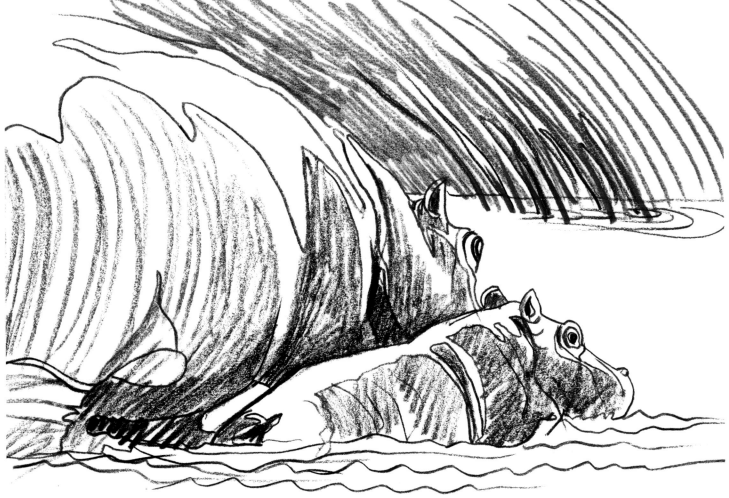

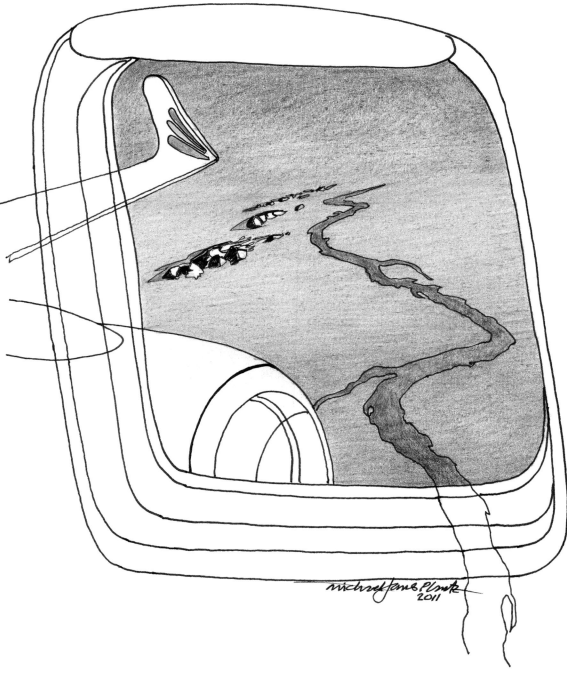

Dawn over the Sudan. En route to Kigali, Rwanda. The headwaters of the Nile reflect seamlessly into the red/blue canvas outside our Ethiopian Airlines window.

The Great Rift begins
first light
a standing seam of
infinitely subtle emerging basalt
water and fire
the Nile pushing through sand
dusting ancient tracks
to
homo sapiens
to
our ancient grandmere
Lucy
our legacy

OVER THE NILE.

2011. Pen and color pencil.

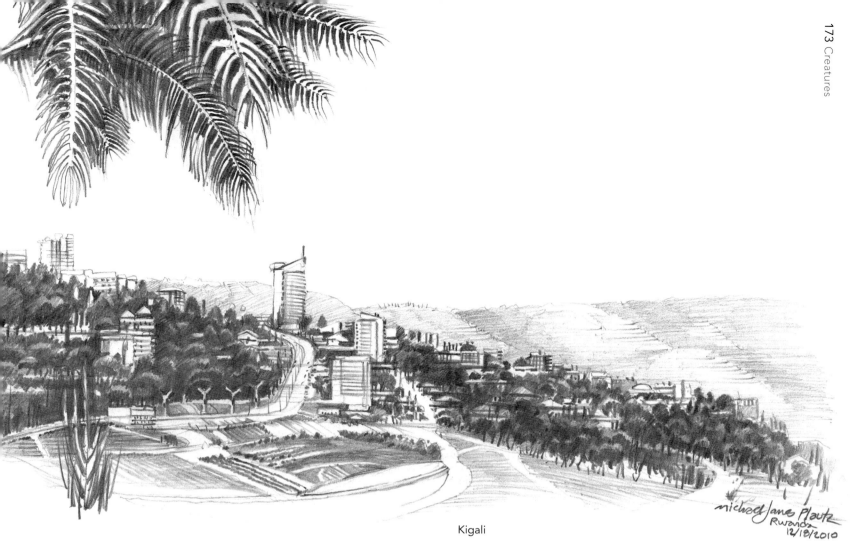

Kigali

KIGALI FROM ANDREA, SCOTT,
ZOE AND STELLA'S HOUSE. RWANDA.
2010. Pencil.

Fields in the city
Blue glass reflections, tin roofs
Two million brown eyes

Faces everywhere
Beautiful chocolate
Dusty rivers wait

Kigali tee shirt
ICH BIN 30 [in 2010]
Pas possible en 1994

Loaded heads up hills
Red dress, green motos press down
Stalemate to nowhere

Bright saris shopping
Beggar girl with sister baby
Golden Mercedes

Gloria and I set off to visit the mountain gorillas in the Volcanoes National Park in western Rwanda. The park bridges the Congo as well as Uganda and, according to the 2004 census, it is the home of approximately 700 endangered mountain gorillas. Rwanda has a vigorous protection and viewing program. We arrived at the park headquarters and were organized into groups of six visitors with two guide/trackers plus two armed soldiers to protect the gorillas from poachers. We were driven to a trailhead to hike into the park and seek out group thirteen, which has twenty-five members, led by one silverback. We started off single file, guards front and rear, walking . . .

. . . through potato fields, past the thatched compound with the larger king's round dwelling with smaller ones traditionally the spaces for the wives, all with a fence around with two openings, past . . .

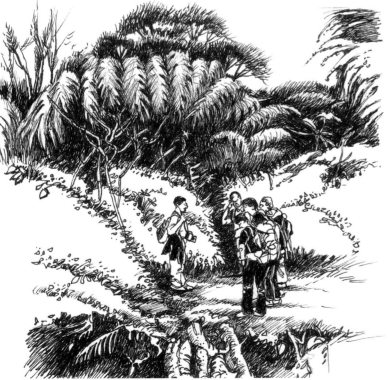

. . . farm structures made of poles and in-filled with clay and mud and twigs. We also passed rock walls and stands of bamboo on our way to the volcanic mountains and mists beyond.

We finally crossed from the potato fields to the jungle via a low stone wall and log bridge over a creek. There, our two guides began communicating with a tracker who was already ahead of us monitoring the location of group thirteen. We could already hear the tracker's voice "talking" to the gorilla group, and our guide began to lead our small group toward them through the thick underbrush, high canopy, and bamboo.

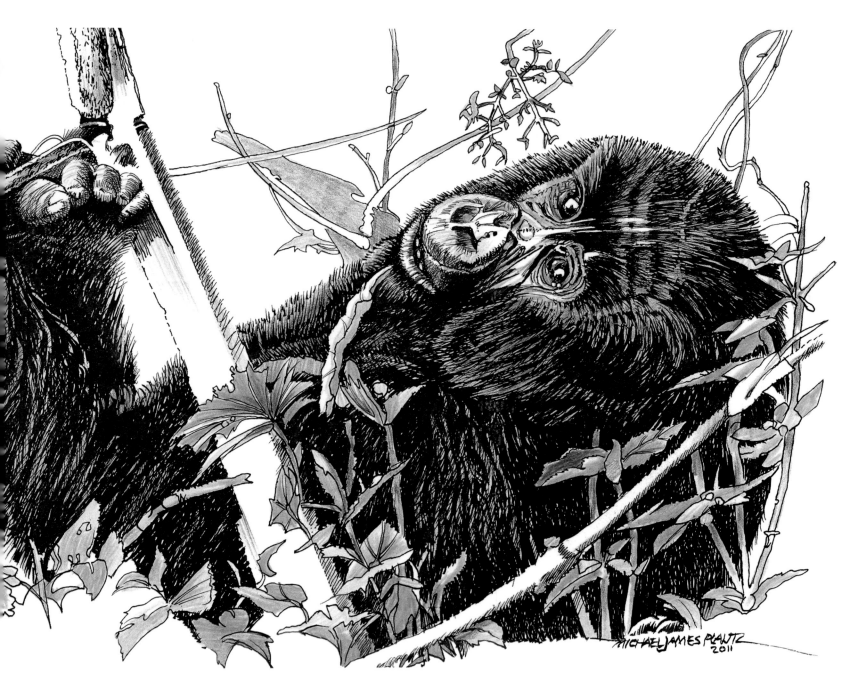

After about a thirty-minute hike there they were! The silverback quickly decided that we were no threat and we had a precise hour in their presence, watching youngsters and adolescents play and tussle, eat bamboo, and rest. A most profound encounter. Eye-to-eye and face-to-face, the kinship between our two species is undeniable and incredibly moving. When our sixty minutes were up, the silverback rose, tore down some bamboo, and started down the steep slope. In thirty seconds, the entire group evaporated into the brush.

GASINDIKIRA, ADOLESCENT MOUNTAIN GORILLA EATING BAMBOO. RWANDA.
2011. Pen and color pencil.

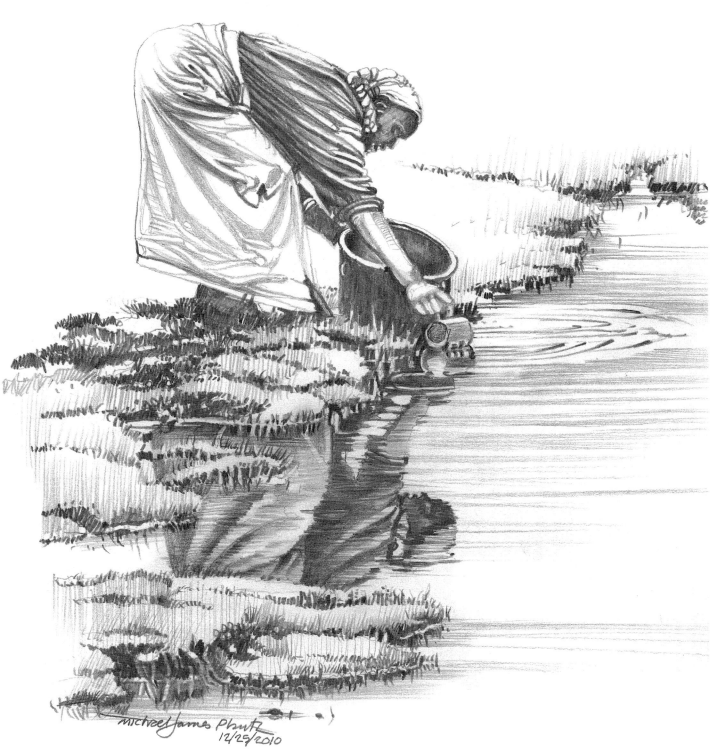

WOMAN IN FIELD
WITH RED CUP. DRAWING
MADE WHILE EN ROUTE TO
GORILLA TREK. RWANDA.
2010. Pencil.

We retraced our steps, back across the farms with men and women with hand tools shaping long furrows and tending grazing cattle. I glanced back and saw this woman with a red cup collecting water for her cooking pot from a rain puddle in the field. This strong, capable woman is my last memory of that day, a powerful symbol of the resilience of this country which has known such grief yet holds such promise.

Whether in sea or fire, in earth or air,

The extravagant and erring spirit hies

To his confine.

—William Shakespeare

10 HILL TOWNS

In its purest form, a hill town is a metaphor for perfect living: enough density for social intercourse and diversity, security, proximity to stimulation; enough mass for identity; a nature's edge for relief and contemplation; and small enough to be beautiful. Today's "electronic village" seems to aspire to possess the virtues that have existed for centuries in a hill town. The physical attributes of place are desperately needed to ground our increasingly virtual world.

Exploring hill towns to sketch with my students is pure joy—each new hill town stalked with great anticipation, my pencil lusting for the organic forms, the whole, the composition of parts, the overall silhouette. Once inside, each city is a laboratory of imageability—the walking streets, the squares and gathering spaces large and small, the materials and colors, the textures, the new compositions around the bend, the sounds of footsteps.

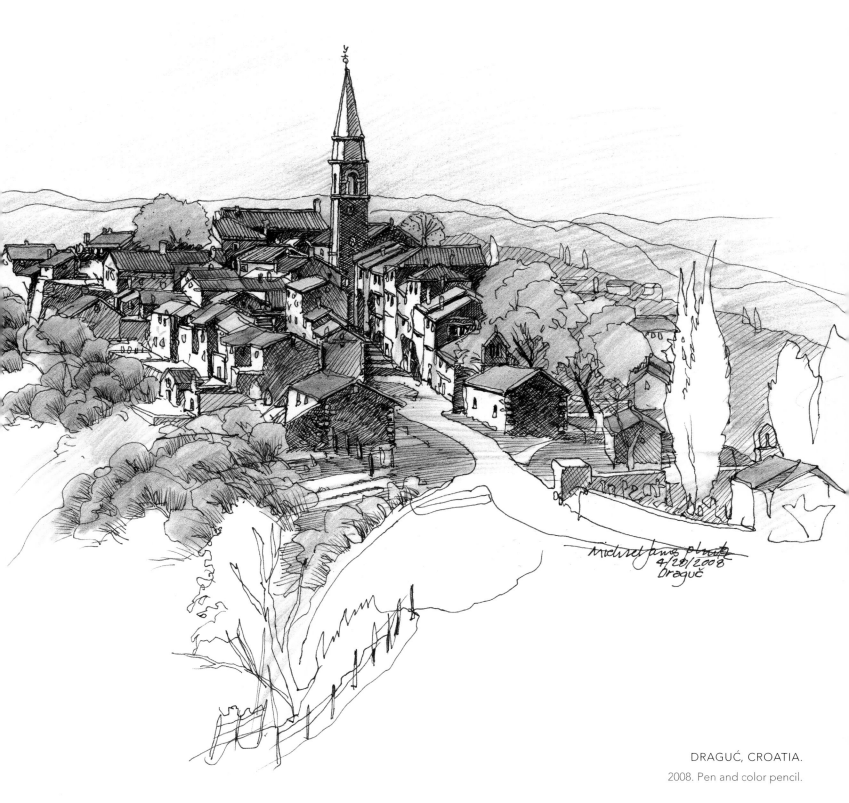

DRAGUĆ, CROATIA.

2008. Pen and color pencil.

CAMPO. SIENA, ITALY.

1991. Charcoal.

I was born to chase light and hill towns;

the sienas and umbers of Tuscany and Umbria;

the golden stones of Provence;

the white cubist sugar crystals of Mykonos and Patmos;

the sun-drenched villages of Andalusia;

the lemon-shrouded slopes of the Amalfi Coast;

the terraced hillsides of Rwanda and its capital, Kigali;

the reverent stones and clay of Southwest cliff dwellings of Bandelier,

Gila, Chaco Canyon, and Mesa Verde.

Did I live in all of these once before?

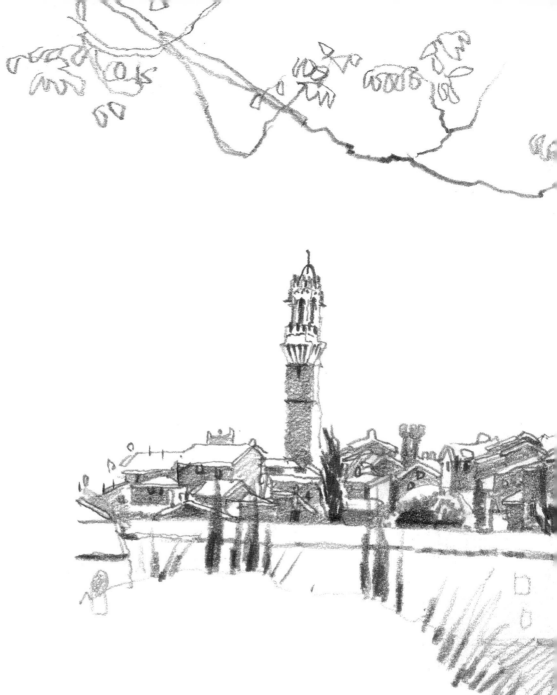

SIENA, ITALY.
2005. Pencil.

Siena, Italy. History and symbol manifest in the main plaza. The Piazza del Campo is the conch-shaped organic living room of the entire town. The Campo's seventeen sloping pie-shaped floor segments at the foot of the bell tower are the site of the famous twice-annual horse race, *Il Pàlio di Siena*, which has been run in some form since the sixteenth century. The race is a stage set symbolic of ten of Siena's seventeen neighborhoods, or *contrada*, each of which is represented by a horse and rider frothing to claim first place with a raucous and dangerous ninety-second ride. The rest of the year the Piazza is a daily kaleidoscope of humanity spinning the soul of a city. Siena is a cohesive whole of unity and diversity, deconstructible into endless spatial layers, a home for the *passeggiàta*, neighbors in their daily evening promenade, a feast for the senses. There is much to learn here.

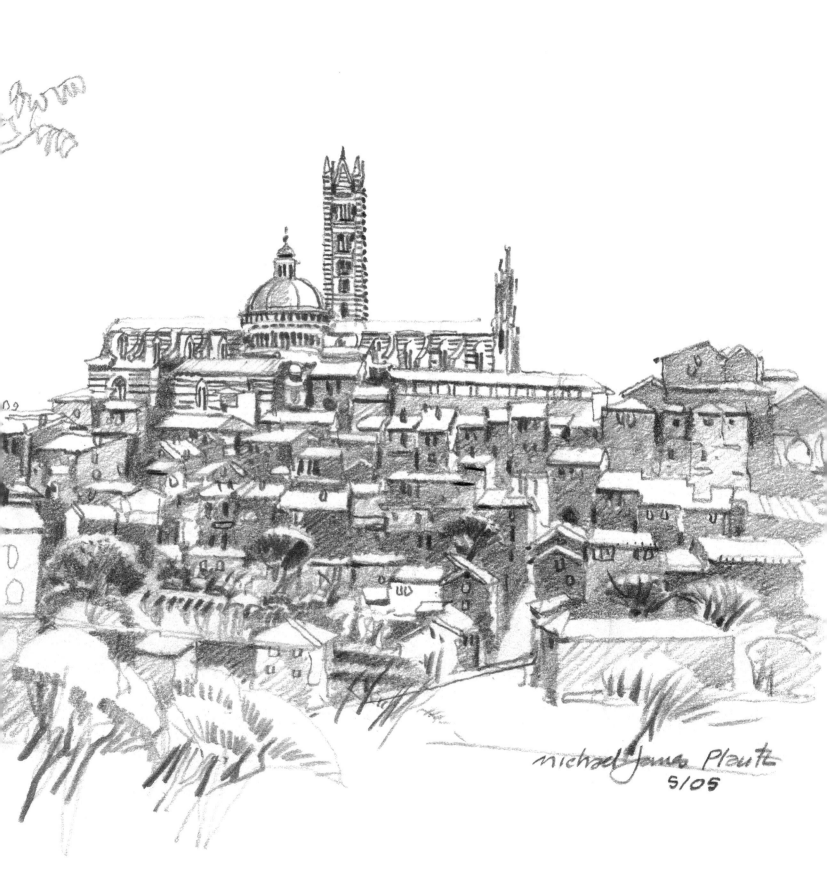

michael James Plautz
5/05

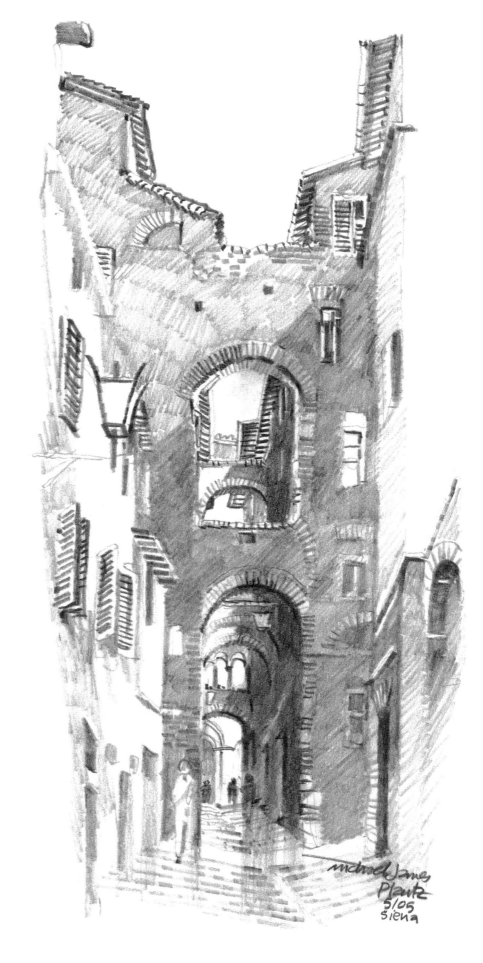

ARCHED STREET LOOKING UP.
SIENA, ITALY.
2005. Pencil.

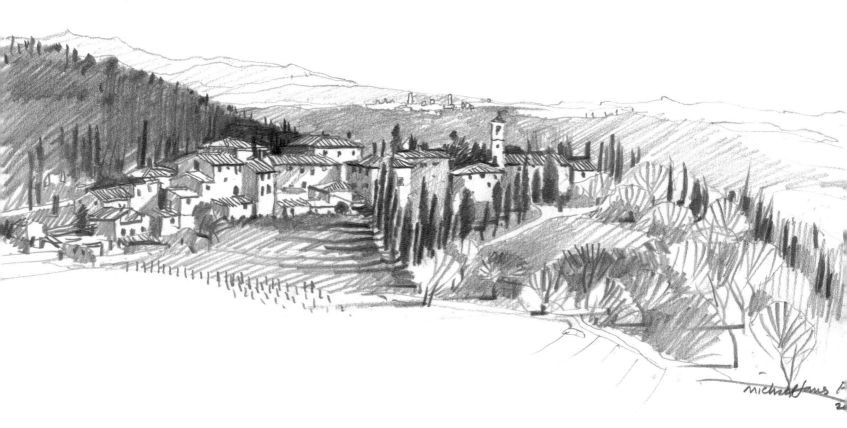

CONSIGNANO TOWN, WITH SIENA IN THE DISTANCE.

2001. Pencil.

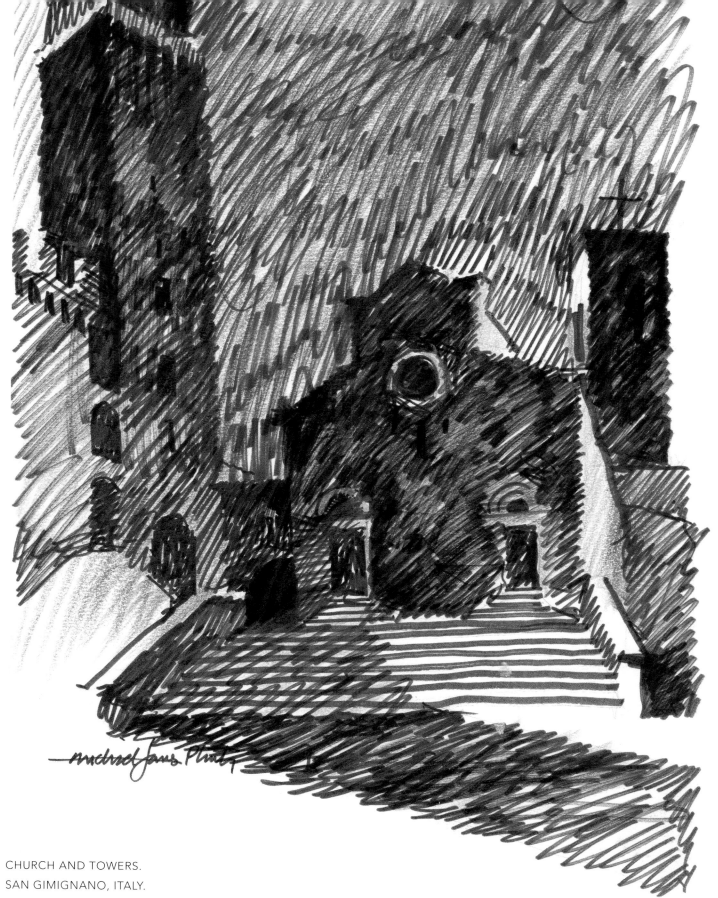

CHURCH AND TOWERS.
SAN GIMIGNANO, ITALY.
1984. Marker and color pencil.

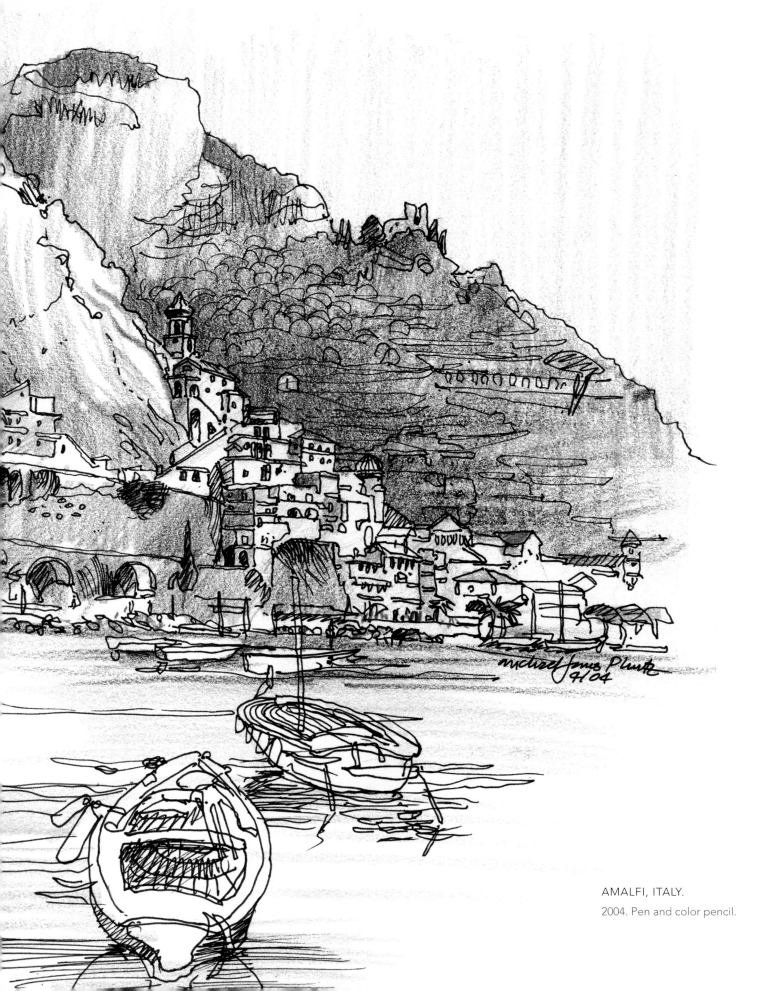

AMALFI, ITALY.

2004. Pen and color pencil.

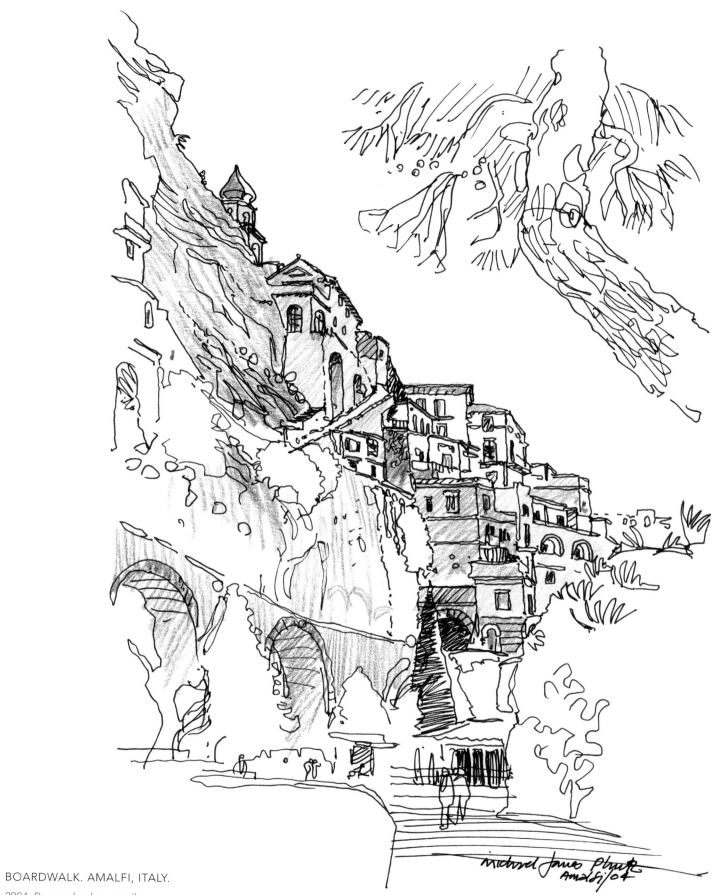

BOARDWALK. AMALFI, ITALY.

2004. Pen and color pencil.

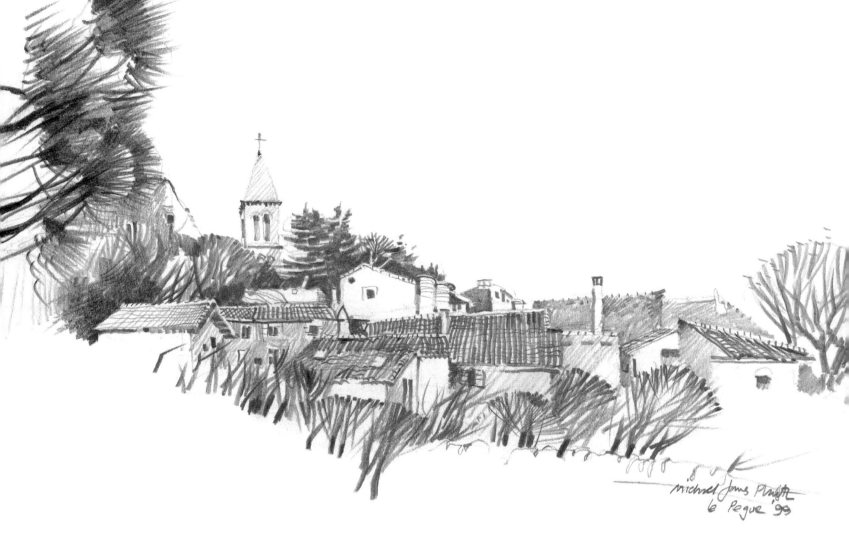

LE PÈGUE. DRÔME, FRANCE.

1999. Pencil.

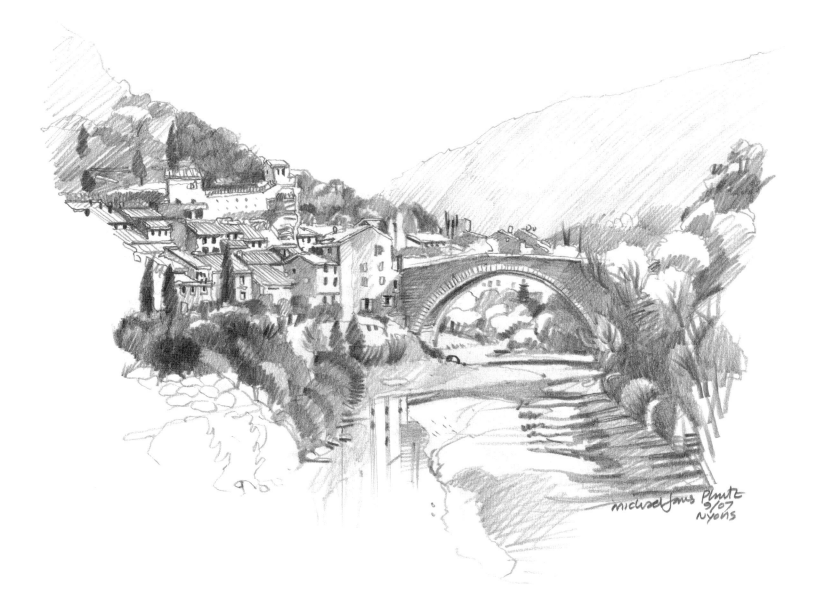

NYONS. DRÔME, FRANCE.

2007. Pencil.

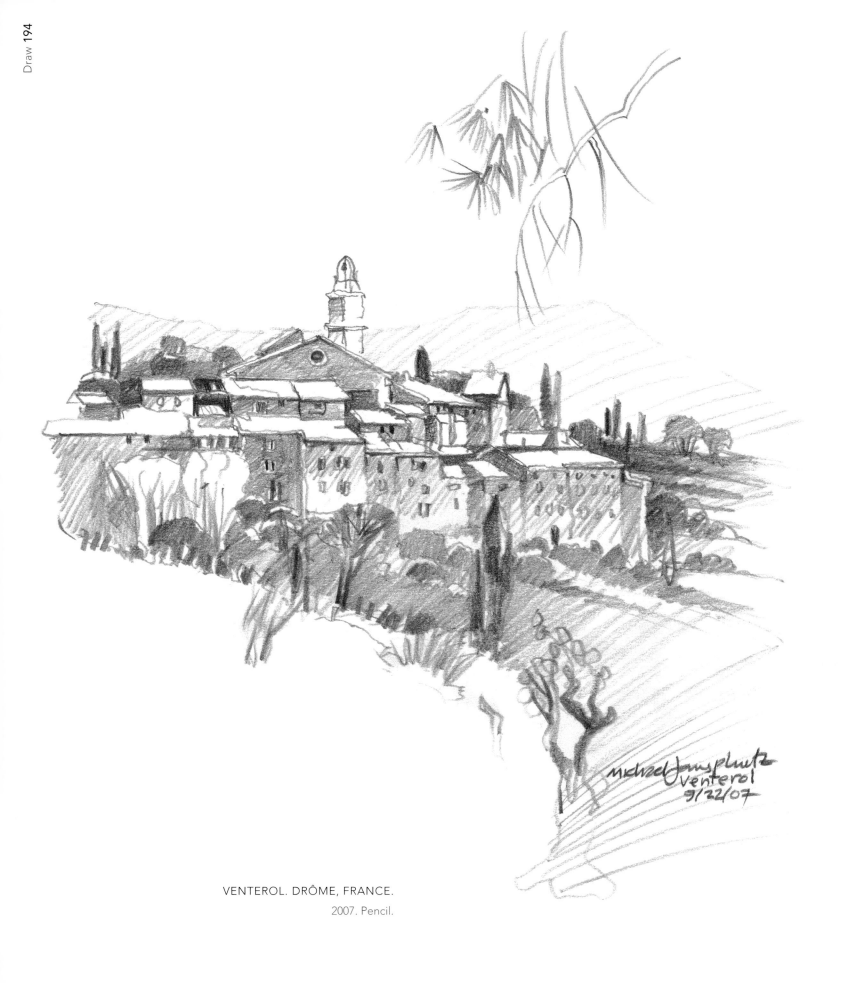

VENTEROL. DRÔME, FRANCE.

2007. Pencil.

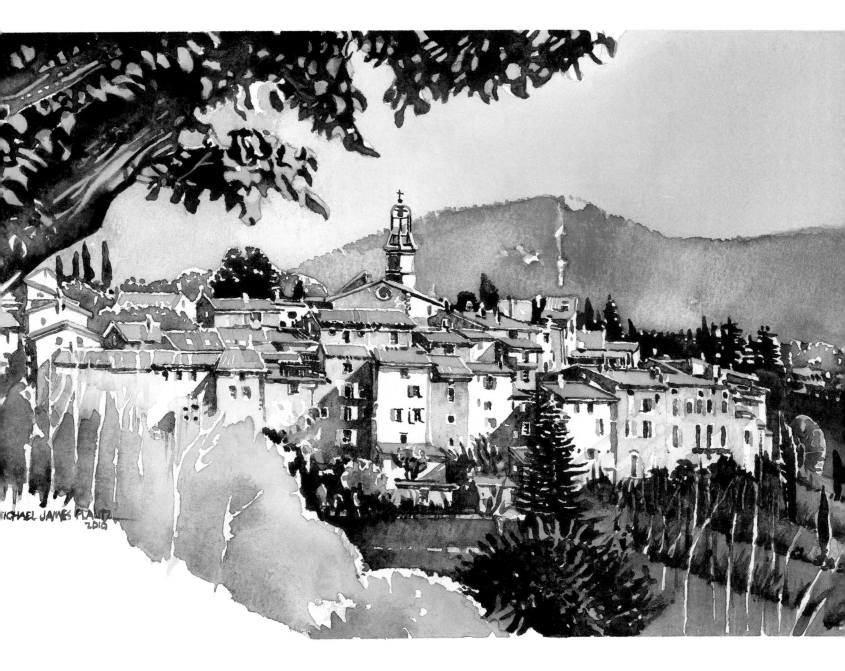

VENTEROL. DRÔME, FRANCE.

2010. Watercolor.

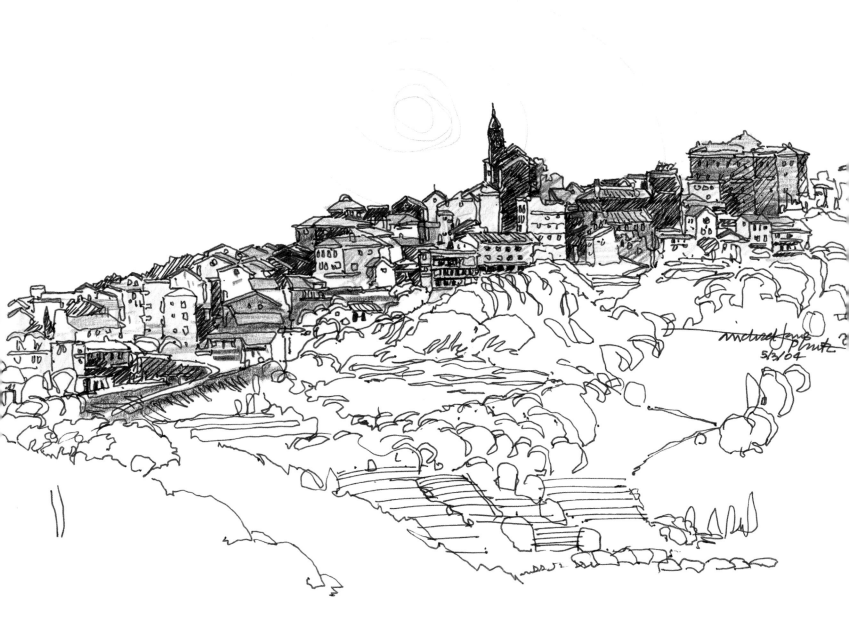

GENZANO. NEAR ROME, ITALY.

2004. Pen and color pencil.

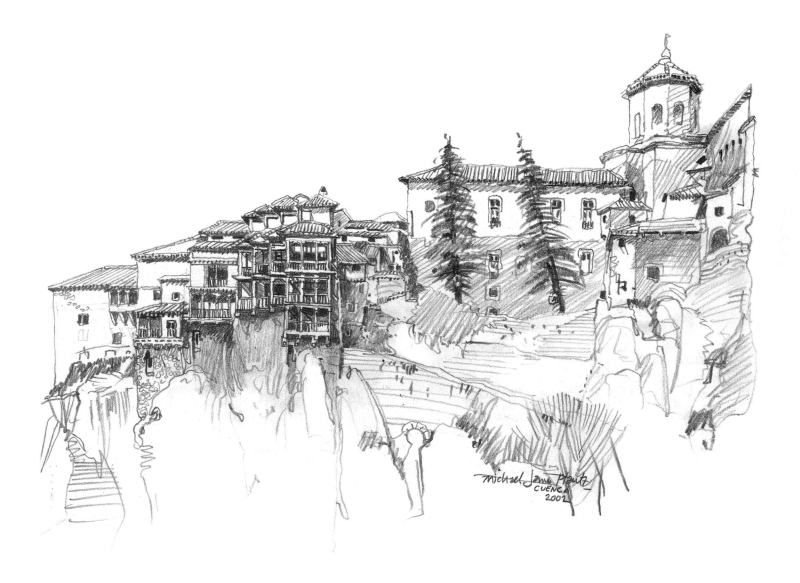

CUENCA, SPAIN.

2002. Pencil.

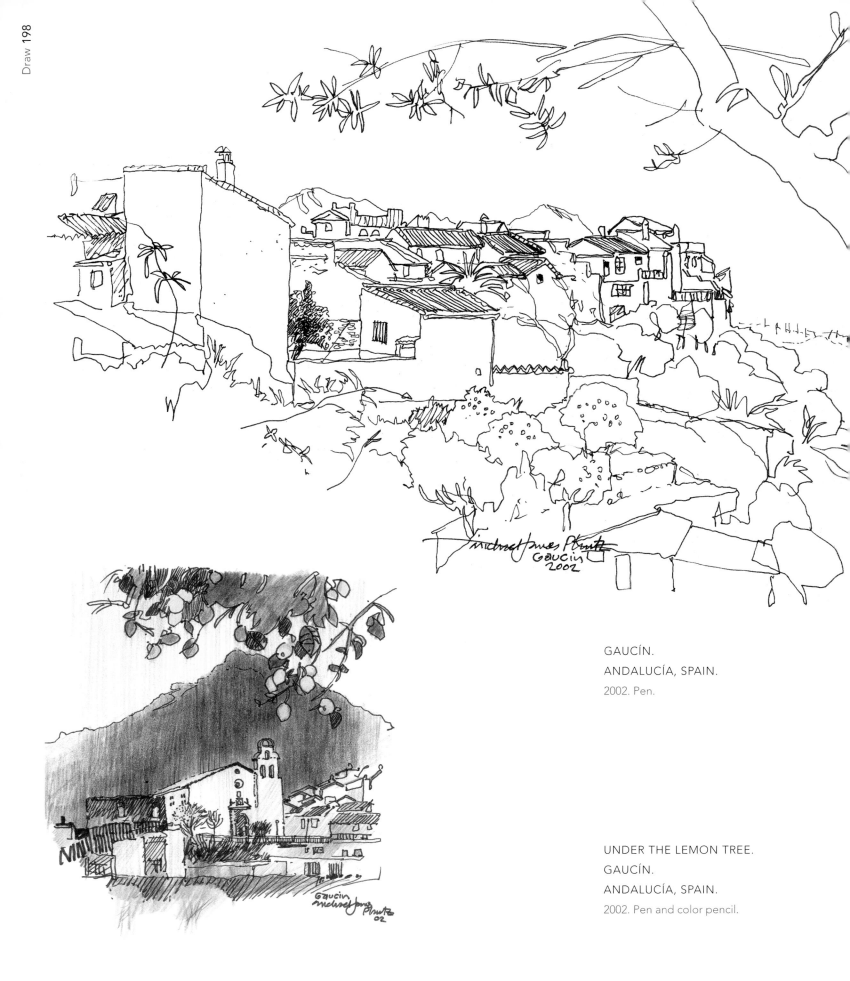

GAUCÍN.
ANDALUCÍA, SPAIN.
2002. Pen.

UNDER THE LEMON TREE.
GAUCÍN.
ANDALUCÍA, SPAIN.
2002. Pen and color pencil.

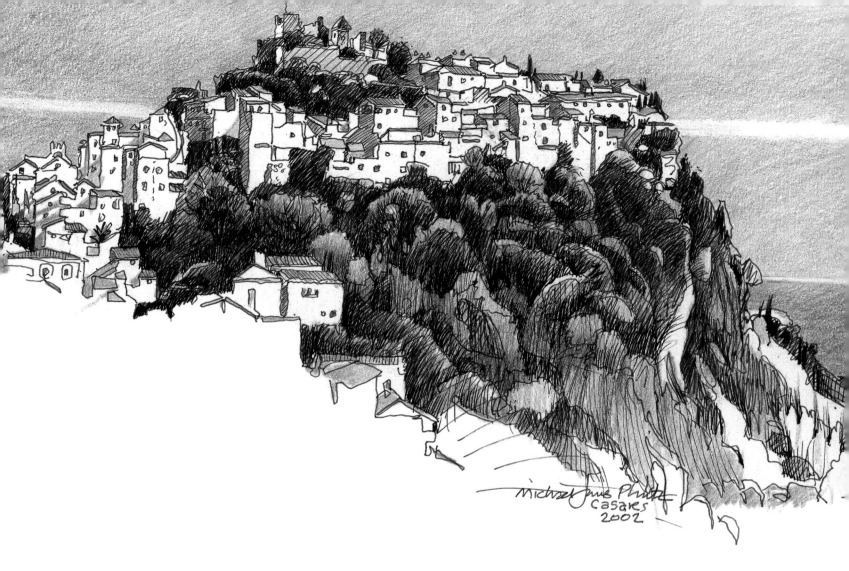

CASARES, SPAIN.

2002. Pen and color pencil.

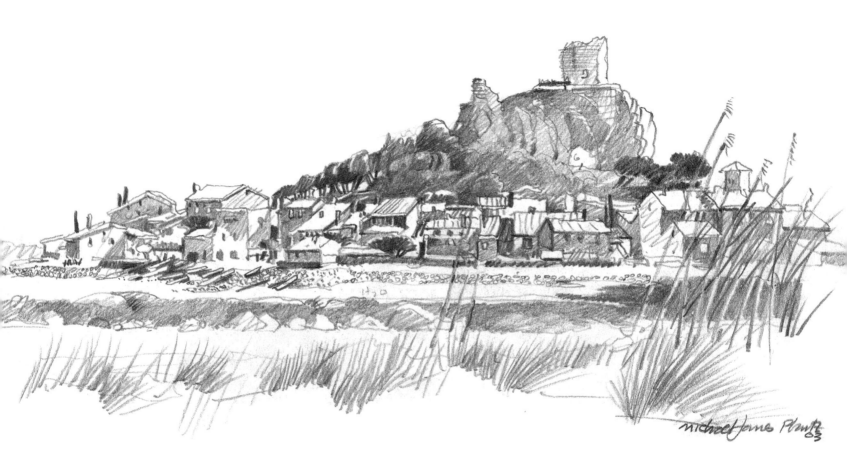

SÈTE, FRANCE.

2003. Pencil.

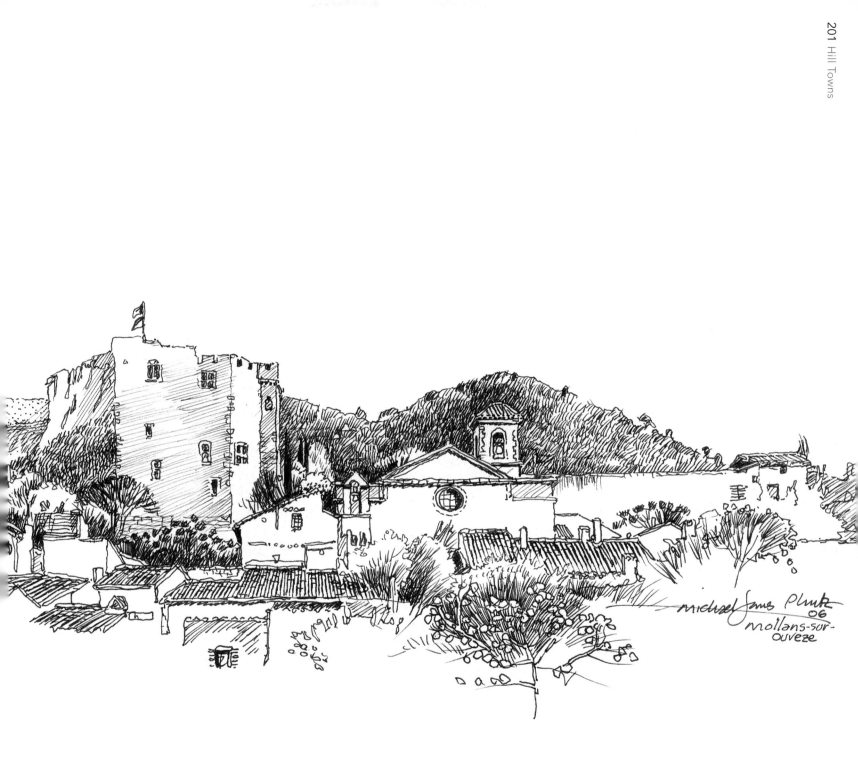

MOLLANS-SUR-OUVÈZE. FRANCE,
2006. Pen.

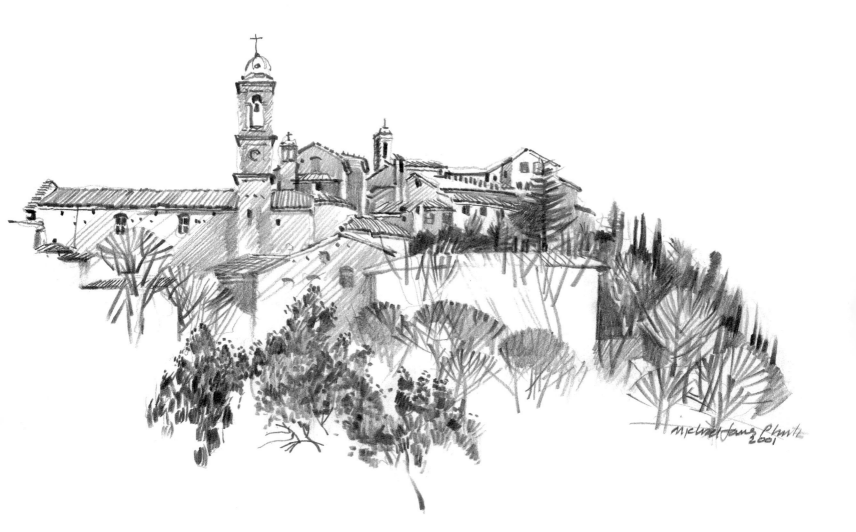

MONTEPULCIANO, ITALY.

2001. Pencil.

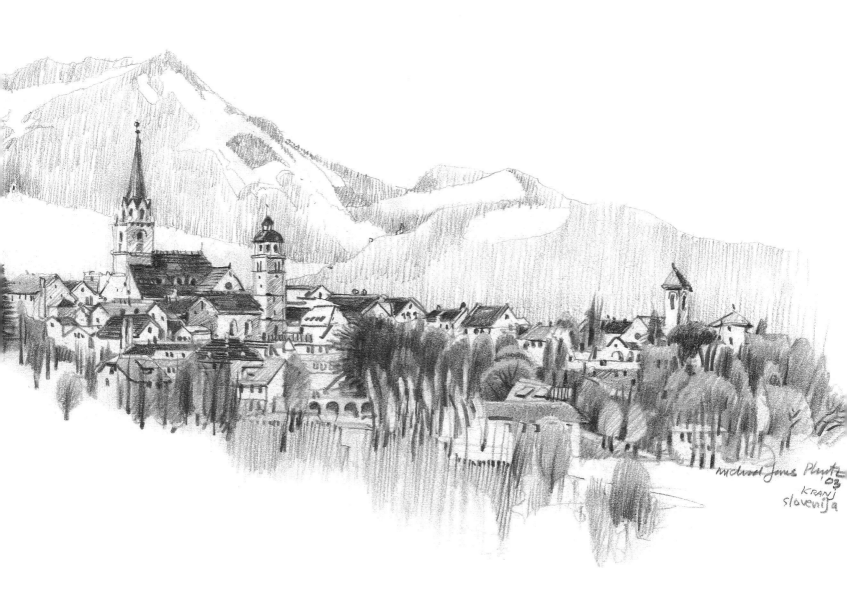

KRANJ, SLOVENIA.

2003. Pencil.

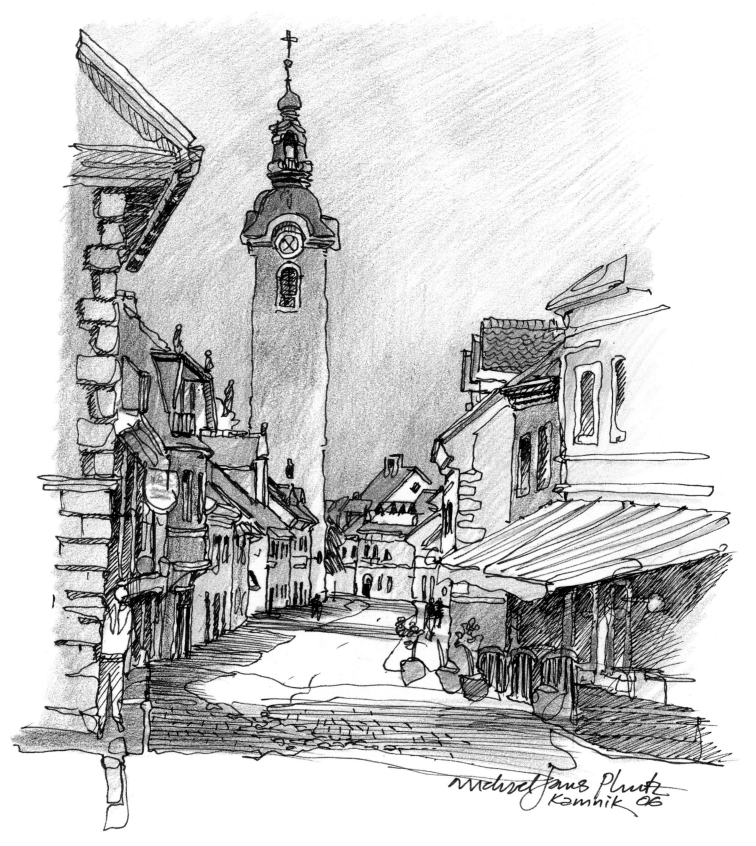

WALKING STREET. KAMNIK, SLOVENIA.

2006. Pen and color pencil.

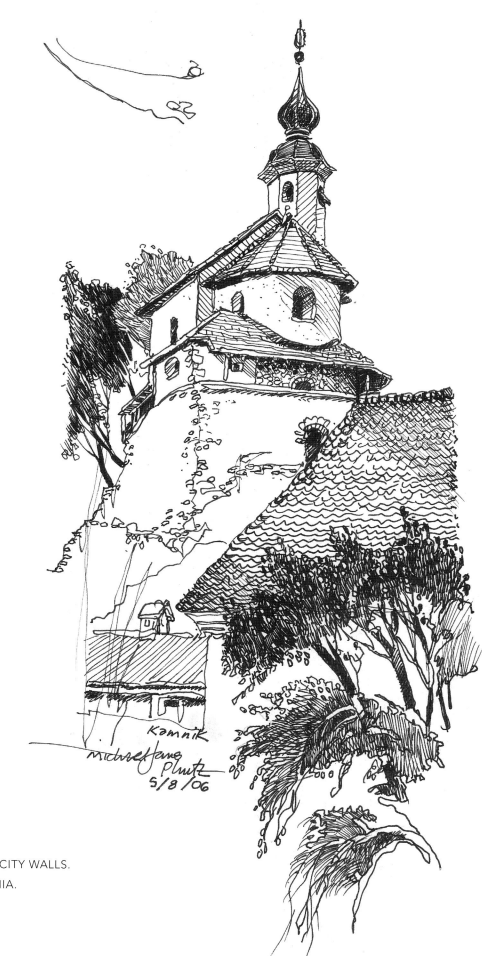

Kamnik

CHURCH ABOVE CITY WALLS.
KAMNIK, SLOVENIA.
2006. Pen.

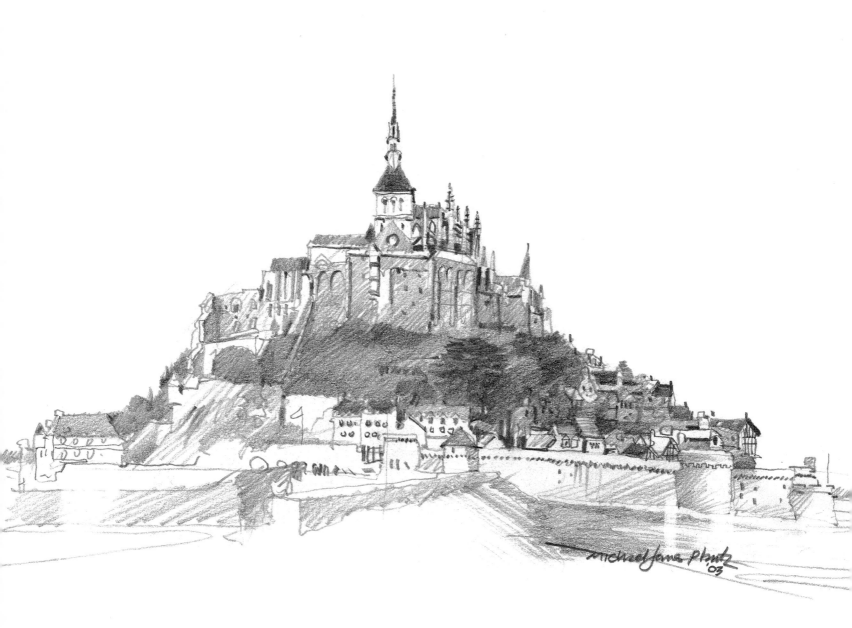

MONT ST. MICHEL. FRANCE.

2003. Pencil.

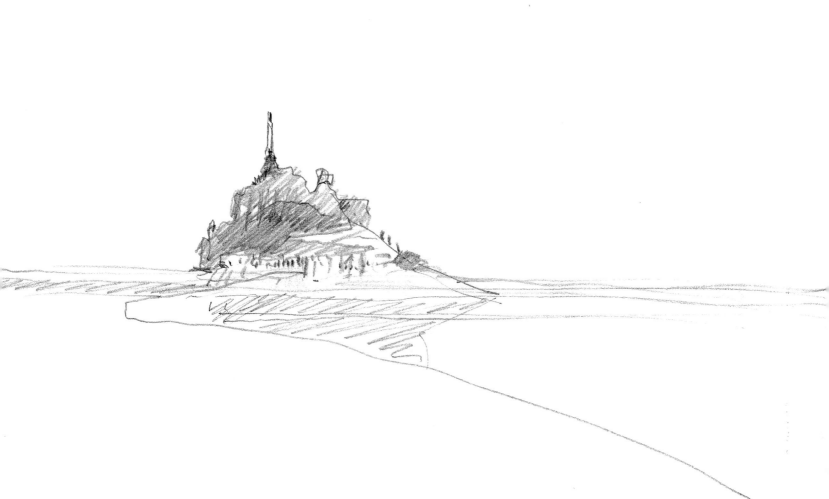

FROM THE BUS. MONT ST. MICHEL. FRANCE.

2003. Pencil.

I awake. My lunette windows, one real, one a reflection to my left on the closet doors, reveal the day. Each day, basswood leaves thicken. Will this be the last spring?

Is the window part of the house or does it belong to the sky? Is this house a mere windowless container for the night, waiting for the kneeling skywindow to blink us into existence?

My ancestral genes remember a cave. Is one window enough to blink us into existence? Where is the second window? Somewhere back in my memory, there is a second opening to create movement, the drafts of inspiration, a place to escape lest the monsters enter the front window. Or is the second window mere illusion, like my mirrored lunette? Turning in my bed from right to left creates the space to define a life, each window a dispersion of photons undecipherable in their mix, alchemy with no hope of measurement, offering only hope.

Michael James Plautz
Written in bed on Sunday morning, May 23, 2011

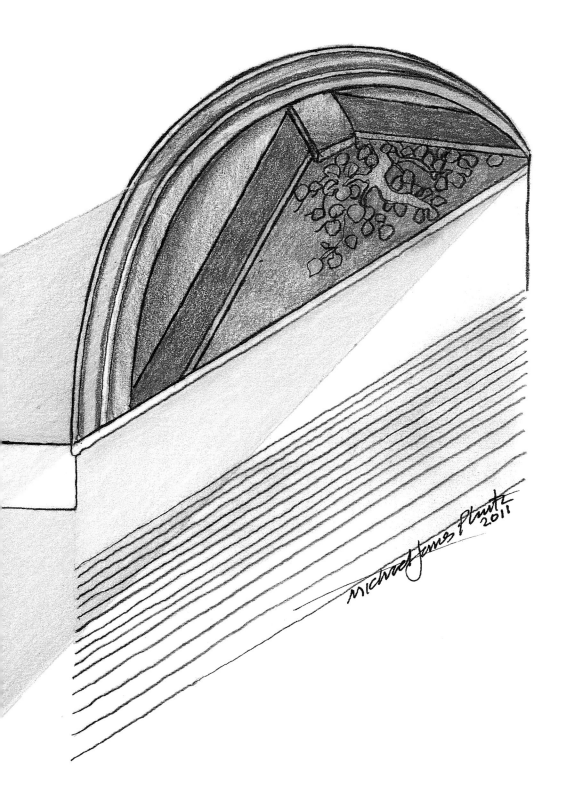

WINDOW LIGHT.
Minneapolis, Minnesota.
2011. Pen and color pencil.

Acknowledgments

I thank the inexplicable genetic fusion of nature and nurture that drove me down this path as well as my family and friends who tirelessly encouraged this curious kid who always had to draw.

To my mother and her brother, John Snedic, who encouraged me and provided role models. To the entrepreneurial gentleman from an art correspondence school in Minneapolis who appeared on my grandmother's farm in summer to seek me out and to enroll me as we stood there, me full of sweat and dust from the wagon load of hay I had just piled. And then to the formal training from talented professors in architecture at the University of Illinois at Urbana-Champaign who nurtured the twin daughters of image-making: the precise ability to define form and relationships (with the tools of Da Vinci) on the one extreme, and the gestalt, impressionistic mind wash of watercolor, lifting and seeking edges between the formed and the unformed where spontaneous pathways burnish possibilities from the subconscious to the light of possibilities.

My thanks to my dear friend and wife, Gloria—fellow traveler, lady of words who taught me what "quotidian" meant and completed the unformed half of me. She has seen me making every one of these drawings and waited patiently for my "just fifteen more minutes" which often stretched to forty-five; for the lovely dinners we make together and discuss events of the day and the origin and meaning of words. And to my dear daughter Andrea and husband Scott and their lovely daughters Zoe and Stella who support me with unbridled love and introduced Gloria and me to the remarkable richness of Africa. May Zoe and Stella walk below the trees we have planted or the trees we may become. For the love and support of my brother Patrick and sister Mary Jo, both artists who pursue their passions in parallel ways and we all learn from each other.

To Alec Notaras—director of the University of Illinois' foreign studies abroad program in Versailles, France, for American college architecture students—for his recruitment of me to conduct one- and two-week sketching and urban analysis workshops with American architecture students throughout Europe. I am eternally grateful to not only Alec but his successor, Professor Alan Forrester, and current director, Professor Alex Lapunzina for continuing the opportunity.

To our dear friend David Hanser—who introduced me to the joys of Bach during our mutual studies of architecture and architectural and art history at the University of Illinois and for decades of traveling and sketching together from Chartres to Rome, from Santa Fe, New Mexico, to his remote farmhouse in central France to critiquing students in Champaign-Urbana, Versailles, and Oklahoma.

To Jean Castex—professor, eminent scholar, author, and fine sketcher whose gracious hospitality and fine food at his apartment in Versailles greets us in every trip there, for our travels and mutual sketch sessions from Greece to Santa Fe. And to Madame Maire-Annick Matovic, past executive administrator of the University of Illinois abroad program in Versailles for her friendship, warmth, generosity, and hospitality in Versailles and especially in her home in le Pégue, our home base for exploring the joys of Provence.

To Burton Shacter—friend, client, fellow fisherman for his support for my art and architecture and for the many tramps through drawings, rivers, and menus.

To Kurt Heikkila—scientist, chemist, entrepreneur, and friend who

has supported me in many realms, a mentor in the ways and means of innovation, in his commitment to the design and manufacture of environmentally friendly products; to his support of design and my art, for his support on my behalf for the Wolf Ridge Environmental Learning Center in Finland, Minnesota; for friendship and wine and for placing me in the midst of large Canadian northern pike, my counterpoint to western trout streams.

To Joe Puppin—friend, teammate, gifted Italian designer, innovator and craftsman for his support in the pursuit of new ideas and for our mutual love for all that is important in life.

To David Pines—scientist, researcher, professor, friend, tireless mentor to many of us seeking to define and to understand this emergent universe we live in with all its inter-related design questions to be answered; to his enjoining me to his ICAM Board of scientists to participate in rich dialogues and challenges. To his tireless efforts to Wolf Ridge and teachers everywhere to make interdisciplinary emergent science curricula available to the youngest set, grade school students; who are future's hope . . . and to his dear wife Suzy, the other half of a marvelous team in all of this plus the hospitality in food and drink and a painter's inspiration in her garden.

To Jim Bracke—scientist, microbiologist, thinker, friend, for tramps through our minds over breakfasts and tramps through the rivers and mountains of the West, seeking illumination. To my founding partner at RSP Architects, Sandy Ritter, who supported my passion for design and drawings with a comment at an early strategic firm retreat upon seeing my list of future goals: "You know, if you don't draw every day it is kind of a wasted day, isn't it?" And to RSP's continuing tradition of sending annual reproductions of my watercolors to a host of clients and friends for almost thirty years.

To Jack Lemon—owner of Landfall Press in Santa Fe, for lugging a heavy lithography stone to my studio and encouraging me to embark on this new, sensuous adventure of drawing on prepared stone and making images through the ancient press craft of "working the stone."

To Al Harris—fishing guide, friend, expert on western art and literature who led me to countless western streams and the many trout which swam free after removing my barbless hook; for his tutorial on the Latin names of wildflowers I painted; for his introduction to literature such as *Diary of a Trapper*, early 1800s accounts of trapping and wintering along the various Yellowstone streams we fished and *Vagabond for Beauty*, about Evert Ruess's mysterious disappearance while seeking images in the wilds of California.

To Terry Bongard—neighbor and friend for his complete support through ad hoc and always timely gifts of meals and intense philosophic discussions; for his admiration and support of my art both physically and intellectually.

To A. Richard Williams— architect, educator, provocateur and designer par excellence who taught and challenged several generations of us as architects and thinkers and continues as a nonagenarian to mentor with acuity and provide a model as to how to live a life.

To the many students I have had over the years whose enthusiasm made me better; teachers do learn the most. May they all become teachers.

To Lee Klancher and Octane Press—for encouraging me to embark on this adventure and for his acuity in tone and direction. It has been a pleasure.

My profound thanks to Juliette Fournot—whose passion and life's story, spirit, and love led me to a marvelous circle of friends in diverse journeys including especially (oh!) Emmanuel Guibert . . . artist, storyteller, author, friend, gentle man, human in the extreme. Each time I read his forward it touches me deeply and reinstructs me in the positive power of touching deeply the world around us and looking beyond the simple surface of things.

And last, but not least, my thanks to all the children who gather around me while I draw and challenge my willful omissions in the scene before me; may they always keep us honest.

List of Illustrations

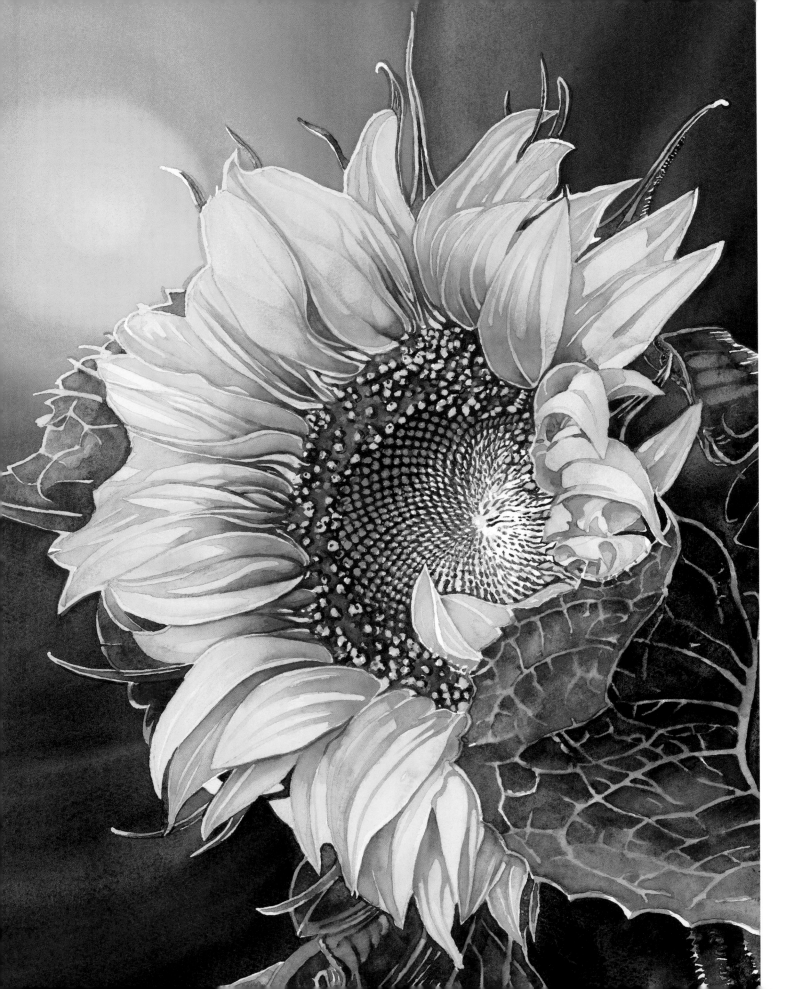

The Art of Michael James Plautz

The art of Michael James Plautz ranges from pen and pencil drawings, watercolor paintings, and lithographic prints. A selection of prints of his finest work are available for purchase at www.michaeljamesplautz.com/. The prints are giclees printed on archival paper as well as lithographs and originals. A number of the images in this book which are not displayed in the website are available as giclees. Please inquire through the website.

Michael and his wife Gloria split their time between Minneapolis and their home and studio in Santa Fe, New Mexico. They have a wonderful family in their daughter Andrea, her husband Scott Folland, and two lovely granddaughters, Zoe and Stella.

Michael continues to draw, paint, and pursue lithography projects both in Minneapolis and Santa Fe.

He is also developing lighting fixtures and light sculpture using LED technology, as well as the occasional architectural project. New work will be posted on the web site as it accrues.

Above:

CHARTRES CATHEDRAL,
FRANCE
No. G2-022
Original watercolor. 1992.
Architecture.

Opposite:

SUNFLOWER ONE
No. G3-001
Original watercolor. 2010.
Florals.

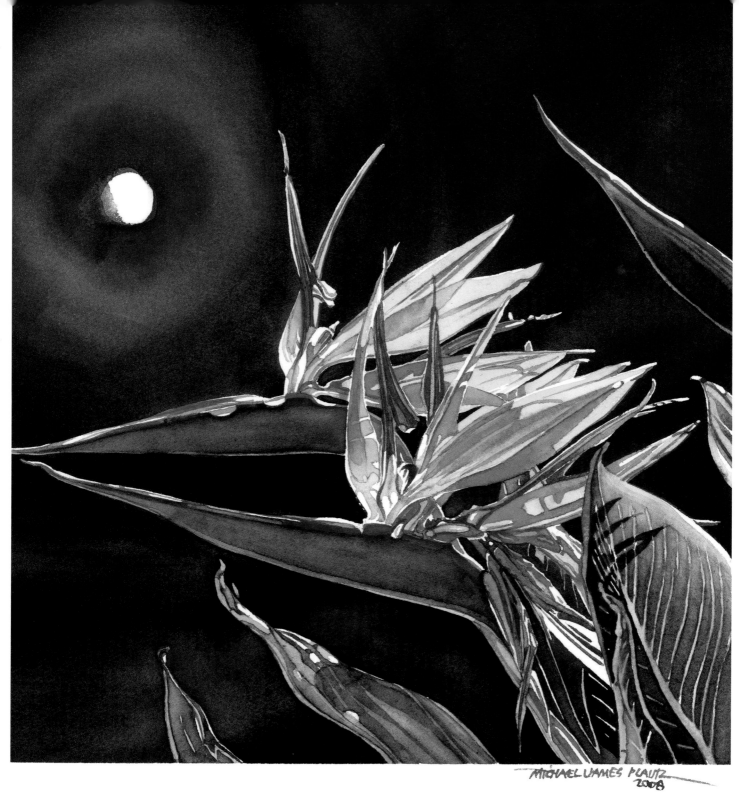

BIRD OF PARADISE

No. G3-004

Original watercolor. 2008.

Florals.

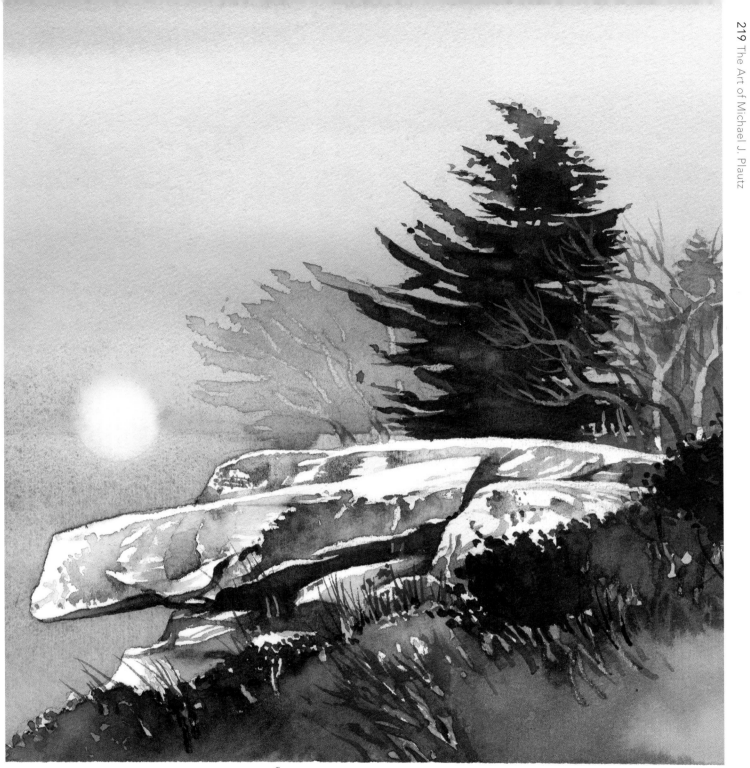

MICHAEL JAMES PLAUTZ
07

LAKE SUPERIOR SHORELINE

No. G4-011

Original watercolor. 2007.

Landscapes.

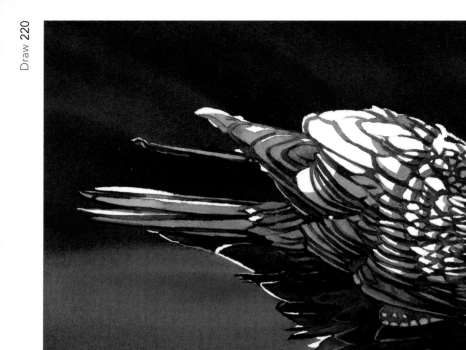

TEMPTATION

No. G5-001

Original watercolor. 2009.

Creatures.

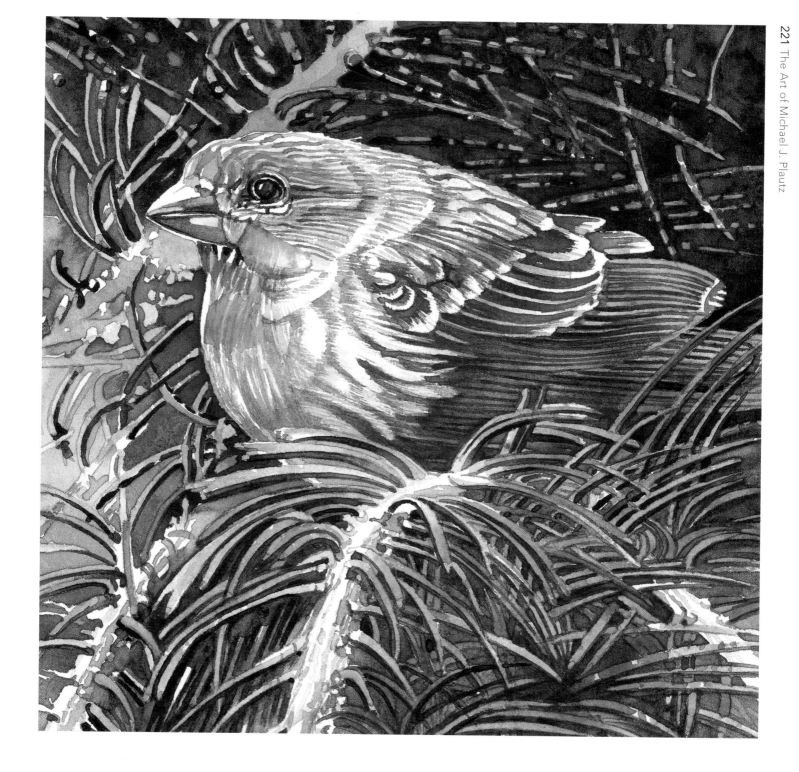

HOUSE FINCH

No. G5-005

Original watercolor. 2007.

Creatures.

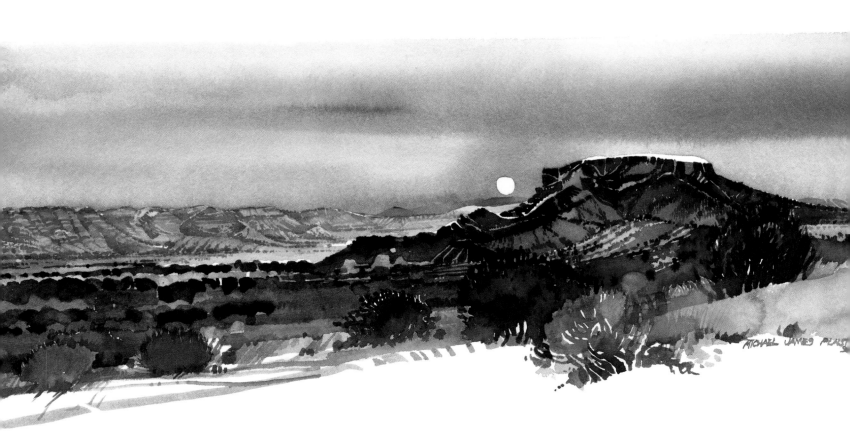

BLACK MESA, NM
No. G4-010
Original watercolor. 1993.
Landscapes.

THREE WAY
CONVERSATION
No. G1-005
Original watercolor. 2007.
Still Lifes.

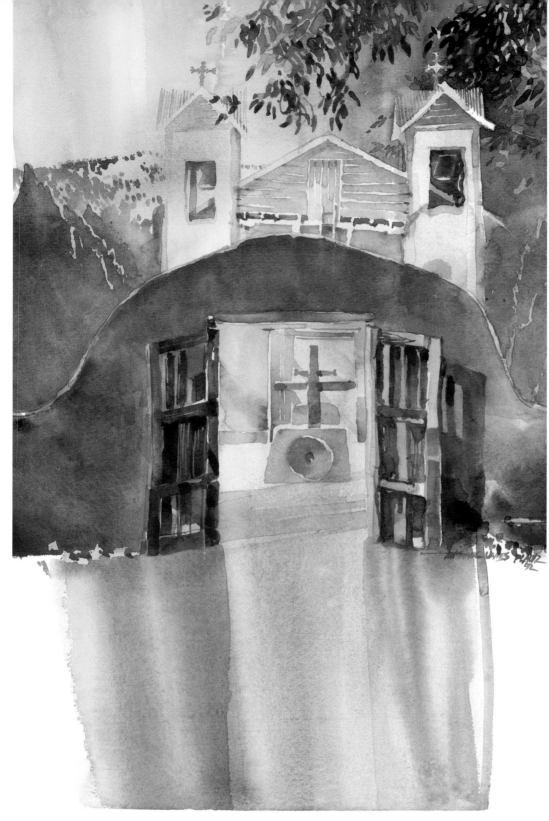

CHIMAYO CHURCH, NM

No. G2-009

Original watercolor. 1992.

Architecture.

Opposite:

RIO GRANDE GORGE, TAOS, NM

No. G4-019

Original watercolor. 1993.

Landscapes.

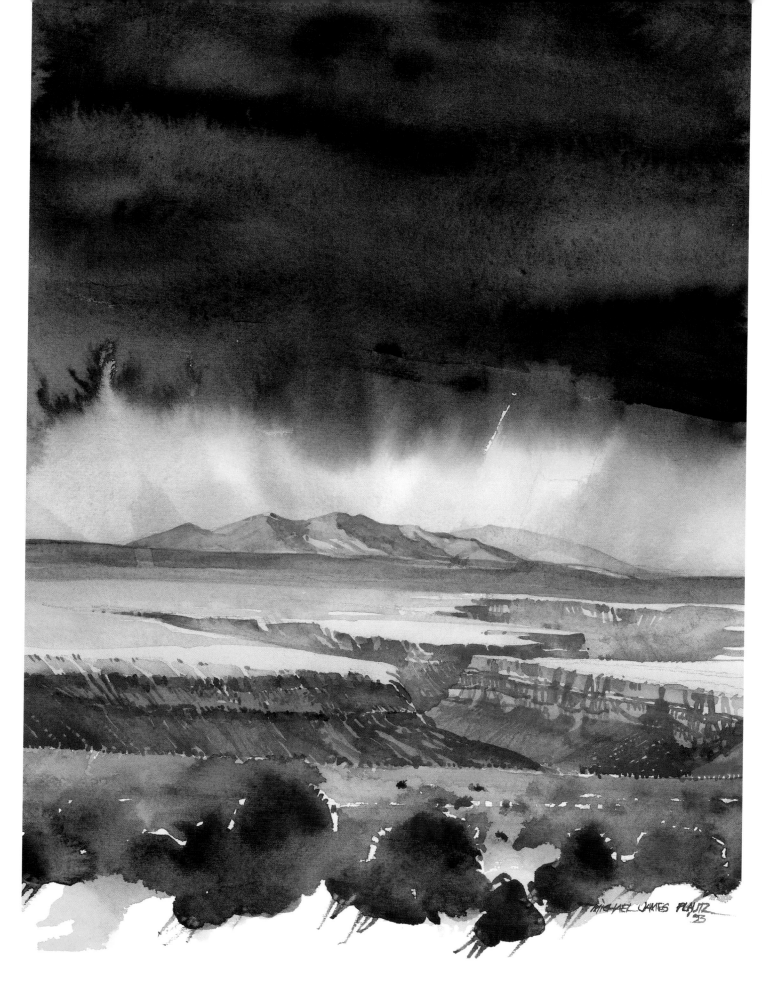

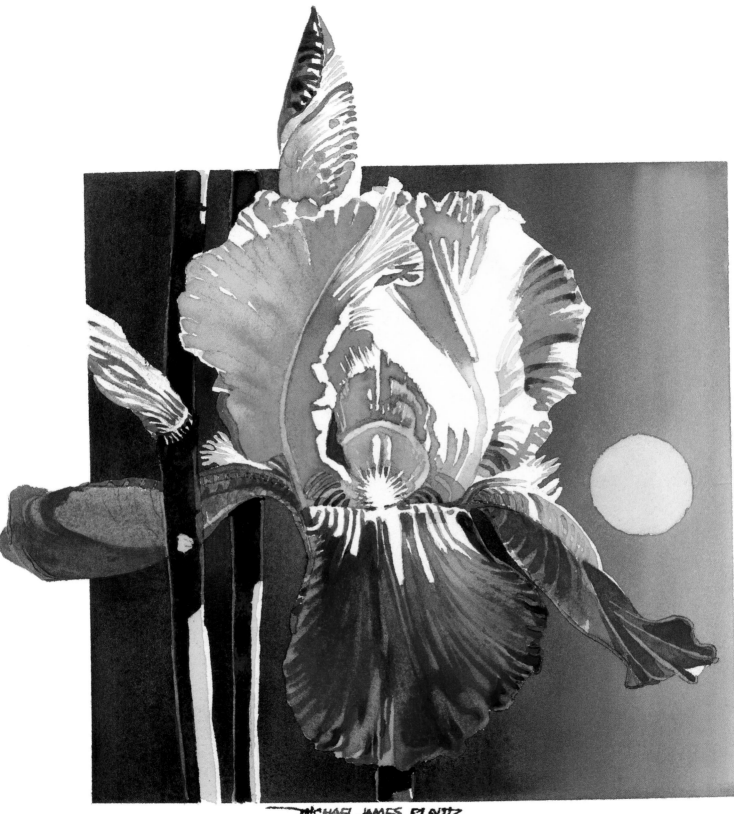

MICHAEL JAMES PLOTZ

YELLOW IRIS

No. G3-005

Original watercolor. 2007.

Florals.

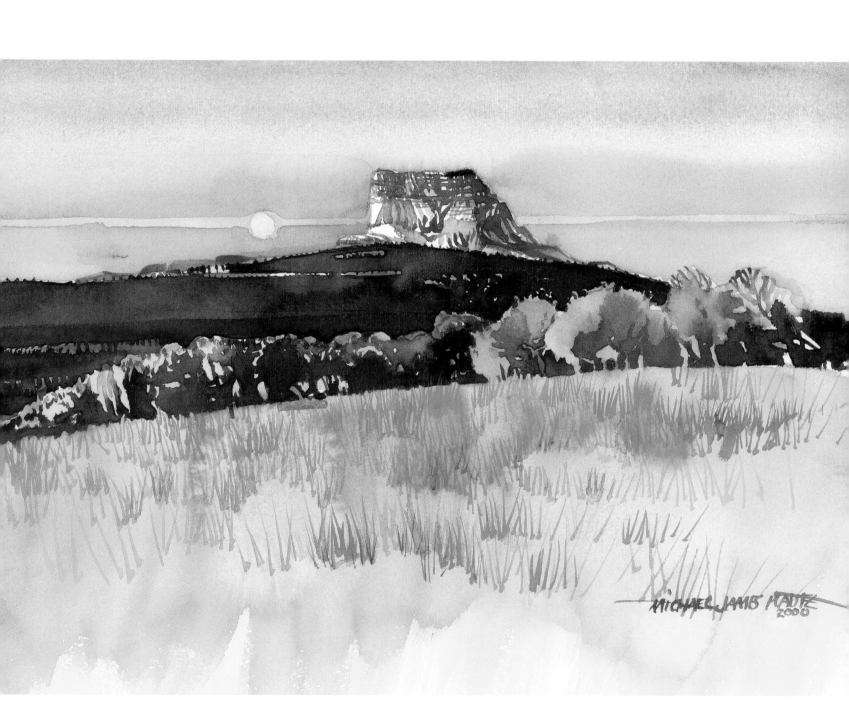

CHIEF JOSEPH

No. G4-012

Original watercolor. 2000.

Landscapes.

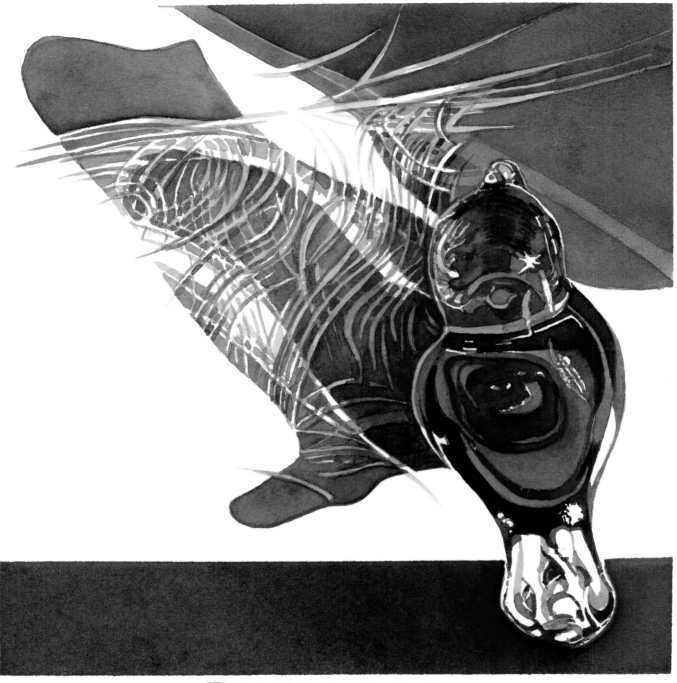

MICHAEL JAMES PLAUTZ
07

BLUE GLASS BIRD

No. G1-003

Original watercolor. 2007.

Still Lifes.

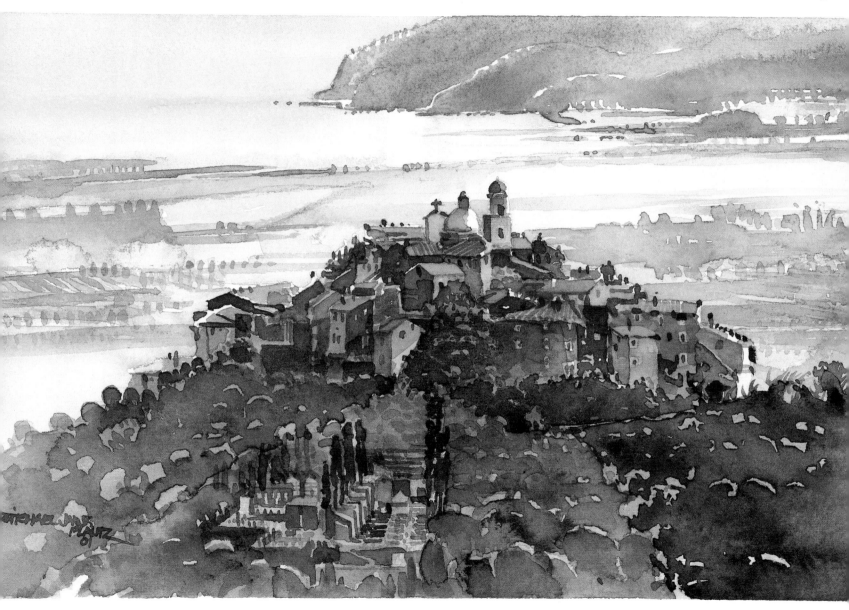

ITALIAN HILL TOWN

No. G2-029

Original watercolor. 2001.

Architecture.